Digital Macro &
Close-Up Photography
FOR
DUMMIES®

Digital Macro & Close-Up Photography

FOR DUMMIES®

by Tom Clark

WILEY

Wiley Publishing, Inc.

Digital Macro & Close-Up Photography For Dummies®

Published by
Wiley Publishing, Inc.
111 River St.
Hoboken, NJ 07030-5774
www.wiley.com

WILEY

About the Author

Tom Clark is a professional photographer in Miami, providing services in portraiture, fashion, advertising, product, landscape, architectural, and editorial photography. While studying to obtain a bachelor of arts in commercial photography, he learned compositional, technical, and lighting techniques, which have been (and continue to be) refined throughout his career.

As part of his technical education, Tom received a thorough understanding of macro and close-up techniques. His approach to macro and close-up photography reflects his understanding of composition and light, and reveals his attention to detail. To view Tom's image galleries and check out his *Photo of the Week* (which highlights his most interesting recent captures), visit his website at www.tomclarkphoto.com.

Author's Acknowledgments

As its writer, this book was both an adventure and a learning experience. I hope the same is true for its readers.

Thank you to Erin Calligan Mooney and John Wiley & Sons for presenting me with another great opportunity. The photographic *For Dummies* series is a valuable tool and resource for photographers of all types. It's a pleasure to be involved.

Thank you Traci Cumbay for keeping the project on track, and for helping to ensure this book provides nothing but the clearest, most useful, and informative material. And thank you to Mark Sawrie for serving as technical editor; you kept me on my toes and helped ensure the validity of this book.

Thanks to Emily Noe for providing creative input and for assisting in the creation of the photography.

Publisher's Acknowledgments

We're proud of this book; please send us your comments at www.dummies.com. For other comments, please contact our Customer Care Department within the U.S. at 877-762-2974, outside the U.S. at 317-572-3993, or fax 317-572-4002.

Some of the people who helped bring this book to market include the following:

Acquisitions, Editorial, and Media Development

Project Editor: Traci Cumbay

Acquisitions Editor: Erin Calligan Mooney

Copy Editor: Traci Cumbay

Assistant Editor: David Lutton

Senior Editorial Assistant: David Lutton

Technical Editor: Mark D. Sawrie

Editorial Supervisor and Reprint Editor: Carmen Krikorian

Editorial Assistants: Rachelle S. Amick, Alexa Koschier

Cover Photos: Tom Clark

Cartoons: Rich Tennant (www.the5thwave.com)

Composition Services

Project Coordinator: Nikki Gee

Layout and Graphics: Claudia Bell, SDJumper, Corrie Socolovitch

Proofreaders: Rebecca Denoncour, Betty Kish

Indexer: Becky Hornyak

Special Help
Alex Mattingly

Publishing and Editorial for Consumer Dummies

 Diane Graves Steele, Vice President and Publisher, Consumer Dummies

 Kristin Ferguson-Wagstaffe, Product Development Director, Consumer Dummies

 Ensley Eikenburg, Associate Publisher, Travel

 Kelly Regan, Editorial Director, Travel

Publishing for Technology Dummies

 Andy Cummings, Vice President and Publisher, Dummies Technology/General User

Composition Services

 Debbie Stailey, Director of Composition Services

Contents at a Glance

Table of Contents

Introduction

*H*ave you ever looked at a photograph and wondered how in the world the photographer captured so much detail in such a small subject? The answer is macro photography.

The purpose of this book is to provide a working knowledge of what macro and close-up photography is, the equipment used to create it, and the techniques practiced to provide amazing results. Your ability to capture fine details of small subjects and wow viewers with your imagery will reach new levels when you apply the practices you find in the following chapters.

Read on if you're interested in photographing flowers, revealing the features of tiny creatures, exploring miniature landscapes, taking close-up portraits of people, making your jewelry photos pop, shooting small products, or if you would like to find ways to get more from your photographic equipment.

About This Book

Macro and close-up photography is one of the more technically challenging art forms out there, but having a firm grasp on its concepts and techniques can open a whole new world of photographic possibilities. To begin exploring this field, you need to know the magnification possibilities and limits of your equipment, how to magnify a subject's appearance on your digital sensor, and how to use your equipment to capture sharp, comprehensive depictions that reveal the quality of detail you want.

In this book you find technical information that helps you get the most from your equipment and determine which equipment would be worth acquiring based on your photographic style. You're also introduced to theories and concepts that help better your ability to notice fine details and create more interesting and beautiful photographs.

As a prepared and knowledgeable macro and close-up photographer, you'll know which camera settings work best in specific situations, how to avoid common problems and mistakes, and how to approach a shot based on your subject and your message.

Although it would be worthwhile to read this book from cover to cover to gain a complete understanding of macro and close-up photography, you don't have to do so. Feel free to jump in at the specific chapters that address

topics you're most interested in. No chapter relies on your kn[...] any preceding chapter to make sense. You may want to practic[...] expressed in one chapter prior to moving on to the next, but y[...] everything you need (or directions to further information) whe[...] begin reading.

Conventions Used in This Book

In this book, I use the following conventions to make sure the text i[...] [...]s-tent and easy to understand:

✔ For each photograph, I include the following information:

- **Focal length:** This number shows the angle of view provided by the particular lens used. It determines how much of your scene you capture when you compose a shot.

- **Shutter speed:** This number indicates how long it took to complete the exposure (usually measured in fractions of a second). It determines how precise the moment of capture is, and it's particularly important when photographing subjects in motion.

- **Aperture:** This number shows how much light the lens let in at the time of exposure (measured by an f-stop). It helps to regulate your depth of field, which determines how much of your scene is sharp or blurry.

- **ISO:** This number displays how sensitive the digital sensor is to light during the time of the exposure. A sensitive ISO rating (indicated by a higher number) can produce a properly exposed image more quickly and with less light than a less sensitive rating (indicated by a lower number).

✔ All web addresses appear in `monofont`.

✔ New terms appear in *italic* and are followed by an easy-to-understand definition.

✔ **Bold** highlights the action parts of numbered steps and the key words in bulleted lists.

When this book was printed, some web addresses may have needed to break across two lines of text. If that happened, rest assured that I've added no extra characters, such as hyphens, to indicate the break. So when using one of these web addresses, simply type in exactly what you see in the book as though the line break doesn't exist.

What You're Not to Read

If you're anxious to start taking macro and close-up images with amazing detail and clarity, then you may want to skip around this book to areas that pertain directly to you. If you're in a big hurry, here's a tip: You can skip the sidebars (those gray-shaded boxes) and any text marked with the Technical Stuff icon. Information found in those areas may interest you and add something to your macro and close-up photography, but it isn't necessary for getting started.

Foolish Assumptions

Before writing this book I had to make some assumptions about you, its reader. For example, I assume that you

- ✔ Are new to macro and close-up photography
- ✔ Have a basic understanding of your camera equipment
- ✔ Have experimented with photography but are still mostly in the beginner camp
- ✔ Are familiar with downloading, viewing, and editing photos on your computer

How This Book Is Organized

Each part in this book covers a different aspect of macro and close-up photography. The parts combine to paint a whole picture, but you can read them in any order that makes sense to you. To help you get straight to the info you want, here's a breakdown of what you find where.

Part I: Getting Acquainted with Macro and Close-Up Photography

This part gives a general overview and introduction to macro and close-up photography. It explains the similarities between macro and close-up photography, how they differ, and how to train your eye to see things from a macro and close-up viewpoint in order to create beautiful images.

Part II: Equipment: What You Need, What's Nice to Have

You need specific equipment and techniques to create stunning macro and close-up photography. This part of the book covers the various options available to get you started, providing comparisons and explanations for each. The information in this part helps you make educated decisions when purchasing gear or practicing certain techniques, and it introduces you to specialized equipment designed for specific purposes and projects.

Part III: Creating Successful Images: Light, Composition, and Exposure

Lighting is very important in all types of photography. This part explains how you can apply the various styles of lighting to macro and close-up photography in order to achieve the best photographic results, depending on your subject and your message. It also covers which camera settings work best in certain situations, and it gives you information on creating ideal compositions.

Part IV: Techniques for Shooting Subjects of All Types

Different subject matter requires different equipment, styles, and techniques. For instance, you probably won't bring the same amount (or type) of gear hiking up a mountain as you would have available in your home or studio. And you won't photograph a transparent gem on a plain white background in the same way you would photograph a flower in a field.

This part of the book provides information that's relevant to specific subject matter, with each chapter covering a certain type of subject. You also find a chapter on making postproduction improvements to images, based on your subject and your message.

Part V: The Part of Tens

The Part of Tens provides two short chapters designed to spark your creativity and get you shooting right away. You discover ways to maximize image quality when using your digital point and shoot camera, and ten subjects worth exploring with macro and close-up photography.

Icons Used in This Book

Icons are used to categorize information, making it easier for you to find what you're looking for and easier to understand what you're looking at. I use the following icons to direct your eyes to specific types of information within the book.

Text appearing next to this icon presents information that you'll rely on again and again when photographing macro and close-up subjects. This is the stuff you want to make second nature.

In some instances, the text gets a little more technical to introduce greater detail than is necessary for beginner macro and close-up photographers. You're welcome to skip these divergences; you won't miss anything crucial.

Whenever I provide information that saves you time, money, or photographic frustration, I mark the text with this icon.

Macro and close-up photography can be a delicate process. Whenever I discuss possible errors or missteps, I highlight the information with the icon that represents a threat.

Where to Go from Here

You don't need to read this book in any particular order; where you go from here is entirely up to you.

You can jump into any chapter, based on which topic interests you the most or what will best help you reach your photographic goals. If you're a jewelry designer and wish to produce photographs for your website, you might like to start with Chapter 15. If you're interested in getting a foundation as to what macro and close-up photography is and how it's used, then start in the beginning of this book. Gearheads feel free to jump right to Part II, and if you're baffled with lighting your macro and close-up subjects then you may want to start with Part III.

To get the most out of this book, be sure to keep your camera handy and to practice the techniques I discuss for some hands-on experience.

Part I
Getting Acquainted with Macro and Close-Up Photography

The 5th Wave By Rich Tennant

CAMERAS

"I want a lens that's heavy enough to counterbalance the weight on my back."

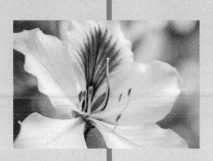

In this part . . .

Macro and close-up photography are typically paired together in the same genre even though they're not technically the same. Understanding their differences and similarities helps you to know what equipment is relevant to each and how to achieve certain results. Building a strong foundation is important to mastering any art form, and this is especially true in macro and close-up photography. This part of the book gives you the information you need to start building an understanding of this genre.

1

Discovering the Basics of Macro and Close-Up Photography

*L*ife presents us with a multitude of potential photographic subjects. Some of them are grandiose and present themselves to you in a blatant way. Others are smaller and a little more difficult to discover; but some subjects can be so small, you may not recognize their potential when it's right under your nose.

By paying attention to the smaller details in life, you can open the door to a whole new realm of photography: One that presents photographic scenes equally as intricate as the grandiose, only smaller in scale.

If you're interested in exploring the complex details of the tiny world, looking for a new hobby, or trying to broaden your photographic abilities, learning the macro photography process will be rewarding and interesting.

In this chapter you find out exactly what macro photography is, how you achieve it, and why it's beneficial for you to know.

What Is Macro Photography?

The term *macro photography* has come to mean many things through time, such as very close-up images, life-size representations of subjects, or photography of magnified subjects.

In reality, *macro* means something very specific and relates to only a small percentage of the ideas associated with it. Macro-specific gear tends to be expensive, so many manufacturers have produced inferior products tagged *macro* simply to increase the size of the market.

By learning the ins and outs, you can know the difference between what's truly macro photography and what's not, which will help you make informed decisions when purchasing gear and producing images. Read on to find out what a true macro photograph is, what has been twisted and referred to as macro photography for the general consumer market, and the technical factors involved.

The 1:1 ratio

Macro photography means creating an image in which the subject is depicted on the digital sensor (or film plane) in its actual size. That means it has a magnification ratio of 1:1, and if you printed an image the same size as your digital sensor (36mm x 24mm for a full frame DSLR), the subject would appear life-size.

I photographed the subject in Figure 1-1 with a 1:1 magnification ratio using a full-frame DSLR camera, and printed it with the sensor's true dimensions. See for yourself that the subject is represented in its actual size.

Macro photography isn't a magnification but a true representation. However, the macro photograph appears to be a magnification because most prints are made to be much larger than the digital sensor's size, and you view most images on your monitor at a larger size as well. A macro subject appears huge in an 8x10 photograph compared to its actual size of about 36mm x 24mm.

Because the size of your DSLR camera's digital sensor is fairly small (relative to most subjects), photographers typically use macro photography

when shooting very small subjects. It's a method for showing detail that would be lost, or unnoticeable if the subject were photographed with less magnification.

100mm, 0.3, f/16, 640

Figure 1-1: A 1:1 ratio captures a life-size depiction of a subject on the camera's digital sensor.

The significance of a 1:4 ratio

In more recent years, the term *macro* has been modified to help manufacturers sell equipment that doesn't have true macro capabilities. (I tell you more about the ins and outs of equipment in Chapter 2.) By doing so, companies can now sell cameras and lenses (in the 35mm format) that enable you to capture a 1:4 magnification ratio — one quarter the magnification of a 1:1 — but refer to it as macro equipment.

The argument for a 1:4 ratio providing macro results is that when making a typical 4x6 inch print, your subject will appear life-size, or close to it. This theory was put to the test in Figure 1-2. As you can see in the 4x6 inch print, the subject appears close to its actual size; but when compared with the 1:1 ratio example in Figure 1-1, you can easily see that true macro photography provides a much more detailed depiction of a subject this size. Notice how much less of the frame's space is dedicated to the subject when using a 1:4 ratio.

The difference between a 1:4 and a 1:1 ratio provides a much different representation of your subject, although each may be referred to as macro, depending on whom you're talking to. To keep things simple, I consider anything with a magnification ratio of 1:1 or greater to be macro photography, and anything less to be close-up photography. (I tell you more about close-up photography in Chapter 2.)

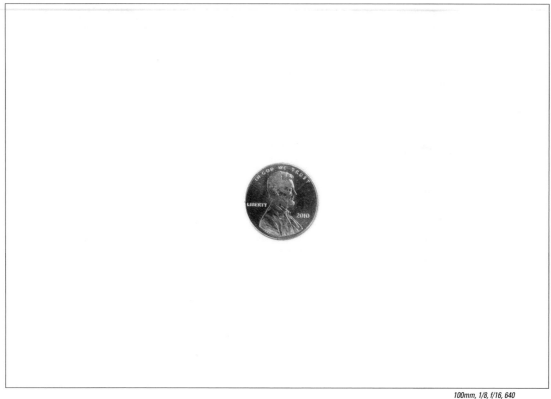

100mm, 1/8, f/16, 640

Figure 1-2: A 1:4 ratio provides a life-size representation of the subject when printed at the typical size of 4x6 inches.

Running Down the Right Tools for the Job

You have numerous options for equipping yourself to capture great macro and close-up images. In fact, you may already have what it takes. Chapter 2 introduces a method for finding out just how close you can get to subjects while achieving sharp photographs of them, and for testing the quality of your results.

If you find that the limits of your gear fall short of where you want to be in terms of magnification, accessories are available to get you there:

✔ *Extension tubes* or *bellows* are hollow spacers that you place between the lens and camera body to increase your ability to focus on close-up subjects.

✔ *Tele-converters,* optical devices that you place between the lens and camera body, magnify the image collected by the lens before it reaches the digital sensor.

✔ *Reversing rings* are attachments that enable you to reverse a lens in order to create more magnification in the image it provides.

✔ *Close-up filters,* attachments that you position in front of a lens, enable you to achieve focus nearer to your subjects.

I discuss tools like these in detail in Chapters 4 and 6.

Macro-specific lenses, which enable you to achieve macro and close-up results without additional accessories or attachments, are ideal for minimizing the amount of gear you have to drag around with you, and for providing pure, unfiltered (straight from the lens to the sensor) results. These types of lenses are for the serious photographer who is very interested in creating amazing macro and close-up images. I talk about macro-specific lenses in Chapter 5.

In addition to lenses and lens attachments, other types of equipment can help you achieve high-quality macro and close-up images. In Chapter 6, you find out about different types of tripods, tools for lighting your scenes, blocking light or wind, items useful for adjusting fine details in a scene, and more.

You don't have to have a DSLR to shoot great macro and close-up images. If you prefer to work with a digital point and shoot camera, check out Chapter 7. There you'll find out ways to use manual settings for enhancing your image quality, composition, and message in macro and close-up scenarios. I also give you information on increasing the macro and close-up capabilities of your digital point and shoot camera.

Attaining Life-Size Representations of Your Subjects

Typically in photography, your subjects appear very small on the digital sensor (or film plane) in relation to their true size. A landscape photograph can cause mountains to fit comfortably into a 36mm x 24mm frame. A portrait fits a person's head into the same tiny frame.

When used in the traditional fashion, ordinary lenses can't produce an in-focus, life-size representation of your subject on your digital sensor. This is fine for subjects that are much larger than your camera's digital sensor; but if you want to photograph a very small subject, or a small detail of a larger subject, then ordinary equipment used in the traditional way won't cut it.

Focal length, focusing distance, and final output determine how large a lens can depict a subject. Understanding these three elements and how they affect your photography gives you a foundation for making wise decisions when purchasing macro and close-up equipment, and when creating your shots.

Focusing distance and focal length

A lens's *focal length* (distance from the lens to the digital sensor, when focused at infinity) is measured in millimeters and determines how a scene is depicted on your digital sensor. When a 50mm lens is focused on a faraway subject, the lens is 50mm from the digital sensor, and because a 50mm lens is a normal lens (in the 35mm DSLR format), it produces an image that's similar to how you see the scene with your own eyes. In order to focus on an object that's closer in distance, the lens must be moved farther from the digital sensor.

At some point, your normal 50mm lens reaches its minimum focusing distance, which falls short of depicting a life-size image of the subject. If you move closer to your subject at this point, you won't be able to achieve focus on it. Figure 1-3 provides an example of how focal length and your focusing distance are related.

Moving the lens farther from the digital sensor

The closer you get to a subject (while still achieving focus), the larger it appears on your camera's digital sensor. Therefore, when it comes to magnifying a subject, you're limited by the closest distance at which a particular lens enables you to achieve focus.

The idea behind macro photography is to move the lens farther from the digital sensor so that you can move closer to your subject. The farther the lens goes from the sensor, the closer you can get and the more magnified your subject appears in your frame.

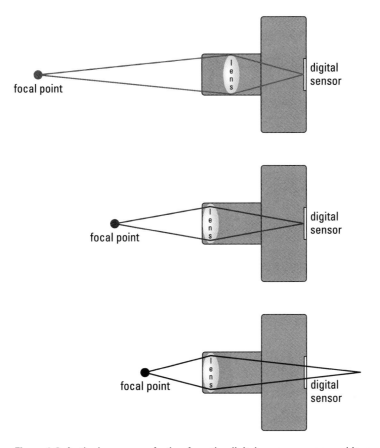

Figure 1-3: As the lens moves farther from the digital sensor, you can achieve focus at nearer distances.

Figure 1-4 reveals the difference between an ordinary 50mm lens and a macro-specific 50mm lens. The macro-specific lens is designed to enable the lens to move farther from the digital sensor, making a 1:1 ratio possible.

The appropriate viewing distance

Do you really need a true macro image? Some photographers argue that the final image — not the magnification ratio behind it — is the only thing worth worrying about. Make sure that you consider the intended usage of an image when determining whether you need a true 1:1 macro ratio to capture the necessary level of detail.

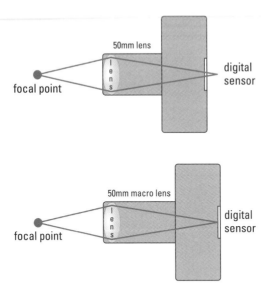

Figure 1-4: An ordinary lens falls short when it comes to creating macro images.

A 1:4 magnification ratio produces an image that depicts the subject at its life-size proportion when printed as a 4x6. If this is the size you intend to make your final print of an image, then everything should work out just fine. Viewers usually look at a 4x6 while holding it. If they wish to see more detail, they can bring the print closer to their eyes.

If that same print were hung on the wall in a gallery or a museum, then the viewer would have a difficult time seeing much detail at all. With a macro 1:1 ratio, the subject is depicted at its actual size in a 36mm x 24mm print. If you blow up that image to 4x6 inches, then your subject appears much larger than life-size when a viewer holds the print in her hand. She can actually stand back a bit and still see detail in the subject. If you blow the print up to 11x14 inches, the viewer will be able to see detail from a pretty far distance, whereas the 1:4 ratio would not be as effective.

Why any of this matters

If you're in a scientific field, such as forensics, or you're discovering and documenting new species in the less-explored parts of the world, you might need to create images that reveal the subject in its actual size.

You can also use macro techniques to create the "life-size" image of shredded wheat that appears on the cereal box, create a series of artistic pieces that show subjects in their true size, or just to brag to your friends that your subjects have so much detail in them because you photographed them at life-size on your digital sensor.

Knowing is simply better than not knowing, and perhaps the best reason to understand the difference between macro and close-up photography is so you know what gear you'll need to produce the style of images you're going for.

When you drive into a mechanic's garage to have your car looked at, you probably throw a few key words out there to let him know you're aware of the parts that make up your car and the purposes they serve. This helps you feel confident that you won't get taken for a ride (so to speak), and it shows your knowledge of the heavy machine you operate on a daily basis.

The camera shop is a lot like the mechanic's garage. You want to be prepared and knowledgeable before walking in, or you may feel overwhelmed by the camera jargon being tossed around by salespeople. This awkward moment can cause you to make poor decisions based on what a salesperson thinks is a good idea, rather than making wise decisions based on what you know is a good idea.

By understanding the difference between a piece of equipment that actually produces macro results, and one that just sort of gets you close to the action, you can ensure that you purchase what's right for you and for the type of photography you'll be looking to produce.

Lighting for Macro Photography

Lighting is an important factor in all types of photography, but the issues you encounter with light in macro photography can be somewhat more challenging than in most other types of photography.

As Chapter 4 discusses, focusing closer to your subjects causes some of the light you're working with to fall off before it reaches the digital sensor. This can cause your images to be underexposed and requires that you adjust your camera settings (see Chapter 6) to compensate for the loss of light. But apart from losing light in this manner, you might also encounter situations in which your camera casts its shadow on your subject (because of its close proximity) or the lighting in your scene fails to serve your intended message.

Chapter 8 covers methods, equipment, and techniques for working with natural light, providing information on altering the quality, intensity, and direction of the sunlight, working in different weather conditions, and ensuring your colors are represented correctly based on the color temperature of the light you're working with. Mastering the art of shooting with natural light can be very beneficial, as it ensures you're prepared for and capable of creating beautiful macro and close-up photographs in any lighting conditions.

You typically use artificial lighting when shooting indoors, at night, or in dark, shaded areas where there isn't sufficient light for macro photography. The tools you might bring in to add light include the following:

- *Strobes:* professional quality flash lighting equipment for which you can easily alter the quality, intensity, and direction of light

- *Battery-powered flash:* small, lightweight flash devices that are great for travel and nature photography situations

- *Ring flash:* circular flash units that surround the lens and provide a flat, even light when your camera is extremely close to its subject

Chapter 9 tells you more about using lighting equipment for your macro and close-up photography.

Composing and Exposing Macro and Close-Up Images

When you find yourself in tight areas, or very close to your subjects, you'll find that each little movement has a dramatic effect on your composition. Changing your camera angle by one inch won't make a noticeable difference when photographing a wide landscape of a mountain range, but when your camera is within inches of your subject, a one-inch change in camera angle will alter your composition entirely.

When you're shooting close-up and macro images, you have less room for adjustment and so need to be precise about even minor changes in

- Focal length
- The position of your focal point
- Your camera's position and proximity to the subject
- Camera settings

Even the tiniest changes in your camera settings or set-up can have major ramifications to your macro or close-up composition.

Chapter 10 gives you detailed information about composing macro and close-up images, and Chapter 11 tells you about the camera exposure settings in detail. Each of these elements impacts your composition and the final look of your photographs.

Seeing Macro's Mega-Potential

Macro photography is a valuable scientific tool and an art form. It can be technical and beautiful at the same time, and can be put to use by all sorts of photographers.

Getting in close to a subject to reveal its intimate details can prove very useful, whether you're selling the sparkles in a diamond ring or selling your own message of how rust and decay is the inevitable fate of manmade consumer products. When working with very small subjects, macro and close-up techniques enable you to reveal the details necessary to create compelling images that draw viewers in.

I shot the image on the left in Figure 1-5 with an ordinary 100mm lens at its closest focusing distance, providing the maximum level of magnification for the subject. The resulting photograph doesn't have nearly as much impact as the image on the right, which I photographed using a 100mm lens with macro capabilities. The subject really comes alive when all of its intimate details can be seen clearly. People aren't used to seeing so much detail in small things, and providing that new vantage point can help to grab their attention.

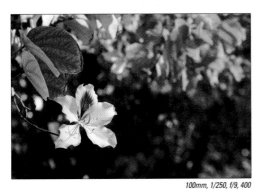
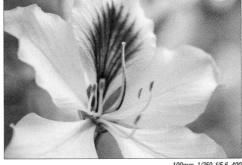

100mm, 1/250, f/9, 400 *100mm, 1/250, f/5.6, 400*

Figure 1-5: Showing more detail draws more attention from viewers.

Macro photography can reveal the process of nature taking its course by giving viewers a detailed glimpse of a bee harvesting pollen from a flower. It can reveal tiny patterns in natural subjects that give an idea of universal order. A very close look into the rough texture of a kiwi fruit can give a viewer the sense that he could walk through the tiny world as if it were a massive forest.

Scientists use macro photography to learn from tiny subjects and to educate students about what they've discovered. The crafty work of artists can reveal tiny perfections and imperfections in items such as jewelry, clockwork, and spider's webs. Water drops can reveal detailed reflections of their surroundings, creating the illusion that each drop contains its environment.

There's a whole world of photographic subjects out there that you've overlooked, stepped on, and passed by. Take a moment to notice those things around you, and you'll find that your own back yard is full of interesting photographic opportunities.

2

Close-Up, but No Cigar: How Macro and Close-Up Photography Differ

Generally, the arts of macro and close-up photography go hand in hand, and if you're interested in exploring one, you find yourself exploring the other, as well. There's a seamless connection between the two that can leave you switching from one to the other without even noticing the difference.

In this chapter you find out how the two are different and how they're the same. You also learn how close you can get to a subject by testing your own equipment and how to apply macro and close-up techniques to your photography.

How Macro and Close-Up Photography Differ

As I tell you in Chapter 1, a photograph is considered to be macro when the subject appears life-size (1:1 magnification ration) or larger on the camera's digital sensor (or film plane). You achieve this ratio by moving your lens closer than usual to your subject.

Plain and simple, macro photography is close-up photography, but close-up photography isn't always macro photography. In the event that you're shooting very close to your subject, but your magnification ratio is less than 1:1 (1:2, or 1:4 perhaps) then you're creating a close-up image rather than a macro image.

Traditionally a close-up refers to an image that tightly frames a subject. The size of the subject determines just how close you have to be in order to achieve this type of composition. In the image on the left in Figure 2-1, I used a macro lens to create a close-up of the very small subject. I used a normal portrait lens to create the close-up on the right.

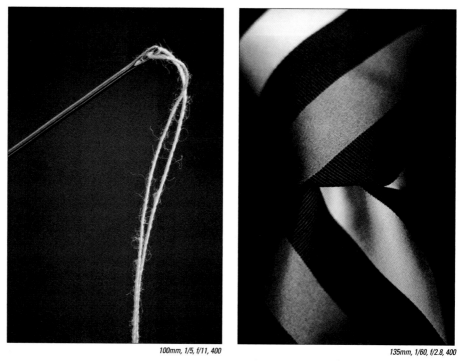

100mm, 1/5, f/11, 400 135mm, 1/60, f/2.8, 400

Figure 2-1: The smaller your subject, the more magnification you need to get a close-up photograph.

Why the difference doesn't really matter

In most cases, the difference between macro and close-up photography doesn't matter. When you have the ability to get extremely close to your subjects, you can reveal smaller details, and photograph smaller subjects, but

how close you get to a subject is relative to its size and your message. Closer isn't always better.

One of your main jobs as a photographer is to make compositional decisions based on how you want to represent the entire scene. Getting in as tight as possible maximizes the amount of detail but cuts down on much of the surrounding details in a scene.

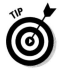
TIP

Instead of burdening yourself with ratios and technicalities, pay attention to your scene and get just close enough to represent it in the best way you see fit.

I photographed Figure 2-2 based on creating the best composition possible, which required a magnification ratio somewhere between 1:2 and 1:3. Truthfully, I didn't even consider the magnification level when composing the shot. Had I chosen my composition based solely on creating a 1:1 ratio, many of the interesting elements would have been cropped out, as they were in Figure 2-3.

REMEMBER

A 1:1 ratio might be ideal for one subject, but that doesn't mean it'll work for the next subject. Photography is a technical process, but creating beautiful and compelling images is an organic process.

Why the difference does matter

Perhaps the actual level of magnification isn't a priority when you're composing and creating images, but it's still a good idea to understand what macro photography is and what separates it from close-up photography of less magnification.

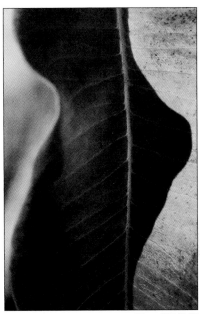

100mm, 1/250, f/8, 200

Figure 2-2: Composition is more important than your level of magnification.

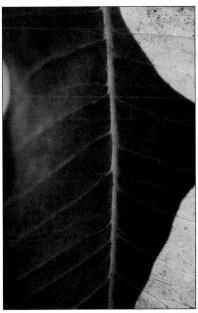

100mm, 1/250, f/8, 320

Figure 2-3: In this case, a 1:1 ratio was not ideal for depicting the subject.

When you gain experience with this genre, you develop an idea of what sort of magnification levels are necessary to reveal sufficient detail in subjects based on their sizes. You know whether you need a macro shot or can get away with less.

When photographing subjects that are smaller than your camera's digital sensor, the ability to capture magnification ratios of 1:1 or greater is a very useful tool. The closer you can get to tiny subjects, the better. If you know you're capable of achieving true macro shots and how to get there, then you'll have an easier time creating images with the highest level of quality details.

Plus, you know how to handle yourself when faced with a salesman who's trying to give you the runaround. Understanding how macro and close-up photo equipment works enables you to make the right purchase decisions instead of taking someone's word for it.

A camera salesman wants to sell you equipment. If you say you're interested in shooting macro shots of flowers, but you're not looking to spend a fortune, then the salesman will most likely sell you something that's not right for you. Macro lenses are generally expensive, but they don't want to lose the sale, so instead they may sell you on something that's cheaper and less effective. At best you'll end up with a "macro" zoom lens that provides the 1:4 ratio I discuss in Chapter 1, but you won't be capturing any life-size images of flowers with it.

By knowing the right questions to ask and the right information to give, you can get better service at your local camera supply store. Let the salespeople know if you want to have true macro-specific gear or if you would be comfortable with something of lesser magnification capabilities. Discuss the lenses you have already and find out whether there are any accessories that can be used in conjunction with them to create macro ratios. (Chapter 4 tells you more about accessories.)

An ignorant customer might be content with whatever the salesman sells him. Let the salesperson know that you're knowledgeable on the topic so he knows you're serious about getting gear that's appropriate for you.

Testing Your Equipment: How Close Can You Get to a Subject?

Before you decide to go out and purchase macro-specific gear, test the equipment you already own to see just how effective it is for macro and

close-up photography. (You also want to read Part II of this book before buying anything.)

Find out how close a specific lens enables you to get to a subject while still depicting it in sharp focus, and check out what the resulting image shows on your camera's digital sensor. This section explains how to do this, and how to analyze your outcome to determine just how close your close-up capabilities are.

A lens's closest focusing distance

Most ordinary lenses enable you to focus on a subject at infinity, meaning there's no limit as to how far away a subject can be. On the other side of the focusing ring, however, is an end point marked with a number. This is your minimum focusing distance, and it's based on how far the lens can move away from the digital sensor.

With the lens focused at its minimal focusing distance, you can move the camera toward a subject until it appears in sharp focus. The distance between your lens and subject at this point is literally your minimal focusing distance. If you move any closer to the subject, it'll fall out of focus and become blurred.

For the test, position your camera and lens at the minimal focusing distance and capture a sharp image of the subject. For best results, choose a subject that's no larger than a couple inches in size. A small subject gives you an idea of how much detail you can get with that lens/camera combo when you review it later on the computer monitor.

 Choose a still subject that will remain consistent throughout your lens and camera tests. Doing so enables you to compare images directly to one another.

If you have more than one lens, then you need to test each individually. If you have multiple camera bodies (especially if one has a full-frame sensor and the other doesn't), test them independently as well. Test a zoom lens at various focal lengths, as the minimal focusing distance varies at each and so provides different results.

I photographed Figures 2-4 through 2-6 at the minimal focusing distance with the same 28mm

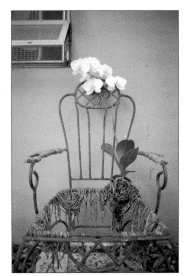

28mm, 1/80, f/5.6, 400

Figure 2-4: A wide focal length causes your subject to appear small in your frame, even at the nearest focusing distance.

to 135mm zoom lens. I took Figure 2-4 with the widest angle (28mm), Figure 2-5 with a normal angle of view (50mm), and Figure 2-6 with the longest angle (135mm).

At 28mm, the lens produces a wider angle of view. The normal angle of view, 50mm, narrows the angle of view and the 135mm focal length provides the narrowest angle of view. Your minimal focusing distance changes only slightly between each of these focal lengths, but the style of the composition changes drastically.

Reviewing your results on the computer

After you test your entire collection of lenses, zooms, and camera bodies, download the images onto your computer in order to view them with comfort and ease. When viewing the images, pay attention to the size of the subject in your various frames and the level of clear detail. Find the lens and camera combination that provides the highest level of magnification and select that image for working with further.

A camera body with a full-frame digital sensor will produce an image that appears less magnified than that of a camera without a full-frame sensor. Because the one sensor is smaller, it's unable to capture the entire image produced by the lens. As a result the image is cropped into, making the subject appear larger in the frame. Figure 2-7 illustrates this point.

Once you've reviewed the results of your various lens and camera combinations, choose the image with the highest level of magnification and view it at 100 percent on your computer monitor. Viewing an image at 100 percent provides a true representation of its fine details and sharpness. You can determine whether your maximum close-up abilities provide high-quality images based on what you see in this image.

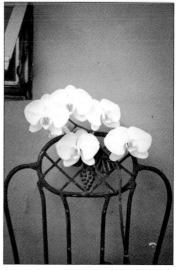

50mm, 1/80, f/5.6, 400

Figure 2-5: Zooming in, and shooting with a normal focal length helps to create a larger depiction of the subject when using the nearest focusing distance.

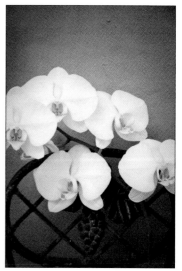

135mm, 1/80, f/5.6, 400

Figure 2-6: Maximizing your focal length (when using a zoom lens) enables you to maximize the level of magnification in your subject.

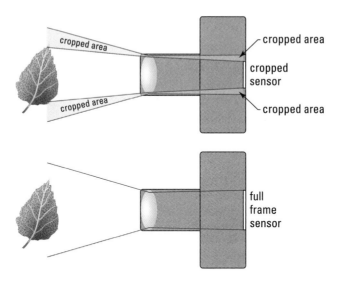

Figure 2-7: A smaller sensor creates the illusion of a more magnified image than that of a full-frame sensor.

If you notice blurred edges in the area where you positioned your point of focus, then the lens you used for that image may not be providing sharp results. You can try sharpening the image in the photo-editing program of your choice (see Chapter 17), or taking the image again to ensure human error didn't influence the original shot. Once you've got the image to have the highest level of quality possible, proceed with the steps in the section "Making prints that maintain high quality."

Cropping into an image in postproduction

Perhaps the closest you were able to get to your subject still left something to be desired, and you feel there's too much unused space in your frame. You wish the subject were cropped into tighter, causing fine details to appear larger in the image and more easily visible. Well, why not crop into the image on your computer and test the results for that as well? Figure 2-8 shows an example of an image being cropped for this purpose. The grey area represents what will be eliminated and the black outline represents the new image frame.

After you've cropped the image (using the crop tool in your photo-editing program) keep in mind that you decreased the overall image size. The new image file will produce a smaller print size than the original. In some cases you may need to increase the image size in order to get the print size you want. If you do increase the image size, be sure to view it again at 100 percent to make sure you didn't lose a substantial (or noticeable) level of quality in sharpness.

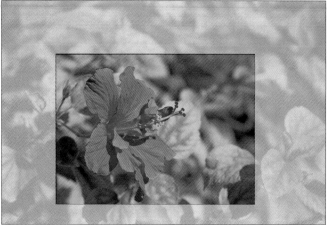

135mm, 1/800, f/5.6, 100

Figure 2-8: If your equipment won't let you get close enough to a subject, try cropping into it on the computer to create the composition of your choice.

Drastically increasing the size of an image can cause blurring and *pixelation* (individual pixels are increased in size and become visible to the naked eye). If the original pixel is enlarged greatly, it actually becomes a clearly visible element of the image.

A camera with a full-frame digital sensor provides more image detail to work with when cropping. In many cases, you can crop out 50 percent of the image frame without losing too much fine detail in your prints. A cropped sensor camera, on the other hand, has already cropped into the original image created by your lens (as Figure 2-8 highlights). If you make a dramatic crop to an image created with this type of camera, you're more likely to notice a major loss of quality in your prints.

Discovering Uses for Macro and Close-Up Photography

By adding macro and close-up techniques to your repertoire of photographic skills, you can create compelling images in a variety of fields. Whether you're a professional photographer, an amateur looking to increase your abilities, an entrepreneur with small products to sell, a jewelry designer, a seller on

eBay, an artist, or a hobbyist just looking to have some fun, this genre is as enjoyable as it is technical.

A startup business owner may find that he can't afford professional photography services in the very beginning of his venture. In that case, knowledge and skills in close-up photography can prove useful in advertising, marketing, and branding the business. If you have a small product or are looking to create a headshot for your bio, then use the close-up techniques throughout this book to ensure people get the message you intended for them to get. If your product is very small, then you'll want to focus on macro techniques, which maximize how much detail your images reveal. Some of the information in Part IV of this book can prove to be very helpful in creating your own professional product, jewelry, and headshot images.

A professional photographer who has not yet explored macro and close-up techniques will find herself with a whole new bag of tricks after reading through this book, and the hobbyist or artist who wants to capture superior detail from tiny subjects is going to find out how to do so in Parts II and IV. By discovering what macro photography is, how it's achieved, and how to maximize the sharpness and aesthetic quality of your macro images, you may surprise yourself with the level of detail you can reveal in a subject.

A biology student or scientist may find herself working with very small subject matter of which she needs detailed photos. Macro photography (or *photomacrography,* which is the technical term for achieving magnification levels greater than life-size in photography) reveals intimate detail that's difficult to see with the naked eye. You can find more about photomacrography in Chapter 16.

Forensics photographers sometimes are required to produce life-size representations of evidence to be used in the courtroom. An understanding of macro photography and the tools necessary to achieve it is a must for this type of photographer.

Close-up photography skills enable you to take interesting shots and reveal a proper level of detail for most subjects, but macro photography represents a more scientific approach to photography, that is not useful only as an artistic tool but for making factual statements about a subject.

In many cases, there's a grey area separating macro and close-up photography. You may choose your composition based on what works best for the subject, without considering whether you're technically using macro or close-up photography. However, in some cases it helps to know which technique will work best:

- ✔ If your subject is larger than your digital sensor and you wish to fit the entire subject in your frame, then close-up techniques are sufficient. A macro 1:1 ratio would create too much magnification to fit your subject in the frame.

- ✔ If your subject is smaller than your digital sensor and you wish to maximize its size in your frame, then you need macro techniques.

- ✔ Any time you wish to depict a perfect life-size representation of your subject on to your digital sensor, you need macro photography techniques.

3

Developing an Eye for Details

"*H*aving an eye" is often considered one of the best traits a photographer can develop. If you have a good eye, you easily spot elements of interest and capture great images. But, whereas one photographer might have a great eye for showing people in their natural environments, another might excel in producing amazing landscapes. A third photographer might have an eye for capturing action sports. Ideally, you develop your eye for each genre that interests you. In this chapter I talk about what it is to have an eye for detail and how to acquire one.

To produce compelling macro and close-up images, you have to be in tune with what's happening within what's happening. That is, you have to look deeper into a scene in search of the elements that make the scene what it is. And when you come in contact with the finer details in a scene, you're faced with determining how you can best represent them for what they are.

Changing How You See to Create Amazing Macro and Close-Up Images

In an ordinary situation, you may pull out your camera and point it at the first thing that grabs your attention. For many people this is the sunset, or the mountain range, or the pretty flower, or some other element that's large enough to grab your attention in an obvious way. Those things are nice to photograph every now and then but tend to become commonplace after a while.

By looking past those first-round attention grabbers, you begin to see more intimate details that exist in the area, which can make for very interesting photographic subjects. This important skill enables you to find (and reveal) beauty in situations where others see none.

Instead of looking at a scene simply for what it is, try looking at it for what it's made up of. Pay attention to the textures, lines, shapes, colors, patterns, and other visual elements that exist, and notice the relationships these elements have to one another. Imagine you're looking at a shoe and you want to describe it to someone who can't see it. Is it made of a smooth material, or does it have a rough texture? Is it shiny or matte, new or worn, polished or faded? Does the texture of the laces resemble the texture of the shoe, or does it contrast with the texture of the shoe? Do the laces create a zigzag or do they go straight across from one side to the other? This section explains methods for paying attention to detail and creating macro and close-up images with strong messages and visual appeal.

Narrowing your attention

One exercise for noticing detail is to narrow your attention, and concentrate on smaller areas of a scene. Rather than looking at the beautiful sunset (which people have seen in photographs many times), pay attention to how the sunset's lighting affects the smaller elements around you. Rather than just photographing the swing set at your old childhood playground, get in close to show some details of the rusty chains that hold the swings in the air.

Sometimes you come across a scene that seems to have no photographic value or points of interest at all. I bet that if you look hard enough, you'll find something that's worth photographing. Try to notice anything interesting going on in the smaller patches of your scene. Maybe insects are hiding in the grass or climbing up the tree. Perhaps a leaf on the ground has an interesting color, shape, or texture. Or maybe a small flower is basking in the sunshine waiting to have its portrait taken.

The image in Figure 3-1 shows a very boring image of a seemingly very boring scene. There are no eye-catching elements in this photo. The light isn't doing anything spectacular, and viewers might get confused as to what the subject is and why the photograph was taken. However, the detail shot in Figure 3-2 shows an interesting aspect of the scene that is unrecognizable in the previous image. Notice how the sunlight falling onto the tiny subject works together with the dark background to bring out the fine details. Four new buds surround the seed head, revealing the beginning and end stages of this type of flower.

Details can be complex, or they can be simple, or they can be both at the same time. And you can find details everywhere. If you're on a nature hike looking for things to photograph, and nothing happens to catch your eye, try

overturning a rock. You'll be surprised by how much life and energy is under a single rock. There's a whole world of activity beneath your feet, which usually goes unnoticed.

(After photographing the creepy crawlers, please return the rock to its original place so they can go on with their daily routine.)

100mm, 1/250, f/11, 800

Figure 3-1: This shot contains nothing eye-catching.

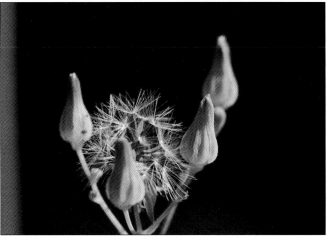

100mm, 1/250, f/8, 800

Figure 3-2: Focusing on one interesting detail makes a great photo.

Knowing what to look for in a subject

By taking a snapshot, you show viewers how a subject looks. By examining a subject and determining what you like about it specifically, you can create an image that shows viewers how you look at that subject.

Each photographic subject contains various visual elements, some of which have more impact than others (depending on the subject itself, and your vision of it). These elements are known as the elements of design. When you use them correctly, they can help express the way you see a certain subject and can help alter the way others see that subject in your photos. Here's a list of some of the major elements of design, which you should be paying attention to when you photograph a scene:

- ✔ **The literal association of a subject** is the way you see something based on what you already know or assume about it. Some people may see a bee and think it's dangerous, while others may just think it's a hard worker. You might see a photograph of peas and (based on your experience with the subject) think they look delicious — or terrible-tasting.

- ✔ **Shape** is determined by the outer edge of a subject or photographic element. It's basically an outline of something, as if you were to lay it down and trace it on paper. The angle at which you view an object determines how its shape appears to you. The angle at which you photograph something determines how its shape appears to viewers.

- ✔ **Form** is similar to shape but includes the three-dimensional representation of a subject or element. If a circle is a shape, then a sphere is a form. How a subject's form appears to viewers depends on camera angle, lighting, focal length, and how the subject relates to its background.

- ✔ **Size** refers to how large or small something is. You can increase the appearance of a subject's size by having it take up much of the space in your frame. To decrease the appearance of a subject's size, have it take up less space in your frame. You can also represent a subject's size by placing it near another element for comparison.

- ✔ **Lines** can be horizontal, vertical, curvy, diagonal, zigzag, or organic. Different types of lines, how they interact with each other, and what they lead to in a frame can alter the way people view an image.

- ✔ **Texture** reveals the condition of a subject or element's surface area. It can be used to tell viewers the age of something or what it would feel like to touch it, and it can reveal impressive levels of detail.

- ✔ **Color** plays a key role in drawing a viewer's attention to certain areas of a frame and causing them to develop specific feelings when viewing an image.

- ✔ **Repetition/patterns** catch a viewer's attention due to their blatant design qualities. These can create symmetry and rhythm in images, both of which are naturally comfortable for people to look at.

For example, imagine that you come across a pretty flower and want to photograph it. The first question you should ask yourself is what makes the subject appeal to you visually? Is it just that you find flowers to be pretty because they're flowers and everyone says they're pretty?

More likely it's something more specific that draws you to a specific subject. Flowers might be pretty, but some are more beautiful than others. Why should your viewers want to look at the one you chose to photograph?

I chose the subject in Figure 3-3 because of its form (the manner in which it takes up space) and the lines its edges produce. The subject has an organic pattern that leads you from one side of the frame to the other, but it's not a perfect pattern. I chose this particular piece of pasta to reveal slight imperfections, showing that it's handmade and not stamped out by a machine.

100mm, 0.4, f/5.6, 320

Figure 3-3: This composition highlights form and lines.

Choosing a Perspective Based on Your Subject

If you've developed your ability to find macro and close-up subjects and to spot their elements of interest, then your next step is to consider how to emphasize those things. Simply moving your camera in close to the subject and snapping a shot isn't always sufficient for getting your message across. Good photography requires a lot more thought than that (but with good practice, this thought process becomes second nature).

This section provides an introduction to creating a relationship between camera and subject that highlights your vision of a particular subject. For a more detailed explanation on this topic, flip to Chapter 10.

Your perspective is unique, like a fingerprint

Although some subjects may seem to be over-photographed, good photography provides a story, and as long as the story changes, the subjects can remain the same.

One technique that enables you to have your own unique message is *perspective* — the appearance of depth or spatial relationships between objects in a photograph. Each photographer has his or her own perspective when creating an image. The combination of the focal length of your lens, your distance to the subject, and your camera angle determine your perspective. The chance of two photographers creating an image with the exact same perspective is pretty slim.

When you create your perspective for a particular subject, you should do so with intent. Consider the following points when creating your shot:

- **Focal length** determines how magnified a scene is through your lens. A wider focal length (such as 35mm) produces a wider angle of view, showing more of the scene and being less concentrated on the subject itself. Wide angles of view tend to provide the illusion of depth in photographs. A longer focal length (such as 100mm) produces a narrower angle of view, showing less of the scene with more emphasis on the subject itself.

- **Your distance** from the subject (in combination with your focal length) determines how your scene appears on your digital sensor. The closer you get to the subject, the more detail becomes apparent, and the less surrounding detail is visible. Using a longer focal length enables you to get close-up detail from a subject at a greater distance. To maximize detail, choose a long lens and a close distance. To show more of the surrounding environment, choose a wider focal length, and a shooting distance that provides the balance between subject detail and background detail you desire.

- **Camera angle** is used to highlight the area of the subject you see to be most interesting. If a subject says his left side is his good side, choose a camera angle to reveal the left side of their face in your photograph. The same goes for any subject. A low angle helps to emphasize the lower portion of a subject, or to give it an epic or heroic sort of look. A high angle emphasizes the top portion of a subject. Your camera angle decisions affect how each element of design appears in an image. When you know what it is you like about a subject, it should be fairly simple to choose a camera angle that highlights it.

I photographed the subject in Figure 3-4 through Figure 3-6 three times, each with a different perspective. Notice how each image tells a different story of the subject.

Figure 3-4 provides a perspective in which the pearl necklace is fairly sharp throughout the image, showing a maximum level of detail, but a minimum level of depth. Figure 3-5 uses a lower camera angle to provide more depth and show the necklace with a shallower depth of field. This perspective gives a sense of grounding to the subject. In Figure 3-6 the necklace was photographed with a longer focal length, and more magnification. This draws attention to one single pearl, rather than the necklace as a whole.

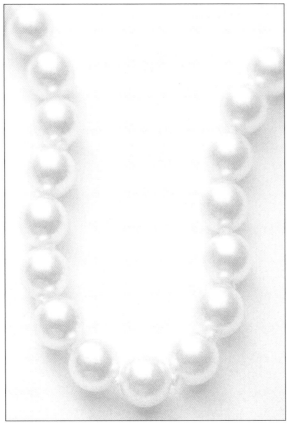

50mm, 1/160, f/14, 200

Figure 3-4: This perspective gives a lot of detail but little depth.

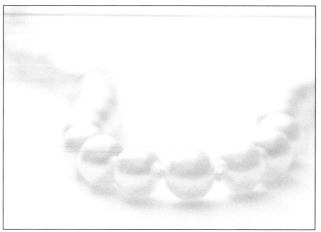

50mm, 1/160, f/7.1, 50

Figure 3-5: A lower camera angle gives more depth and grounds the subject.

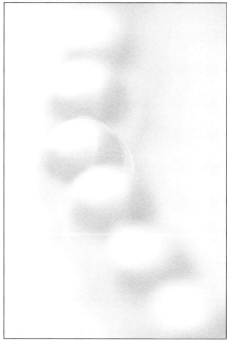

50mm, 1/160, f/3.5, 50

Figure 3-6: A longer focal length and higher magnification draw attention to one pearl instead of the whole necklace.

Understanding your subject

Each subject has a personality that you can emphasize in an image. Before you can successfully convey what that is, you need to understand your subject and the potential it has to communicate to viewers.

Not all subjects are capable of conveying the same messages; for instance, a rusty nail carries a literal connotation of being weathered, rough, and old. It has a harsh surface texture and a rigid shape and form. You would have a difficult time conveying a soft, dreamy message with a rusty nail for a subject.

Consider the qualities a subject has and base your photographic message on them. Notice in Figure 3-7 how the subject and the photo techniques work together to create a mood, feeling, and story. The rusty chain looks like it's had a rough life, and has seen its share of foul weather. A hard sidelight creates drama and matches the feel of the subject. On the other hand, in Figure 3-8 the subject is soft and delicate. A soft, non-directional light ensures that the image captures all of this subject's fragile details.

100mm, 1/125, f/5.6, 400

Figure 3-7: Hard lighting matches the hard life this subject has had.

100mm, 1/60, f/5.6, 1000

Figure 3-8: Soft lighting draws attention to the fragile details of the subject.

Incorporating Macro and Close-Up Techniques in a Photo Story

Having the tools and abilities to create macro and close-up photographs can help you add interest and well-roundedness to your portfolio, your photo albums, photo essays, blogs, and online image galleries.

Often, your macro and close-up detail shots work with the big-picture shots to provide a more clear and thorough story. A landscape photograph may provide information on what the river looks like winding toward the mountains as the sun rises over them; a macro photograph may provide information on what the ladybug looks like taking a sip from a dew drop on a tiny leaf at the edge of the river. Each is a strong image on its own, but when you show them together, the viewer gets both grandiose and intimate details. One without the other tells only half of the story.

Online web catalogs for fashion usually include photographs of the clothing on a model to provide an idea of how the piece will look on the viewer. They also provide a close-up shot of the piece to provide a sense of the fabric's texture, or any details such as buttons or special stitching. As an online shopper, you can probably appreciate this combination of image styles because they make it easier for you to feel confident in making decisions. It's better to know as many details as possible about the product before you go through the process of ordering it, waiting for it in the mail, and then finding out it's not what you expected.

Figure 3-9 provides an example of a photo story in which big-picture shots were combined with macro and close-up shots to provide a full photo essay.

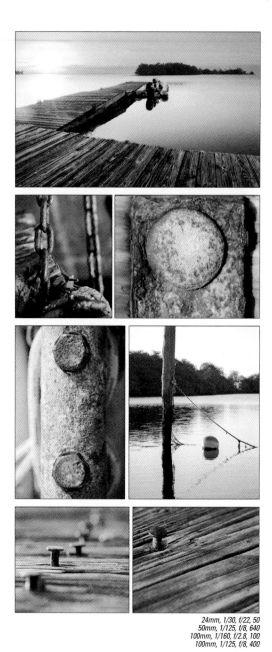

24mm, 1/30, f/22, 50
50mm, 1/125, f/8, 640
100mm, 1/160, f/2.8, 100
100mm, 1/125, f/8, 400

Figure 3-9: Including macro and close-up shots in a photo story helps to reveal intimate details that would otherwise be overlooked.

Part II

Equipment: What You Need, What's Nice to Have

The 5th Wave By Rich Tennant

"If you don't mind, my kid's got a new digital camera and he's looking for fun things to photograph for school..."

In this part . . .

You can create macro and close-up photographs in a whole bunch of ways, depending on the equipment you have and the subject you're shooting. This part of the book lets you know how you can use your gear to get amazing results, whether or not it's macro-specific equipment. I run through the gamut of gear so that you can make wise decisions when you buy equipment. I also give you information on manipulating camera settings for macro and close-up situations and tell how to get great shots with your digital point and shoot camera.

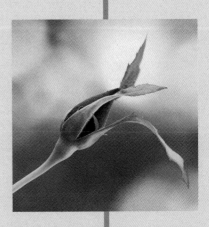

4

Lenses and the Tools That Enhance Them

Getting in very close to a subject is the first step to creating macro and close-up images; the challenge lies in achieving sharp focus on the subject while you're so close. Your lens is the tool you use to conquer such a task. Understanding how a particular lens works enables you to analyze a situation and determine what you need to do to get a sharp photograph.

For the sake of clarity and simplicity, throughout this book I refer to any lens that's not specifically made for macro photography as an ordinary lens.

Although some ordinary lenses may be useful in creating interesting close-up images — especially when photographing larger subjects — they aren't useful for getting close-up details of smaller subjects. An ordinary lens doesn't let you get close enough to your subject to create macro images. That's not to say you have to go out and purchase a brand-new macro lens, though.

You have options for getting macro results with your ordinary lenses. Some of those options are more cost-efficient than buying a new lens, and some are free! Try out the various methods I describe in this chapter and check out the results for yourself before you consider whether you need a macro lens.

In close-up situations, your limitations come from your equipment and how you use it. This chapter gives you an understanding of how ordinary lenses operate, what their uses are, and what you can do to convert them to macro and close-up lenses.

The Benefits of Using Extension Tubes

One of the most effective ways to turn an ordinary lens into a macro or close-up lens is to use an *extension tube* — a piece of equipment that is fixed in place between the lens and the camera body in order to create a greater space between the two. Extension tubes work as a middleman between the lens and the camera's digital sensor, with their main purpose being to hold the lens in place. You can see an example of an extension tube in Figure 4-1.

To achieve focus on a subject at a given distance, the lens has to be positioned at a certain distance from the camera's digital sensor. If the distance of the subject changes, the distance between the lens and sensor has to change accordingly.

As you rotate the focusing ring on your lens (refer to your owner's manual to locate the focusing ring), the lens itself moves backward and forward in relation to the digital sensor. The farther the lens is from the sensor, the closer you can be to the subject and keep it in focus. The closer the lens is to the sensor, the farther you can be from the subject and keep it in focus. When you use the lens's auto-focus feature, the camera rotates the focusing ring automatically to achieve focus.

100mm, 1/160, f/16, 100

Figure 4-1: An extension tube creates distance between the lens and the digital sensor.

The diagrams in Figure 4-2 show an example of the subject-lens-digital sensor relationship. The camera on top is focused farther because the lens is closer to the sensor. The camera below is focused nearer because the lens is farther from the sensor.

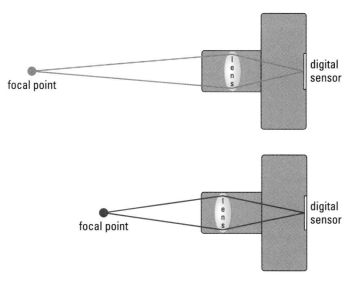

Figure 4-2: The distance between lens and digital sensor determines how far away your point of focus is.

If moving the lens farther from the camera's digital sensor enables you to achieve focus on closer subjects, then it only makes sense that creating a greater distance between the two by using an extension tube enables you to get much closer to subjects with an ordinary lens. Figure 4-3 compares the focusing abilities of a lens with and without an extension tube attached.

Here are some important points about extension tubes and how they work:

✔ Unlike filters and tele-converters, extension tubes don't contain any glass optics and therefore they don't affect the quality of your lens. Extension tubes are simply hollow tubes that create distance. The light that is refracted through your lens passes through the tube unaffected on its path to the digital sensor.

✔ The auto-focus feature on some lenses doesn't work with an extension tube. This is not the end of the world; because your subjects show up huge in your viewfinder when you shoot macro or close-up, you can easily adjust focus manually. However, if you prefer to rely on auto-focus, be sure to research which lenses are compatible with which extension tubes before making a purchase.

✔ You may lose the ability to select the aperture value of the lens from the camera settings when using an extension tube. Older lenses enable you to select the aperture value manually on the lens itself, but newer equipment is designed to be controlled from the camera alone. Try to find an extension tube that is electronically compatible with your lens before making a purchase.

Figure 4-3: A lens's focusing ability with and without an extension tube.

✔ Ordinary lenses can normally focus to infinity, but when you pair a lens and an extension tube, the maximum focusing distance becomes limited. The extension tube enables you to get in closer to a subject but also limits how far a subject can be from the lens.

✔ Extension tubes place the lens farther from the camera body and add additional weight to it. This extra weight can cause problems when you need to keep the camera still at slower shutter speeds. Use a tripod to avoid motion blur.

✔ Because the lens is farther from the digital sensor when you use an extension tube, some light is lost during the exposure to the area just outside your camera's sensor. After taking an image, review it on the LCD screen and check the image histogram to see whether you need to adjust your exposure settings. The *histogram* is a graph that shows the tonal distribution in an image based on your exposure. Read more about histograms in *Digital Photography For Dummies* (Wiley).

Choosing the right size extension tube

The relationship between your lens's focal length and the size of an extension tube determines how close you can get to a subject while achieving focus. The closer you can get, the greater the magnification.

REMEMBER

By creating more space between the lens and the digital sensor (using a larger extension tube) you enable yourself to get closer to the subject. As you increase the size of the extension tube, you increase the ability to move even closer.

A simple mathematical equation helps you determine what level of magnification you will achieve when using a specific size extension tube on a specific lens:

> Additional magnification = Extension tube's length in millimeters divided by the focal length of a lens

A 50mm extension tube combined with a 50mm lens (50 divided by 50) gives you a 1:1 ratio. Likewise, a 25mm extension tube combined with a 50mm lens (25 divided by 50) can offer a 1:2 (or half size) representation of your subject.

A 1:2 ratio is great for close-up photography and although it's not technically macro photography, it looks very similar. Macro photography is ideal for subjects that are very small, which have intricate details. However, for some subjects and scenarios you may prefer less magnification in order to show more of the environment.

Figure 4-4 shows that a 1:1 ratio clearly reveals more detail in the nickel. Notice how it just barely fits into the frame. Subjects larger than the size of a nickel will be cropped into when photographed at a 1:1 ratio. When photographed at a 1:2 magnification ratio, the nickel fits in the frame with much more breathing room. Consider the size of your subject and how much of its surrounding environment you want to include in your frame when choosing how much magnification you need.

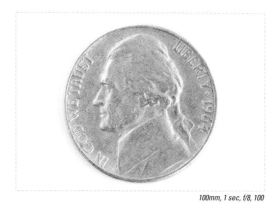
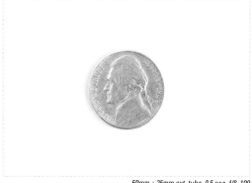

100mm, 1 sec, f/8, 100 50mm + 25mm ext. tube, 0.5 sec, f/8, 100

Figure 4-4: Comparison of a subject photographed at a 1:1 ratio and a 1:2 ratio.

As a photographer, you need to determine what magnification levels work best in which situations depending on your subject and your intended message. Extension tubes give you access to many levels of magnification. For instance, a 25mm extension tube affects a 50mm lens much differently than it affects a 35mm lens or a 100mm lens.

If you have multiple extension tubes, you can stack them in order to gain even higher levels of magnification. Some brands offer sets of extension tubes at various sizes for discounted rates. Remember to ensure that the brand and models you are purchasing are compatible with your particular lenses.

Bellows: The original extension tube

Bellows are an alternative to extension tubes. They're based on a design from older large-format and field cameras, which used a mechanical system to extend and retract a lens from the *film plane* (which is now your digital sensor). Much like extension tubes, bellows are positioned between your lens and your camera. They contain no glass optics, and their purpose is to create distance between the lens and the digital sensor to allow for a closer focusing range.

The difference between bellows and extension tubes is that bellows can be adjusted to increase or decrease the distance between the lens and the camera with precise movements. This allows more possibilities for creating the exact level of magnification you desire, and provides more versatility in combination with each lens you own.

Although bellows are a more versatile tool, they are generally not as compact as extension tubes and usually don't provide auto-focusing controls.

Some high-end bellows systems come equipped with tilt/shift technology, which enables you to alter the orientation of your focal plane and to correct distortion caused by extreme camera angles. Use this piece of equipment when available as an alternative to the distortion correction techniques I discuss in Chapter 17.

Increasing Magnification with Tele-Converters

A *tele-converter* is a secondary lens that you position between your lens and the camera body (just like the extension tube). A tele-converter receives the image created by your lens and provides a magnified version of it to your camera's digital sensor. This can be a useful tool in macro photography

but can also be problematic. You need to know when and why to use a tele-converter as well as what to avoid and how to ensure maximum quality when using one.

Uses for tele-converters

The primary use for a tele-converter is to get a greater amount of magnification in situations when you can't move in closer to the subject. A sports photographer who is confined to the sidelines may use a tele-converter to enhance magnification in order to capture more detail of the players on the field. Placing your camera close enough to get a macro image can be problematic when you deal with living creatures or shoot with natural light.

When applied to an ordinary or macro lens, a tele-converter enables you to get closer to the subject without having to physically move your camera in. Unlike the extension tube, tele-converters don't alter the focus range of your lens. Your lens continues to focus with the same distance range it naturally has, and the tele-converter enlarges the image from the lens to the digital sensor.

You may want to use a tele-converter in the following situations:

- Living subjects may be scared off if you position your lens too close to them. A tele-converter enables you to magnify the subject without moving in closer.

- Natural light can provide excellent shooting conditions but can be tricky in macro photography. Your camera can cast a shadow on your subject or into the scene. Tele-converters can add space between your camera and subject to avoid this potential problem.

- When you're already using a macro lens and are as close to the subject as the lens allows, but you still feel the need to get a tighter shot, combine the tele-converter with the macro lens. Doing so maximizes magnification, enabling you to capture a tremendous amount of detail.

- If you want to take a close-up of someone and you don't want to cause discomfort by positioning your camera right in their face, a tele-converter may come in handy. People tend to get self-conscious when you're taking their photo, and getting in extra-close certainly doesn't relax them.

Levels of magnification

A specific tele-converter delivers a fixed level of magnification. The common magnification levels available in 35mm DSLR photography are:

- **1.4x:** This increases magnification by 40 percent and has the lowest level of *chromatic aberration* (the uneven refraction of light rays of different wavelengths, which produces a blurred image with fringes of color) of all tele-converters.

- **1.7x:** With a magnification of 70 percent, this tele-converter gets you closer to the action than the 1.4x model but has a higher level of aberration flaws.

- **2x:** This tele-converter magnifies a subject by 100 percent, but typically produces results with a noticeable level of chromatic aberrations.

- **2.4x and 3x:** Tele-converters are available in this range, but many photographers feel that anything higher than 2x magnification produces an unacceptable level of aberrations. Instead of using a 2.4x or 3x tele-converter to get maximum detail in a subject, try shooting with a lower-level tele-converter and cropping into your image. Doing so enables you to get the tight shot you want without compromising sharp focus. For more on postproduction techniques read Chapter 17.

The pros and cons of tele-converters

Tele-converters can be a useful tool to carry in your camera bag, but before making the purchase, examine the pros and cons associated with them and compare them to the other pieces of equipment that I discuss in this book. Determine what type of subjects you are most interested in photographing and concentrate on obtaining the gear that supports your own style.

Before you buy, consider the following points about what you can expect from a tele-converter and how this option compares with others:

- Tele-converters enhance a lens's focal length by magnifying the center of the image created by the lens. Getting this effect is more cost-efficient than buying a longer lens in most cases, but a tele-converter doesn't produce the level of quality that a longer lens does. You can read reviews online from photographers who have used a specific tele-converter to see what they have to say about it before making a purchase. In general, lower levels of magnification produce sharper results.

- Unlike extension tubes, tele-converters don't enable you to get closer to your subjects. They only create the illusion that you have done so. And unlike extension tubes, tele-converters contain glass optics that compromise the quality of the lens you are using. This means if you purchase a $3,000 lens and a $300 tele-converter, combining them may mean the cheaper optics in the tele-converter diminish the quality of the expensive optics in the lens.

↙ Slow shutter speeds may be necessary, and you may want to keep a tripod handy when using a tele-converter. Tele-converters increase the size and weight of the lens, meaning that you're going to have a tough time keeping the camera still while photographing. And on top of that, tele-converters cause a high level of light to be lost off the edges of the digital sensor during an exposure. Because the tele-converter magnifies the original image created by your lens, only a portion of the light actually affects the sensor. Figure 4-5 shows what I mean.

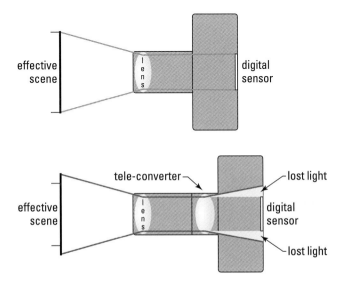

Figure 4-5: A tele-converter's magnification of an image causes some loss of light.

Reversing Rings: A Backward Approach to Shooting Macro

If you would like to start experimenting with macro and close-up photography but don't want to make any purchases just yet then try taking one of your ordinary lenses and turning it around. No, really: hold your camera in one hand and an unattached lens in the other. Reverse the lens so it faces your camera and press it up against the opening where the lens would normally be fixed in place. Now look through the viewfinder and position your camera very near a subject. Move the camera toward and away from the subject until you find the distance at which it comes into focus.

By reversing the lens, you enable yourself to achieve focus at a much closer distance. Experiment with photographing in this way to get a feel for macro photography, but keep these things in mind when doing so:

- A wide-angle lens provides a greater level of magnification when reversed than a longer lens.

- You have to rely on your shutter speed and ISO settings in order to control your exposure. Because your lens isn't attached to the camera, none of its electronic functions are useful. On newer lenses this means you can't control aperture. You're forced to use the aperture value that the lens naturally has when unattached from the camera. (Some older lenses enable you to select the aperture manually on the lens itself. One of these lenses gives you more control in this handheld, reverse-lens shooting style.)

- Using a lens in reverse doesn't provide ideal shooting conditions. Because your lens isn't fixed to the camera, you need to handhold it. Doing so can cause problems with movement during the exposure and may make focusing the lens on your subject difficult. Mounting the camera on a tripod helps by freeing up one of your hands, and perhaps you can rig the lens to the camera body with gaffers tape. If so, be sure not to tape over any glass elements or electronic areas of the lens.

- Changing the distance between the lens and the camera alters your focal range and enables you to focus nearer or farther from the subject. Experiment with this to see how close you can get to something while achieving focus.

- Shooting without a proper seal between your lens and your camera body can cause moisture and dust to find its way into undesirable areas such as your digital sensor and the back element of your lens. Also, be careful not to scratch the glass surface of your lens while holding it near your camera, and not to get so close to your subject that your lens comes in contact with it.

Shooting with a hand-held, reversed lens is for experimental purposes and is not recommended for professional or important shooting situations. I recommend performing a reversed lens experiment in a familiar area and with as little movement as possible. Achieving focus in this manner requires most of your attention and may cause you to be unaware of your immediate surroundings.

You can use this same technique in a different way by using your camera with an ordinary lens fixed in place, and a second lens reversed and positioned directly in front of the first. You can even tape the lenses together

in order to make them more stable — just avoid taping any moving parts on the lenses. You can also purchase a fairly inexpensive *macro coupler,* which screws into the filter threads on the front of the two lenses to secure them. If the outside lens has zoom capabilities, try zooming in and out to get more or less detail in your subject. But remember: Because the outside lens is reversed, zooming in actually causes you to have a wider angle of view, and zooming out causes you to get tighter on the subject.

If you determine from your experiments that the reverse lens technique provides adequate results based on the lenses you already have and the subjects you wish to photograph, look into buying a *reversing ring.* This is a specialized adapter that attaches to the filter thread on the front of a lens and secures it to the camera body.

Using a reversing ring eliminates the nuisance of having to jerry rig the reversed lens in place. And, if you purchase the correct model to go with your current equipment, you may be able to shoot with full access to your lens's electronic controls. That way, you get to select your aperture based on your desired depth of field, rather than being forced to work with the lens's default setting.

Before purchasing a reversing ring be sure to do your research. Find out which models work best in conjunction with your equipment, and read reviews written by other photographers to find out how a particular model has worked for them.

Getting the Most Out of Your Ordinary Lenses

Each lens has a variety of different uses and serves best in certain photographic scenarios. You generally want to make a lens choice based on your subject, your physical limits in a particular situation, and your compositional goals. You need to know which lenses work best in which shooting scenarios and how to use your lenses to achieve the most interesting and successful compositions.

This section lays out some of the specific uses for different types of ordinary lenses and introduces your options for accomplishing macro and close-up results with them.

Wide-angle lenses

In the 35mm DSLR camera format, a lens is considered to have a wide angle of view if its focal length is 35mm or less. Photographers commonly use wide-angle lenses when they intend to show the big picture. In other words, if the surrounding environment is important to your message, then you need to shoot with a wide-angle lens.

Here is a list of compositional techniques photographers use when shooting with wide-angle lenses:

- Capturing expansive scenes, such as landscapes
- Revealing as much of a scene as possible when confined to a tight space
- Getting very close to the subject to reveal intimate details in it while maintaining a decent view of the background
- Creating depth in a photograph by using a high camera position and angling it down to show details in the foreground and in the background
- Capturing multiple subjects that are at a fair distance from one another in one frame
- Exaggeration of space and distortion of shape

People rarely associate wide-angle lenses with macro and close-up photography, which is all the more reason to experiment with it. The techniques in the list above transfer over to your macro and close-up compositions with one of the various techniques to turn your wide-angle lens into a close-up lens that the upcoming sections describe.

Extension tubes and wide-angle lenses

Adding an extension tube to your wide-angle lens enables you to get very close to a subject while keeping a good amount of background detail in the composition. Doing so can be very useful for creating images with a great deal of depth and for capturing the finer details in a subject along with its surrounding environment.

In the two examples in Figure 4-6, I used a 35mm lens in conjunction with a 25mm extension tube. If I had used a normal or telephoto lens instead of the wide-angle, a great deal of the background information would have been cropped out of the composition. The wide-angle lens enabled me to capture the descriptive elements of these scenes and provided a greater depth of field than a normal or telephoto lens would have.

35mm + 25mm ext. tube, 1/10, f/8, 3200 35mm + 25mm ext. tube, 1/125, f/10, 100

Figure 4-6: A wide-angle lens combined with an extension tube helps to show more of your scene, while still getting close to the subject.

Combining a wide-angle lens with an extension tube will cause your lens to be very close to your subject in order to achieve focus. Be careful not to scratch the surface of your lens, and consider using a UV filter in front of your lens to protect it.

Reversing a wide-angle lens

Using a reversing ring with a wide-angle lens is actually more effective at magnifying subjects than a long lens. You can maximize magnification by reversing the widest lens you own. Just be aware that the wider the lens, the closer to the subject you have to get to achieve focus. In some cases you may find your lens to be positioned within a centimeter of the subject.

Figure 4-7 compares the difference of a scene photographed with both a 28mm reversed lens and a 135mm reversed lens. Notice how much more magnification was produced by the wide-angle lens (right), than with the telephoto lens (left).

Normal lenses

A lens is considered to be *normal* in 35mm DSLR photography when its focal length ranges from above 35mm to below 100mm. Normal lenses provide an angle of view that is very similar to the way you see things with your eyes (as far as what's directly in front of you, but not peripherally). They have the least amount of distortion (caused by wide angles of view) and compression (caused by telephoto angles of view).

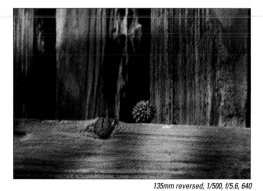
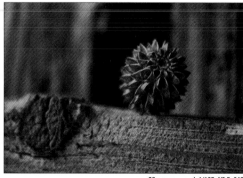

135mm reversed, 1/500, f/5.6, 640 28mm reversed, 1/125, f/3.5, 640

Figure 4-7: Wide-angle lenses produce more magnification than long lenses when reversed.

A normal lens provides an accurate depiction of a scene based on how it looks to you from your perspective when taking the shot. Normal lenses work great for scenes in which you wish to show your subject with little to no distortion and want to include some background details in the composition.

A normal lens crops into the background considerably compared to a wide-angle lens, but it reveals much more of the background than a long lens.

Combining a normal lens with an extension tube

A 50mm fixed lens makes a great counterpart to a number of extension tubes. For instance, the 50mm extension tube when combined with a 50mm lens provides a focusing distance that reveals a true macro (1:1 ratio) image of your subject. This is great for tiny subjects that require you to get in very close to capture fine details.

If your subject is small but you wish to include a bit more of the background in your composition, try combining a 50mm lens with a 25mm extension tube. This combination enables you to capture your subject at a 1:2 ratio, which is not technically macro, but is certainly considered close-up.

If you would prefer to have an even wider angle of view (while still maintaining a close-up style of photography) try the 50mm lens combined with a 12mm extension tube.

Reversing a 50mm lens

Even when reversed, the 50mm lens is a trusty middle-of-the-road lens. It doesn't provide the extreme closeness of a reversed wide-angle lens, but it does get in very tight. You can produce excellent macro images with this

technique, but because the focusing range exists so close to the subject photographing some living beings with this lens and technique can be difficult.

The reversed 50mm lens is ideal for shooting small products, flowers, miniature landscapes (such as the surface of a weathered piece of wood), and creatures that are less likely to move, such as spiders.

Telephoto lenses

In 35mm DSLR photography a lens is considered to be telephoto when its focal length is 100mm or greater. These lenses are also referred to as long lenses; you typically use them in situations where you want to capture as much detail in your subject as possible while minimizing the background detail. The narrow angle of view provided by long lenses makes this happen.

You might also want to use a telephoto lens in situations where you are limited physically and are forced to shoot your subject from far away. With a long lens, you can capture images of wildlife without scaring off the subject, and you can get close-up images of people without intruding in their personal space.

Long lenses and extension tubes

The long lens is already known for magnifying photographic scenes, but by applying an extension tube to a long lens you can increase the magnification even more. The nice part about this combination is that you don't have to get extremely close to your subject to capture great detail. Long lenses combined with extension tubes work great for close-up photography of people and some smaller subjects as well.

This combination is not ideal for macro photography. If you combine a 200mm lens with a 50mm extension tube your focusing range moves in closer to your subject, but not enough to capture a 1:1 ratio. This combination of lens and extension tube will get you a 1:4 ratio.

In order to create a true macro 1:1 ratio, you need to apply 200mm worth of extension tubes between the lens and the camera. You can achieve this by stacking extension tubes; however, you will then come across issues with a major loss of light and an extremely heavy and lengthy lens. Besides, for the price of four 50mm extension tubes you can probably purchase a decent telephoto macro lens.

Reversing long lenses

When reversed, telephoto lenses can provide a great deal of magnification, or not, depending on how you set your focus. By altering the lens's focusing ring, you can work with a fairly decent range of distances between your subject and your camera.

Notice in Figure 4-8 the different levels of magnification I was able to capture with a reversed 135mm lens by simply rotating the focusing ring and moving the camera's position accordingly. I photographed the top left image with the focus ring set to one meter, and I shot the top right with the focus ring set to five meters. In the bottom left image, I set the focus ring at ten meters, and finally, I pushed it to infinity for the image on the bottom right.

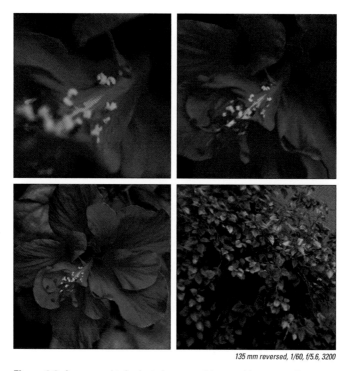

135 mm reversed, 1/60, f/5.6, 3200

Figure 4-8: A reversed telephoto lens provides a wide range of magnification options.

5

Choosing the Right Macro Lens for You

In This Chapter

- Making informed decisions when purchasing a lens
- Finding quality in a macro lens that suits your needs
- Choosing a focal length that works for your intended message

*T*he better informed you are about photography equipment, the more likely you are to make wise decisions when purchasing camera gear. Knowing your stuff means you don't have to rely on the advice of a salesman and can get the right gear for you. Photographers have many options when it comes to choosing a macro lens, which can make it hard to get what you're looking for at first without wasting time and money.

This chapter (and furthermore this book) prepares you to walk into a camera-supply store with confidence, knowing what lens you want to purchase and how to tell when a salesman has good intentions or bad.

Read on to learn how some lenses use the term *macro* as a selling point even though they don't have macro capabilities, to understand how to identify the pros and cons of varying lenses, and to make informed decisions on which focal length best suits your macro and close-up photography style.

Comparing Zoom Macro and Fixed Macro Lenses

Some photographers prefer a *zoom lens* (camera lens with a variable focal length) because it enables them to cover a variety of focal lengths without having to change lenses. This can come in handy for photographers who shoot wildlife, events, weddings, sports, news, or anything that requires capturing images quickly. Spending the time to change lenses to achieve different focal lengths can cause a photographer to miss the shot in these types of photography.

On the other hand, *fixed lenses* (camera lenses with a permanent focal length, also known as *prime lenses*) in most cases provide sharper images and are faster (or have a wider maximum aperture). These lenses don't have the ability to zoom in and out, so photographers who use them have to switch between lenses in order to achieve different focal lengths. Those who have more control over their subjects, such as landscape, portrait, product, fashion, and still-life photographers tend to prefer fixed lenses because of their high quality of sharpness and their ability to work well in low-light situations.

Some zoom lenses include the term *macro* in their selling points to draw in photographers who are interested in versatility that includes macro capabilities. The only problem is that zoom lenses don't actually provide macro-focusing capabilities.

No zoom lens on the market is equipped with true macro capabilities. Macro photography requires a subject to be represented on your digital sensor with a 1:1 ratio. (See Chapter 1.) The only lenses that can accomplish this without any special accessories or attachments are macro-specific, fixed lenses. A macro zoom lens enables you to focus slightly closer to a subject than a given focal length would normally allow, but it doesn't come close to enabling life-size representation of the subject. A salesperson who tells you that a zoom lens doubles as a macro lens is not being 100 percent honest with you.

Zoom lenses that boast macro features enable you to get in a little bit closer to your subjects than zoom lenses that don't have macro features. They can produce nice close-up images, as Figure 5-1 showcases, but to really get you in close these lenses require macro and close-up accessories, as I explain in the upcoming section "Making zoom macro lenses work for you." The images in Figure 5-1 show magnification achieved with a zoom macro lens that contains no accessories.

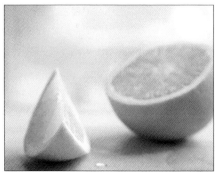

135mm, 1/4, f/6.3, 50

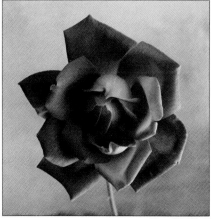
50mm, 1/15, f/13, 400

Figure 5-1: Images taken with the macro feature on a zoom macro lens.

Making zoom macro lenses work for you

A zoom lens with macro focusing technology doesn't provide the close-up and macro results that professional or serious amateur macro photographers are looking for, and it's not an ideal lens for photographers who are interested in achieving simple and instant macro results. However, flexibility in focal length makes these lenses extremely useful for photographers who are constantly on the move. To transfer this characteristic into the realm of macro and close-up photography, combine your zoom lens with the correct accessories.

Using an extension tube

An *extension tube* is a piece of equipment that you fix in place between the lens and camera body. It enables you to get closer to your subject and maintain focus. (Chapter 4 tells you more about extension tubes.)

Combine an extension tube with a zoom lens to get all the versatility of your zoom and still get great close-up (and sometimes macro) images. A 28mm to 135mm zoom lens paired with a 25mm extension tube offers an extensive range of shooting options:

✔ At the lens's widest focal length (28mm in this case), you can achieve focus while the subject is practically pressed right up against your lens. This can provide a 1:1 subject to sensor ration and a unique perspective that can produce images that really stand out. Just be careful not to

scratch your lens. I recommend utilizing a *UV filter* (a transparent glass filter that covers the front of your lens) to protect the front surface of your lens.

✔ At the lens's mid focal length (50mm in this case) the 25mm extension tube enables you to capture a subject with a 1:2 ratio. This is not technically macro but does make for excellent close-up quality. When your subject is larger than your digital sensor, you may prefer a 1:2 ratio in order to fit the entire subject in your frame.

✔ When zoomed in to the lens's longest focal length (135mm in this case), a 25mm extension tube has a less drastic effect on the lens. You can't achieve macro results (or even a 1:2) because it doesn't allow you to focus on your subjects from extremely close distances, but this can be good for some subjects. Your lens is transformed into a great tool for shooting close-ups of people, or any subject that you would prefer to keep a safe distance from.

Adding a reversing ring

A reversed zoom lens gives you the option to choose from a variety of focal lengths at a close-up range. You can reverse a lens and fix it to your camera body with a reversing ring. (For more about reversing rings and reversing a lens, read Chapter 4.)

Reverse your zoom lens and experiment with how it works at different focal length settings and try adjusting your focusing ring at each focal length to see how they work with each other to affect the focusing distance and magnification of your subject. With a 28mm to 135mm zoom macro lens, you can achieve multiple levels of macro and close-up photography:

✔ Reverse the lens and set it to its widest focal length to achieve the greatest amount of magnification. A reversed 28mm lens provides a representation of your subject that is greater than 1:1. The subject is larger than life-size on the digital sensor. When reversed, wider focal lengths (such as 28mm) enable you to achieve focus within only a small range of distances from the subject. Rotating the focusing ring has a minimal effect on changing your focusing distance.

✔ With the lens reversed and set to its mid focal length, you get less magnification than you do with the widest focal length setting. You also get a larger range of focusing distances when you adjust the focusing ring.

✔ A reversed lens at the lens's longest focal length setting gives you less magnification and enables you to focus when you're farther from your subject. You get a greater range of focusing distances when you adjust the focusing ring.

Working with fixed macro lenses

A *fixed macro lens* has an unchanging focal length and enables you to focus when you're close enough to your subjects to achieve a true 1:1 macro capture. Use this type of lens to achieve the highest quality macro and close-up images and to avoid having to deal with extra parts, pieces, and accessories.

The only downside to shooting with a fixed macro lens is its lack of focal length options. Any photographer who is used to shooting with fixed lenses won't mind, and in macro shooting situations you often have sufficient space to move toward or away from your subject as needed because your subjects are so small.

Some of the benefits to using a fixed lens include the following:

- Fixed lenses tend to provide sharper image quality than zoom lenses.

- Fixed lenses often have larger maximum apertures, letting in more light during a given exposure time, and making them more useful in low-light scenarios.

- A fixed macro lens doesn't require any extra attachments or accessories to produce true macro images. (Although you can combine your fixed macro lens with an extension tube or tele-converter to get even more magnification out of it.)

- Most newer models of fixed macro lenses enable you to focus on subjects that are very close (within a few inches) or on subjects that are very far away (up to infinity), and everything in between. You can reveal detail in the tiny bee in your garden, or on the moon in the sky with just one lens.

Grasping the Importance of Focal Length

When you're considering which fixed macro lens is best for you, the first thing to contemplate is which focal length works for your shooting style.

When it comes to macro and close-up photography, the longer a lens's focal length (the higher the number in mm) the farther you are from a subject when shooting. For instance, a 50mm macro lens and a 100mm macro lens may be capable of producing a life-size image of the subject on your digital sensor, but the 50mm macro lens achieves this at a closer distance to the subject than the 100mm macro lens. Each of these lenses has its own pros and cons, which I discuss in further detail in the upcoming sections.

How focal length affects your composition

A scene basically is comprised of your subject and the environment that surrounds it, and when composing a photograph you have to consider how you want to fit your subject into that environment. The focal length that you choose to shoot with determines how much of the background your composition includes when your subject is a particular size in your frame.

Consider Figure 5-2, which shows a pencil photographed at a 1:2 ratio. The pencil is represented at half-size on the camera's digital sensor. I took the image on the left with a 50mm macro lens (the wider of the two lenses) and the one on the right with a 100mm macro lens (the longer of the two lenses). Notice how the image taken with the 50mm macro lens includes more of the background and surrounding environment than the image taken with the 100mm macro lens.

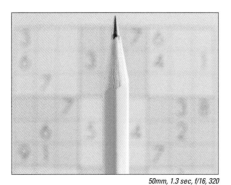 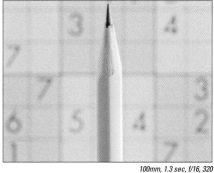

50mm, 1.3 sec, f/16, 320 100mm, 1.3 sec, f/16, 320

Figure 5-2: Focal length affects the relationship between your subject and your background.

Fixed macro lenses for 35mm DSLR photography typically offer normal to telephoto focal lengths (45mm to 200mm). The smaller the focal length, the closer you have to get to your subject in order to achieve a 1:1 ratio, and the wider your angle of view. The larger the focal length, the farther you are from your subject when achieving a 1:1 ratio, and the narrower your angle of view.

If you like to shoot with wide-angle lenses in order to include as many details of the scene as possible, or if you prefer to maximize the amount of sharp detail in a scene, you will likely benefit most from a macro lens with a normal

focal length. If you favor creating compositions that minimize how much of the background is included in your frame and have a very shallow depth of field, a telephoto macro lens will work best for you.

Keeping your subject in mind when considering focal length

A key component to consider when looking for the macro lens that best fits your style is what subjects you will be photographing with the lens. If you generally shoot inanimate subjects, you can position your lens extremely close to them. Other subjects may require that you keep a safe distance, meaning that you need a longer macro lens that enables you to shoot from farther away.

You're better off keeping your distance when you shoot subjects like the following:

- ✔ **Living subjects:** Any creature that can easily be startled may not trust you enough to get in super close to them. Examples include small lizards, snakes, flying insects, or any living thing that humans tend to swat at. You can't always predict a creature's reaction. Certain species of frogs jump away if you get too close, while others don't budge regardless of how much you invade their space.

 As a general rule, I prefer to keep a respectable distance from any living thing that I don't have the ability to communicate with.

- ✔ **Subjects in hard-to-reach places:** Spiders in a web make very cooperative macro subjects, but if the web is in an awkward area that keeps you from setting up a tripod or is just too far-off to reach, a long macro lens can help a great deal.

- ✔ **People:** Human subjects most likely appreciate you keeping your distance when shooting close-up details of their faces or bodies. Some subjects may agree to let you move in extra close, but hanging back usually makes your subjects more comfortable and lets them provide more natural poses.

- ✔ **Reflective surfaces:** Placing your camera too close to a reflective surface may spoil the shot. The farther you are from the reflective surface, the smaller your own reflection becomes. Some examples of reflective surfaces include water, eyes, glass, some metallic materials, and any mirrored or glossy surface.

Focal length and light

In macro and close-up photography, issues with light are common. When using a wider macro lens (such as 45mm) you get so close to your subject that you're likely — in the beginner stage, anyway — to cast a shadow over your scene. When relying solely on natural or available light, the farther you can be from your subject the less likely you are to run into this issue.

A longer macro lens can help you avoid this type of problem, but I would not make any purchasing decisions based on it. Longer lenses tend to be slower than wider lenses (meaning they let in less light and require longer exposures). Choose the focal length of your lens based on your subject matter, your shooting style, and your own preference. Part III equips you to make wise decisions regarding light, and then you don't have to worry about your own shadow.

Summarizing which factors are most important to you

Because the focal length of your macro lens affects your composition, your subject, and in some cases your light, you need to choose carefully. If you have multiple macro lenses in your camera bag, you have to decide which one will work best in a given scenario. If you're considering purchasing your first macro lens, you have to determine which one will work best for the majority of the images you take.

Prioritize your needs. Consider these scenarios before you choose a lens:

- ✔ If you are mostly concerned with the subject's relationship to its background in your compositions, and you prefer to reveal as much of the background as possible then go with a wider macro lens such as a 50mm.

- ✔ If you know that you'll be photographing finicky subjects, go with the longest possible macro lens (which are generally more expensive).

Most macro lenses serve multiple purposes. You can use them in close-up scenarios, but they also have the ability to focus to infinity. This means you can use them just like any other ordinary lens. So a 50mm macro lens can be used just like a 50mm lens.

I recently purchased a 100mm macro lens based on its broad versatility. The 100mm macro enables you to keep a safe distance from most subjects and it shows more of the scene than, say, a 200mm macro lens. Also, I already had a perfectly fine 50mm portrait lens. With the addition of the 100mm macro lens, I also gained a 100mm portrait lens.

Considering Overall Quality in a Macro Lens

Because the lens works as your camera's eyes, it's the first factor that determines the level of quality in your photographs. When you have a good idea of what focal length is best for your photographic style or need, you need to consider what quality and features you want in a lens.

You can have the best camera in the world, but attach a low-quality lens to it and you get low-quality results.

Read on to find out what makes some lenses perform better than others, to understand what features are necessary for you, and to realize how to achieve maximum quality in your photographs.

Optical quality: Your No. 1 priority

Not all lenses were created equal, but that doesn't mean you have to spend a ton of money to get great quality. You simply have to know what to look for.

The *optical quality* of a lens refers to how sharp a resulting image is displayed on your camera's digital sensor. Light waves are refracted through the lens and refocused onto the sensor in order to create an image, and any flaws in the lens's design can cause some of the waves of light to miss their mark. This causes blurry results. Notice the difference between the images in Figure 5-3. I took the one on the left with a high-quality lens, providing sharp results. I took the other image with a lower quality lens, which provided blurrier results.

Higher quality lenses are made with higher grades of glass and therefore cost more. If your preferred camera gear brand offers two macro lenses with identical focal lengths, but at different prices, the more expensive one likely has higher quality and more features (which I discuss in "Understanding a lens's features").

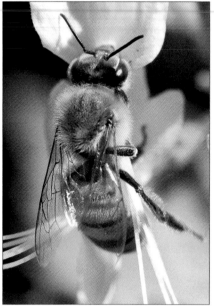 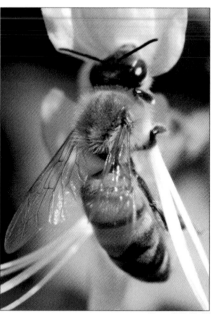

50mm, 1/500, f/8, 400 *50mm, 1/500, f/8, 400*

Figure 5-3: The optical quality of a lens determines how sharp its images will be.

Read customer reviews online to find out which lenses meet your needs. You can find these reviews on product sites, provided by customers who have recently purchased and used the product, or on photography forums, such as `dpreview.com`. After you narrow your choices down to a few products, type their names into an online search engine and you may find discussions in which photographers directly compare the products.

Most macro and close-up lenses are made with high quality glass and provide precise sharpness. If you notice that both lenses are being praised for their sharpness, then the cheaper one is the way to go — as long as it has the features that you want.

Understanding a lens's features

A lens's features are basically its main selling points. Photo companies like Canon and Nikon use these features to compete with each other and also to convince you to go with the more expensive lens. Make sure that you are well informed about lens features so that you know which ones you need.

The quality and size of your DSLR camera's digital sensor

Having the right lens for the job provides the image you're looking for, but what you capture that image with is another story. The quality of your camera works together with the quality of your lens to determine the overall quality of your photographs.

Consider three important factors when determining which DSLR camera is most appropriate for you. Here is a list of what to look for:

✔ **Digital sensor size**. Larger digital sensors contain larger individual pixels, which let in more light and provide images with less *digital noise* (red, green, and blue artifacts that appear in digital images, similar to film grain).

The size of your camera's digital sensor can also determine the working focal length of the lens you are using. Some cameras that don't contain full-size digital sensors (equivalent to the size of a 35mm piece of film) can't capture the entire image provided by a particular lens. This causes your photograph to appear to be taken with a lens of a longer focal length than the actual lens you used. Some lenses are designed to be used with full-frame cameras and some are designed to work specifically with cameras

that aren't full frame. Be sure to research which lenses will work with the camera you have.

✔ **Megapixel count** determines the resolution of images produced by a particular camera. This represents how large your images are perceived on a monitor and what size prints you can make. Cameras these days generally have high megapixel counts. Anything over 10 megapixels is very good, but if you're looking to make prints that are extremely large you can go with a high-end DSLR camera that has very high megapixel count such as 21.1 or in some cases higher.

✔ **The features** included with a particular digital sensor type should be researched to determine what sensor works best for you. Some cameras offer the ability to shoot at very high ISOs with minimal digital noise. This works great for photographers who prefer to shoot handheld or in low-light situations. Other digital sensors offer self-cleaning features, or a live-view feature that enables you to use the camera's LCD monitor to view your scene rather than the camera's viewfinder. This can come in handy when the camera is in a tight space.

Here are the common features associated with macro and close-up lenses:

✔ **Focal length and maximum aperture** describe the focusing distance, angle of view, and speed of a lens. (I talk earlier in the chapter about focal length.)

Aperture determines how much light your lens can allow in at one time. A lower number represents a larger max aperture, which allows more light in, creating a faster lens. (The term *fast* is used because a large

aperture enables photographers to use a more rapid shutter speed.) A lens with a max aperture between f/1 to f/2.8 is considered fast, and can be very useful in low-light situations. A larger aperture setting is also associated with creating a more shallow depth of field, meaning less of the scene is depicted in sharp focus. Photographers often use a shallow depth of field when they want to separate the subject from the background as much as possible.

✔ **Focus adjustment** refers to how a lens focuses. Some wider macro lenses extend away from the camera in order to achieve focus on close subjects. This may scare off some subjects or even come in contact with some elements in your scene. A selling point to higher end macro lenses is that they usually have a fully internal focusing system so the lens never extends farther from the camera. Focus adjustment can also describe whether a lens has auto-focus or if it is strictly a manual focus lens.

✔ **The closest focusing distance** describes how close a lens will enable you to get to a subject while still achieving focus.

✔ **Image stabilization (IS)** gives you sharp results when handholding your camera during an exposure. The IS can freeze the image in place even when your hands are shaking.

✔ **A floating system** enables multiple lens groups inside a particular lens to move independently of one another in order to maximize quality at different focusing distances. A floating system enables a lens to produce high quality images from all focusing distances rather than working better at one distance than another.

✔ **Extra-low dispersion** minimizes *chromatic aberration* (the separation of different wave lengths of color after refracting through a lens). Chromatic aberration can cause issues in an image when the red waves of light are focused onto a different point than the green and blue. This results in halos of color around your subject such as in the example in Figure 5-4. Notice how the right side of the subject has a red halo, which is balanced by a greenish-blue halo on the left.

✔ **Flat field** refers to a macro lens's ability to receive light and provide a uniform signal to the digital sensor at very close distances to the subject. This ensures that your *plane of focus* (the area in front of the camera where focus is achieved) is level and parallel to your digital sensor.

✔ If a macro lens is said to be **multi-purpose** it means you can use it for both macro and ordinary shooting. A **macro-only** lens can't be used for anything but macro and close-up photography.

✔ **A coated** lens may produce sharper overall image quality and a higher quality color reproduction.

✔ The lens's **diaphragm** refers

100mm, 1/250, f/3.5, 400

Figure 5-4: Chromatic aberration causes a colored halo around your subject.

to the shape of its open aperture. The diaphragm affects how light sources in your frame and blurry elements are represented. A rounder opening produces a more round appearance of blurred edges, while a ridged opening produces a more ridged appearance. Figure 5-5 shows an example of different diaphragm shapes paired with their accompanying image results.

✔ **The lens dimensions** tell you just how big and heavy a lens is.

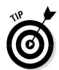

Be sure to read user reviews on specific lenses before making a purchase. And always be prepared with a good knowledge of the product before entering into a sales situation, as some salespeople can be a bit slick. You might also want to research which off-brand lenses work with the specific brand of your camera, as these companies usually offer similar products with lower price tags. Just remember to compare the features of the off-brand lens to that of the name brand and to read what experiences other photographers have had with each. You might be able to bring your camera body to the store and try out various lenses for yourself. Take some exposures with each and compare the results later at home to ensure you get the one that works best for you.

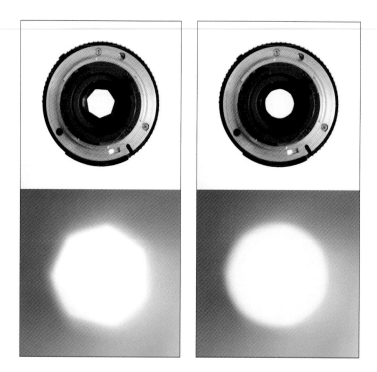

Figure 5-5: The shape of your lens's diaphragm determines how your photographs will depict blurry elements and light sources.

Grasping the Gear That Gets You the Shot

*P*hotography would be a lot easier if you could simply point and shoot your camera and expect amazing results. The reality is that you have a lot to consider before you shoot — especially when you want to capture flawless macro and close-up images. To achieve a great-looking image that gets your message across, you need to position your point of focus exactly where you want it, control your depth of field, and minimize motion blur.

This chapter helps bring you closer to your photographic goals by introducing you to equipment that stabilizes your camera, tools that help you to manage various elements in your scene, and the camera settings you need to get the job done right.

Being Prepared for Obstacles in Macro and Close-Up Photography

High levels of magnification bring special challenges: light loss, shallow depth of field, and exaggerated movement (the slightest movement in your subject or camera can have a drastic effect at such a close range). All of these factors make motion extra difficult to deal with, and this section explains what to do about it.

Compensating for light loss

Light loss occurs in macro and close-up photography because the lens is so far from the digital sensor in order to achieve focus at close ranges. The image produced by the lens (known as the *circle of illumination*) becomes larger than usual and is spread out beyond the borders of the sensor. Light that falls outside the surface of the digital sensor is lost, and so less light is used in making the exposure. Figure 6-1 shows a diagram of how an ordinary lens directs light to the camera's digital sensor, and how a macro lens does the same. As you can see, light falls off (or spreads out) at the same rate in each example, but because the macro lens creates a greater distance for the light to travel, it has more time to spread out before reaching the sensor. If you were to expose the photograph exactly the same using each camera in the diagram, then the photograph created with the macro lens would appear darker than that of the ordinary lens, due to the loss of light.

TIP

The more your subject is magnified (the closer you get to it) the greater your light loss. A 1:1 ratio can cause about 2 stops of light loss, but you need to read your lens's manual to have an accurate idea of how much light loss you're dealing with. In any case, if your images seem underexposed when you view them or according to your camera's *histogram* (a built-in feature in most DSLR models that provides a reading of the tones in an image telling you if it's exposed properly) you'll want to correct your exposure.

Figure 6-1: A lens's distance from the digital sensor causes light loss.

To compensate for light loss, adjust your exposure settings to brighten your exposure. Use one of these methods, or use some combination of them:

- ✔ Opening up your **aperture** (the setting that determines the rate of light entering your lens during an exposure) lets in more light and can compensate for light loss.

Aperture also controls your depth of field. In macro and close-up scenarios you already have a very shallow depth of field due to the high levels of magnification. If you want to work with a shallow depth of field, opening up is your best option. But if you wish to use a great depth of field in order to maximize sharp detail in a scene, then you have to keep your aperture closed down as much as possible. Read more on how aperture affects your macro and close-up photography in Chapter 11.

✔ Slowing down your **shutter speed** can cause your exposure to be longer, letting in more light. This is a valid way to compensate for light loss when you're photographing a still subject and don't have to worry about the wind. If there is any movement at all in your scene then you want to shoot with the fastest shutter speed possible. For more information on using your shutter speed to freeze motion, read Chapter 11.

✔ Raising your DSLR's **ISO setting** makes the digital sensor more sensitive to light and can compensate for light loss. This option is great because it doesn't affect your depth of field or the length of your exposure. Just note that raising the ISO causes more digital noise to appear in your images; if you raise it too high, your image quality starts to diminish. Each camera is different, so you need to become familiar with the ISO levels you are comfortable with using.

Try testing your camera by shooting at the lowest ISO level, going up one stop at a time all the way to the highest level and comparing the results on your computer monitor. Find out more about ISO in Chapter 11.

✔ Use a **combination** of aperture, shutter speed, and ISO settings in order to minimize how much each is affected by compensating for light loss. Instead of making one do all the work; spread it out between two or all three based on which is most important in a particular situation.

✔ Add **light** to your scene. When you're controlling the level of light in a scene, you can raise its intensity if necessary. This is a great option because you can choose the specific exposure setting that works best for your situation and control the exposure by controlling the light. Lighting is explained in detail in Part III of this book.

Using a tripod to minimize camera shake

In macro and close-up photography, motion is the most difficult obstacle to overcome. You may encounter subjects that move (such as busy bees), your camera may shake during the exposure due to various reasons, and the wind may cause everything in your scene to move. How you deal with motion is based on your subject, your message, and the equipment you're working with.

Macro and close-up photography demands a steady camera to produce sharp, clear results. The best way to ensure that your camera is steady during an exposure is by fixing it to a tripod. The tripod ensures that your camera stays in one place, and it frees up your hands for other things, such as holding a reflector to bounce light into your scene, holding unwanted foreground elements out of the way during your exposure, or blocking unwanted light from falling on your subject. Chapter 8 tells you more about manipulating light with reflectors or scrims.

You need to use a tripod in the following scenarios:

✔ **A low-light scenario** can require lengthy exposures. The longer an exposure lasts, the more time for error (in this case camera shake). A tripod can allow you to use slower shutter speeds (in some cases lasting for seconds, minutes, or even hours) and still get sharp results. Depending on the focal length of your lens, your ability to capture sharp images while handholding the camera will vary. A 45mm lens is easier to keep steady than a 180mm lens. In macro and close-up photography, it's a safe bet to use a tripod for any exposure that's longer than 1/250th of a second. If you're adding extension tubes, tele-converters, or using a 200mm or longer lens, then use the tripod for anything longer than 1/500th of a second.

✔ If your composition requires a **great depth of field** in order to maximize sharp detail in a scene, you probably need to use a slow exposure. You create a great depth of field by using a smaller aperture (indicated by a larger f/stop number such as f/22), which lets in a small amount of light during the exposure. Because less light is coming in, the exposure time increases and you therefore need a tripod. In Figure 6-2, I needed a great depth of field in order to show all the details of the piece of jewelry. Notice the difference between the image in which ring's band is blurry, and the one in which the band appears more clearly.

✔ When you want to produce **a very specific point of focus** in your composition (such as getting the eyes of a tiny insect to be the sharpest point in the image), a tripod helps. Macro and close-up photography relies on getting so close to the subject that the slightest movement — which changes the distance between your camera and your desired point of focus — can have drastic effects.

When shooting handheld, your breath or shaky nerves can cause the camera to move after you've locked your focus point causing your point of focus to change right before you snap the shot. A tripod ensures that this doesn't occur. In Figure 6-3, I needed to make sure the point of focus was dead on. Because of the shallow depth of field, any change to the point of focus would have meant the eye of the frog was not in focus and the shot was ruined.

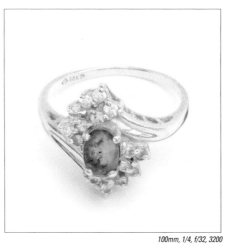

100mm, 1/4, f/8, 200 *100mm, 1/4, f/32, 3200*

Figure 6-2: A great depth of field is necessary to reveal all of the detail in a subject.

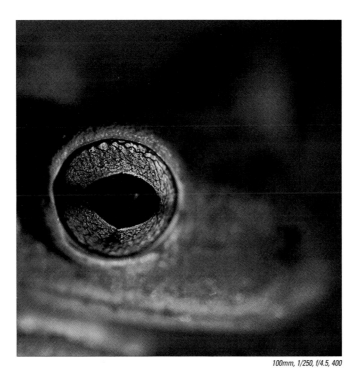

100mm, 1/250, f/4.5, 400

Figure 6-3: When using a shallow depth of field, you need to position your point of focus exactly where you want it.

Finding the right tripod for the job

When photographing certain subjects and trying to achieve certain results, the tripod you use can determine whether you succeed or fail. Knowing what's available on the market and the differences among tripods can be very valuable and helps you decide which tripods best suit you.

Different types of tripods serve different purposes: Some are great for getting very low to the ground, others are ideal for reaching up high, and still others enable you to slide the camera toward and away from your subject without having to move the legs of the tripod itself.

When selecting a tripod, pay special attention to the legs (the base of the tripod, which enables you to raise and lower the height of your camera, often referred to as *sticks*), and the head (the part that you mount your camera to, which enables you to tilt, rotate, and swivel your camera). These parts are interchangeable as long as they're produced by the same manufacturer or are compatible, and each serves a specific purpose. Look for the combination that provides the most versatility based on your shooting style, or purchase multiple parts that you use for specific tasks.

Below is a list of the various leg options and what they work best for:

- **Studio tripod legs** have support attachments that connect each leg to the center column of the tripod. This makes them very sturdy, which is ideal for supporting heavy cameras and lenses.

 The downside to studio legs is that in cheaper models the support beams force the legs to stay at a uniform distance from one another. This limits how low you can go with the tripod and makes it less effective on unlevel surfaces. Studio tripods can be used in the field, but they tend to be heavy and bulky, making them difficult to travel with. This type of tripod base is available in different sizes to photographers who wish to have low, normal, or high vantage points.

- **Varying angle tripod legs** don't have support attachments connecting the legs to the center column and therefore each leg can move independently from the others. This makes them very useful in unlevel terrains and in creating unique stances that work well when your camera's weight is not centered on the tripod.

 Varying angle tripod legs provide the most versatility out of all tripod types. The material that a tripod is made of combined with its weight will determine how sturdy it is. More affordable models are made of aluminum and are significantly heavier than their equivalent, more expensive lightweight models made of carbon fiber. This type of tripod leg is available in different sizes to photographers who wish to have low, normal, or high vantage points.

✔ **Small, lightweight tripod legs** (sometimes referred to as table-top tripods) are great for getting very low to the ground or for use right on your tabletop studio setup. This type of tripod base is very short, and lacks a center column, making it ideal for positioning your camera just above your shooting surface. When using this type of tripod base, you can get your camera so low that you may find difficulty looking through the viewfinder. Photographers often use a right-angle viewfinder on their cameras in order to see what the camera sees without having to lie down on the ground or stress their necks. Small, lightweight tripod legs can be very helpful in ground level or tabletop shooting situations, and they are very easy to travel with, but they're not very useful in most other shooting situations. A small, lightweight tripod base isn't ideal when shooting with large, heavy cameras, as it may not have what it takes to keep such a camera steady.

After you decide which sticks work best for your shooting style, choose a head to go with them. The tripod head is what fixes your camera to the tripod and it determines what type of movements you'll be able to make. Three kinds of heads are most common among serious photographers:

✔ The **three-way head** enables you to move your camera in three precise ways in order to set up your composition. (See Figure 6-4.) Loosening or tightening grips moves the camera's position as follows:

- By moving it on the vertical axis, you can angle the camera upward or downward. Doing so determines your camera's angle.

- By rotating it, you can determine whether your image is framed with a portrait or landscape orientation. You can also use this particular axis to ensure your horizon line is straight.

- Rotating the camera on a horizontal axis enables you to pan the scene from left to right until you find your composition.

The benefit to a three-way head is that it gives you accurate and precise movements. This head is great for landscape and still-life styles of photography. The drawback is that it lets you move in only one direction at a time, and you have to create a combination of the three movements to achieve your final composition. It is not ideal in fast shooting situations, such as fast-moving subjects or journalistic photography.

✔ The **ball head** is a mount with a spherical base that enables you to move your camera freely. If you loosen the grip on the base, you can turn, angle, and rotate the camera in any direction you please. This option provides you with more freedom but is not as accurate for precise movements, because the camera can move slightly from the time you position it to the time you tighten the grip on the base.

✔ The **geared head** is the most precise out of all tripod heads, and therefore is typically the most costly. A geared tripod head enables you to make adjustments in a similar fashion to the three-way head but rather than using grips that loosen and tighten, you use knobs (or digital settings in some cases) that change the camera's position based on which direction you turn them. The drawback to geared heads is that they tend to make slow movements compared to the other two types of tripod heads.

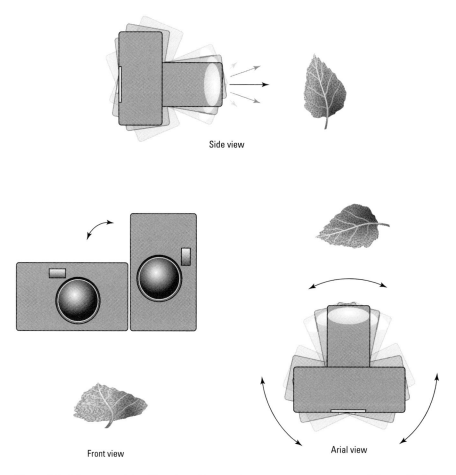

Side view

Front view

Arial view

Figure 6-4: A three-way tripod head enables you to move your camera up and down, flip it around, or pan it side to side.

Adding a focusing rail

Whatever tripod combination you go with, it's always a good idea in macro and close-up photography to include a *focusing rail* (a slider that enables you to move the camera in and away from your subject without moving the tripod itself) in your setup. The focusing rail attaches to the tripod head in place of your camera and then you mount your camera to the focusing rail.

The principles of macro photography make a focusing rail important. Only one focusing distance provides a 1:1 ratio for a particular macro lens. To achieve it you must set the lens to its manual focus mode and rotate the focusing ring until it's set to the 1:1 ratio. (You achieve this ratio when the focus marker is lined up with "1:1" on the lens's dial.) You then move the camera to achieve your desired point of focus in the scene. Doing so gives you a true life-size representation of your subject on the digital sensor.

Moving your tripod in order to achieve focus in macro situations can be frustrating, as it's not very accurate and can alter your composition. Using a focusing rail enables you to work more quickly, and with fewer annoyances.

Using a cable release

With your camera positioned on your tripod, your composition lined up, and your focus point set, the last thing to do is to take the shot. When you press the shutter release button with your finger, you can cause the camera to shake during your exposure even though you're using a tripod. In ordinary photographic situations this amount of camera shake is unnoticeable, but in macro and close-up photography the effect of camera shake is amplified.

Ensure you get the perfect shot by using a *cable release* to avoid having to touch the camera at all during the exposure. A cable release sends a signal to the camera (either through a cable or wirelessly) and enables you to release the shutter without touching the camera at all.

If you don't have a cable release you can achieve the hands-off technique by utilizing your camera's self-timer. Set the camera to the self-timer mode (refer to your owner's manual to learn how to do so), set up your shot, press the shutter release button, and then sit back and wait for the camera to do the rest. Some cameras offer self-timers that can be adjusted for different delays. Two seconds should suffice for this purpose. Of course, this method works best on subjects that are still, and would not be suitable for subjects that move frequently or if you are trying to capture a specific moment in time.

In Figure 6-5 my exposure was a half second long. I used a cable release to get the image on the left and my finger on the shutter release to get the image on the right, which shows camera shake.

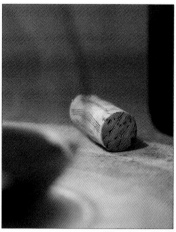 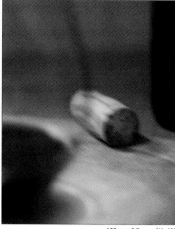

100mm, 0.5 sec, f/4, 400 *100mm, 0.5 sec, f/4, 400*

Figure 6-5: Using a cable release (left) versus a finger on the shutter (right) for long exposures.

Handholding the camera for subjects on the move

A tripod works great in many cases and is by far the best tool for getting sharp macro and close-up images. But even so, there are times when it's simply not realistic to take the time necessary to set your camera on the tripod. And in some cases your tripod might not be able to position your camera in the exact place you need it to be. In these scenarios, you have to take matters into your own hands, literally.

You can take perfectly sharp macro and close-up photographs while handholding your camera, but doing so requires certain techniques. The speed of your exposure in comparison to the level of camera shake is of the utmost importance and needs to be considered to achieve flawless results. With a fast enough shutter speed, you can freeze motion completely, and the faster your camera is moving, the faster your shutter needs to be.

Photographers often handhold their cameras when dealing with subjects in motion. What good is it to have your camera in a stationary position if your subject won't sit still? The best way to guarantee a fast exposure time that enables you to minimize subject movement and the effect of a shaky camera is to shoot in well-lit environments. Rather than trying to photograph in a shady spot, move to an area where there is bright sunlight shining on the scene. Avoid dimly lit rooms; low light can cause you to have to slow down your shutter speed.

One way to ensure you have a well-lit scene is to use a flash. An electronic flash enables you to control exactly how much light is produced during an exposure and what direction the light comes from. There are macro-specific flashes and flash mounts that can be attached to your lens, camera, or tripod, or you can place the flash on a stand of its own and position it wherever you want it. For details on what's available and how to use a flash for macro and close-up photography, flip to Chapter 9.

Whether you're shooting in a well-lit area with a fast shutter speed or working to maximize light, stabilize your camera to the best of your ability. Here are some ways to do so:

- **Use your body as a tripod.** The most stable position for the human body in aiming a camera is the *prone position* — lying with your stomach on the ground and using your elbows (pressed on the ground in front of you) to prop your hands up. In this position, the ground supports your arms much like a tripod's legs would.

 If you need to shoot from a slightly higher position you can sit cross-legged and place your elbows on your inner thighs for support. This is slightly less stable than the prone position but better than nothing. And if you need to get a higher position than that, stand up and press your left arm tight against your torso. Then bend your elbow and bring the camera in to your face. Keep your hands in tight to your core; the farther your limbs extend outward, the less stable you are.

- **Work with a monopod.** A monopod is a handy tool when you're shooting handheld. It works in a similar way to a tripod, but has only one leg. You can move more freely with a monopod, but it's less stable than a tripod. You can adjust the height of a monopod to suit your needs and it might just give you that extra bit of stability that helps to produce sharp images of moving subjects.

- **Use your surrounding environment to your advantage.** Maybe you can brace your camera on a nearby stump while getting the shot. Lean against a tree or telephone pole for support, or position your camera on

a table or a bench. Take whatever means necessary (as long as it's safe) to steady your camera during an exposure.

✔ **Take advantage of the image stabilization feature on your macro lens.** If your lens is equipped with an image stabilization feature, the time to use it is when you're shooting handheld macro and close-up photography. To activate it, locate the switch on the side of your lens and click it to the "on" position. Image stabilization (IS for short) is a function that shifts the elements in your lens to compensate for any movement made between the time your shutter release button is pressed halfway down until the time it's pressed all the way. Image stabilization does not work miracles, but it can greatly reduce minimal movements made due to shaky hands or breathing.

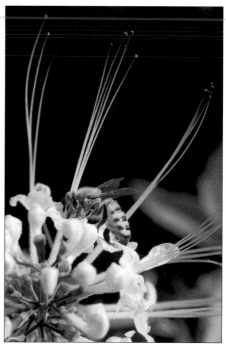

100mm, 1/400, f/9, 4000

Figure 6-6: Sharp results can arise from handholding the camera and applying the techniques discussed in this section.

In Figure 6-6 I handheld the camera while photographing the bee in action. I was able to capture it in sharp focus by keeping my limbs in close to my body and by utilizing a fast shutter speed in combination with the image stabilization feature on my macro lens.

Discovering Handy Items for Getting the Shot

From a technical standpoint, macro and close-up photography can be more difficult to master than other styles of photography. Certain obstacles that you come across are much easier to deal with when you're equipped with the proper tools for the job.

In many cases your own two hands are just not enough to handle all that's involved in getting the perfect shot. Your subject may need to be propped up in a specific way, some obstructing leaves may need to be held out of the way during your exposure, a flash may need to be positioned to a particular side of your subject, and you may want to fill in some shadows with a reflector.

Controlling light and getting a "grip"

The equipment used to hold lights, support subjects, and to clamp props is referred to as *grip*. Grip goes hand in hand with your lighting equipment to provide ideal shooting conditions, and in macro and close-up photography this equipment can make your life easier and your photos amazing.

Here is a list of lighting equipment that is extremely useful:

- **Strobe lights** are the industry standard for studio photography. Chapter 9 gives you the specifics on using them. Because strobes have to be attached to heavy power packs that require a generator when used in the field, photographers rarely use them outside of the studio for macro and close-up purposes.

- **Mono-lights** are similar to strobe, but they don't need to be attached to a power pack in order to work. They do, however, need to receive power from a source. When indoors you can simply plug them into the wall, but when in the field you need a portable power source. Mono-lights are easier to travel with than strobes but aren't as convenient as battery-powered flashes. For more information on mono-lights, read Chapter 9.

- **Battery-powered flashes** are what most macro and close-up photographers use to light subjects in the field. They are compact and don't require a separate power source to operate. Chapter 9 tells you more about using battery-powered flashes.

- **Flash diffusers** enable you to change the quality of light provided by your battery-powered flashes. Chapter 9 explains how you use these tools.

- **Flashlights** are effective for macro and close-up photography because of the small nature of your subjects.

- **Reflectors** redirect sunlight into your scene and can be purchased at a photo supply store or made by using a white piece of foam core, a mirror, or any shiny, reflective surface.

- **Black cards** or **flags** (black pieces of foam core) take away light from a subject. If you wish to create a shadow in a flat lighting scenario, position the black card on one side of the subject in order to take light away

from that side and make it darker. You can also use these to block direct light from your scene.

✔ **Colored gels** change the color of light produced by your strobes, mono-lights, or flashes.

✔ **A scrim** can diffuse or lessen the intensity of direct sunlight on your subject.

The items in this list are useful for lending a hand when you need more than your own two:

✔ **Light stands** and **C-stands** hold strobes or mono-lights in place in the studio.

✔ **Accessory stands** (smaller versions of light stands) combined with a **hot shoe** can hold an off-camera flash. The stand holds the flash in place and the hot shoe receives the signal (either through a wire or a transmitter) from the camera telling the flash when to fire.

✔ **Clamps** hold anything in place or out of the way. A clamp combined with a tripod socket can hold a flash, enabling you to position the flash anywhere that you can attach the clamp.

✔ **Clothespins** are similar to clamps but work better for smaller, more fragile objects.

✔ A **ground spike** is a metal pin with a tripod socket attached to the top. You can stick it into the ground to hold extra flashes in place.

✔ **Clay or putty** is great for propping up your subject or holding it in place. Its sticky surface provides a good grip, and you can shape it to work with your specific subject.

✔ **Hot glue guns** fix things in place without fuss because the glue dries quickly and is easy to remove from hard surfaces.

✔ **Double-sided tape** doesn't show up in your shot.

✔ **Gaffers tape** holds things together or in place without leaving behind a sticky residue.

✔ **Bendable wire** positions small diffusers, scrims, and black flags in tight areas.

✔ **Tweezers** enable you to make precise movements with fine objects.

✔ **A small paintbrush** is great for cleaning hard-to-reach areas and for dusting surfaces without disturbing your subject or other elements in the scene.

✔ **A viewfinder loupe** magnifies the image in your camera's viewfinder, making it easier to see where your point of focus is located.

✔ **A right-angle viewfinder** enables you to see what your camera sees without having to press your eye right up against it. This is ideal for when your camera is very low to the ground.

Purchasing macro-specific gear vs. creating your own

A lot of specific equipment is available to photographers and in some cases it may be best for you to go ahead and purchase it. Still, sometimes you're better off finding an alternative product or simply making your own equipment. Here are some cases where you need to weigh the pros and cons before making a decision.

Light reflectors

Any reflective surface can function as a reflector for bouncing light into your scene before you photograph it. You can make a white reflector out of a white piece of foam core or even poster board. You can cut these to any size you desire; they are lightweight, easily replaced, and no problem to store. The downside to this type of reflector is that it's not stable in high winds and isn't weather resistant.

You can make a more stable white reflector out of a thin piece of plywood that's painted white. You could even attach foil to one side to make a multi-purpose reflector. Foil provides a more intense light than a white reflector. A plywood reflector isn't as easy to travel with as the foam core version.

A photo-specific light reflector comes in a round shape that is made of cloth material. You can twist the reflector down to a smaller size, making it easier to store and carry around. This tool is more expensive than the other two options but typically comes with variable layers (diffusion, white, silver, gold, and black), making it a very versatile piece of equipment. This type of reflector holds up fine in inclement weather but tends to bend and is difficult to hold steady in high winds.

Grip materials

Some of the most common grip materials, such as clamps, putty, tape, and brushes are available in photography stores, but you can usually get a better deal if you buy them somewhere else. A photo-specific clamp may be made in the same exact factory as the clamps found at a general hardware store, but because it's deemed for photography use it gets a higher price tag.

Go on a reconnaissance mission into your favorite photography supply store and look at the various grip materials that are available to macro and close-up photographers. Determine what you need based on your shooting style, and then figure out which items you can realistically find cheaper somewhere else and which items you can build yourself.

Macro and Close-Up Lens Filters

A *filter* is a piece of glass that you position in front of your lens and that serves many purposes to a macro and close-up photographer. A filter protects the surface of your lens, cuts down the appearance of reflections, changes the colors in your scene, or even increases the magnification of your subject. This section covers various types of filters and how you can use each to your advantage.

Important filters for macro and close-up photography

In this day and age, photo manipulation software can do many tasks that photographers used to rely on filters for. You don't need a complete array of color-changing filters because you can now alter your images' color temperature and add or reduce contrast with the touch of a button. Still, some filters do their job more quickly and effectively than any postproduction software.

Here are some filters that photographers will continue to use for a long time:

- **UV filters** are said to absorb UV light and produce images that are more brilliant. Perhaps that's true, but it's not very noticeable to me. From my experience the UV filter is ideal for protecting the front surface of your lens because it doesn't seem to have much of an effect on the resulting image. Would you rather scratch a filter that costs a few bucks, or a lens that costs a few thousand?

- **Neutral density filters** enable you to slow down your exposure even if you're already set to your camera's lowest ISO and smallest aperture. One reason for slowing down your exposure may be to cause moving water to appear smooth, or fogged.

 Figure 6-7 shows a scene photographed with and without a neutral density filter. Each image is exposed exactly the same, but the one with the neutral density filter (left) used a much slower shutter speed than the one without the neutral density filter (right). Neutral density filters also enable you to shoot wide open in bright sunny conditions giving you the shallow depth of field you may desire.

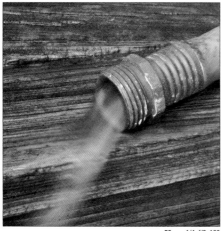 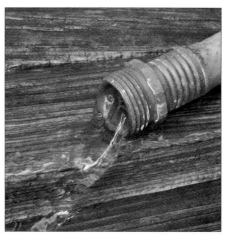

50mm, 1/4, f/8, 100 50mm, 1/125, f/8, 100

Figure 6-7: Applying a neutral density filter enables you to slow down your shutter speed drastically, even in the middle of the day.

- ✔ **Graduated filters** are similar to neutral density filters, but only one side of the filter is darkened with a smooth transition from the dark side to the normal side. These are ideal for scenarios in which one part of your scene is much brighter than the rest. By positioning the dark side of your filter over the bright area in your scene you can expose properly for the image as a whole.

- ✔ **Polarizing filters** manipulate how much glare is in a scene and how much reflection shows on a reflective surface (such as water or glass). By rotating the filter and looking through your viewfinder you can see reflections disappear and reappear. Figure 6-8 shows an example of a scene shot with and without a polarizing filter. You can also use these filters to darken blue skies and saturate warm colors in sunlit scenes.

Close-up filters

Close-up filters (referred to as *close-up lenses*) screw onto the filter threads of a lens and enable you to achieve focus at close distances to your subjects. They can provide ordinary lenses with macro capabilities much like extension tubes (see Chapter 4). Unlike extension tubes, close-up lenses contain optics. Therefore these filters affect the quality of your image and may not be suitable for use with cheaper lenses and may lessen the quality of your expensive lenses.

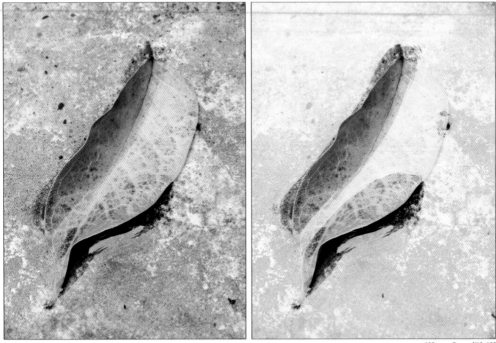

100 mm, .5 sec, f/16, 100

Figure 6-8: A polarizing filter can eliminate distracting reflections.

Close-up lenses come in various levels of magnification, and these filters are lightweight, easy to store and simple to work with.

For a more professional quality close-up filter, consider using the *Zoerk Macroscope*. This is an *aspherical* (shaped in a non-spherical manner in order to work better in combination with a spherical lens) coated lens that screws on to the front of your ordinary lens. It provides high-quality optics and can produce 1:1 ratios when combined with an 80mm lens. Because the Zoerk Macroscope has an aspherical shape, it eliminates most *aberrations* (flaws that occur when light is refracted through a lens) that are normally caused by using multiple lenses in one image capture.

Macro Photography and Your Point and Shoot Digital Camera

I can hardly believe my own eyes when I see how well some of today's point and shoot digital cameras (also known as compact, or fixed lens, digital cameras) perform in close-up situations. Though a digital point and shoot probably won't produce a 1:1 representation of your subject onto its digital sensor, some of them can get very close.

A point and shoot digital camera offers a lot of benefits, and if the one you own has great close-up abilities then those benefits can carry over to your macro and close-up photography. Whether this type of camera is your main camera or your backup (or your "fun" camera), why not find out how to make interesting and good-looking images with it?

This chapter introduces different types of digital cameras, shows you how to set up your digital point and shoot for close-up photography, explains how it differs from DSLR cameras, and how to achieve the best results when using it.

Comparing Compact Digital, Fixed Lens, and DSLR Cameras

There are three general categories for digital cameras on the market, each designed to suit the needs of a different type of photographer.

Because each type of camera suits a different style of shooting, you can select the camera that works best for your particular style, or (like some photographers) you can own all three, which enables you to choose your camera based on the occasion. Here are the specs for each type of digital camera:

- ✔ **Compact digital cameras** are designed for the mainstream consumer who is more concerned with instant results than in spending time enhancing the quality of her photography. These cameras are typically very small and lightweight, and come with a minimal amount of features or accessories. A point and shoot camera enables you to literally point and shoot without having to worry about achieving focus on your subject or worrying about your exposure. Some digital point and shoot cameras can be operated in manual mode, but this depends on the model and usually is somewhat limited.

- ✔ **Fixed lens digital cameras** enable you to simply point and shoot, but also offer more features and accessories than compact digital cameras. Generally these cameras are larger in size than the compacts and smaller than DSLRs. And they offer a great deal of manual controls for point and shoot cameras. They're ideal for the photographer who likes to travel light and capture high-quality photographs at the same time.

- ✔ **Digital single lens reflex cameras** are not typically used as point and shoot cameras, because they're more complex in nature and tend to be more expensive. The DSLR provides the greatest amount of manual control and is most commonly used by photographers who are serious about creating images with top quality.

Although DSLR cameras offer the highest quality and control, they tend to be expensive and heavy, and they're often accompanied by multiple lenses and accessories. If this doesn't seem like the camera you want to travel with or use on a day-to-day basis, then a digital point and shoot may be more up your alley.

Compact and fixed lens digital cameras don't offer all the macro and close-up versatility of a DSLR, but they can be used to create amazing images all the same. And they'll do so without causing anxiety for those of you who prefer not to get caught up in the technical side of things.

It's good to know your limits when shooting macro and close-up subjects with a digital point and shoot in comparison to using a DSLR so that you know when your photographic goals will require a camera with higher quality and more control, and when you can get away with the more simplistic type of camera. Here's a rundown of the differences:

- ✔ **Point of focus:** DSLR cameras provide more precise control over your point of focus and produce images that generally have a higher quality of sharpness.

- ✔ **Depth of field:** Digital point and shoot cameras tend to produce images with greater depth of field. This is great for scenes in which you prefer to include as much sharp detail as possible, but makes it more difficult to create images with selective focus.

- ✔ **Image size:** Most digital cameras made today produce large image files. Whether you use a DSLR, a compact digital camera, or a fixed lens digital camera, you should have no problem creating the print size you desire.

- ✔ **Shooting speed:** Digital point and shoot cameras tend to operate more slowly than DSLR cameras. If you plan to photograph fast-moving subjects, or are big on capturing the decisive moment, then perhaps a DSLR is the more logical choice.

Using the Macro Setting on Your Digital Point and Shoot

Point and shoot digital cameras get their name from the idea that you can set one to its automatic mode and take images that are, for the most part, of acceptable quality. They free you from having to worry about camera settings, focusing on a subject, or anything too complicated. These cameras are ideal for that style of photography, but some models actually provide many shooting options, and when used properly in manual modes can produce images with far more interest and aesthetic quality.

Most point and shoot digital cameras come equipped with a *macro mode,* which enables you to achieve focus on subjects from a closer distance than the camera's normal shooting mode. The macro mode is typically symbolized by a flower icon that resembles a tulip. Some models enable you to choose macro mode from the dial on top of the camera, while others make it available in the camera's menu screen. (Refer to your owner's manual to find out how to set your digital point and shoot to macro mode.)

I took the image in Figure 7-1 with a point and shoot digital camera at about one centimeter from the subject.

Setting the camera to macro mode is the first step in taking great close-up images with your digital point and shoot, but you do need to consider some other settings and techniques.

Some cameras become fully automatic once in macro mode and don't allow manual adjustments. If you have one of these cameras, then you're limited to what the camera thinks is best when shooting close-up photography.

If your camera offers manual control while in macro mode, then you're in luck. The upcoming sections tell you how to make the most of it.

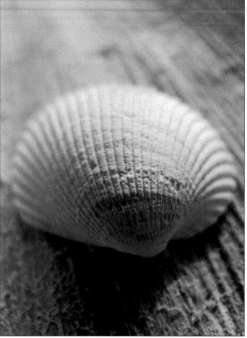

6.1mm, 1/160, f/2.8, 100

Figure 7-1: Even a point and shoot digital camera is capable of great close-up shots.

Focusing, in auto mode and otherwise

In macro and close-up situations, depth of field tends to become very shallow, so having control of your point of focus is very important.

- ✔ In **auto-focus mode** you can position your point of focus by centering your subject in your frame, pressing and holding the shutter release button halfway, and then composing your image after your focus has been set on your subject. Be sure not to let go of the shutter release button once your focus has been set, or you will have to do the whole process over again.

- ✔ If your digital point and shoot allows you to use **manual focus** controls, you can position your point of focus without readjusting your composition. Each camera is different, so refer to your owner's manual to see whether yours offers manual focus and to learn how to use it.

This feature can come in handy when you really want to pinpoint the position of your focal point; however, manual focus on this type of camera can be slow and is mainly useful in situations where your subject is still.

Managing depth of field

Adjusting aperture enables you to change the depth of field in your photographs. Use a shallow depth of field to create *selective focus* — a technique that uses a shallow depth of field to isolate one sharp area among an otherwise blurry scene to draw viewers' eyes to the selected area — or a great depth of field to maximize the amount of sharp detail in a scene.

If your point and shoot digital camera provides manual control of the aperture setting when shooting in macro mode select a smaller f/stop number (larger opening in the lens) to have a shallower depth of field and a larger f/stop number (smaller opening in the lens) to have a greater depth of field.

Aperture also affects exposure. (Get the details in Chapter 6.) In a low-light scenario, a smaller f/stop number lets in more light and enables you to reduce the time of your exposure.

Adding attachments and accessories

Some point and shoot digital cameras enable you to attach close-up filters and lens adapters (like the ones discussed in Chapters 4 and 6) that increase magnification in your images, or macro specific lighting accessories (like the ones discussed in Part III of this book). These can come in very handy in most macro and close-up shooting scenarios.

Typically you'll find more accessories for compact digital cameras than you will for point and shoot digital cameras. This is mainly because point and shoots are marketed to mainstream consumers, and compacts are marketed to those who want the convenience of a smaller camera but still want more shooting options and higher quality.

Items to look for include the following:

✔ **Tele-converters** (or tele-converter lenses) are available for most high-end compact digital cameras (such as the canon G12 or the Nikon Coolpix line). You place a tele-converter in front of or behind the lens on a compact digital camera in order to increase magnification.

✔ **Macro lenses** (or macro lens filters) increase magnification. You position them in front of the lens on your compact digital camera or point and shoot digital camera.

✔ **Mini-focusing rails** can be used in conjunction with your digital point and shoot (or compact digital camera) and your tripod to make focusing and composing macro and close-up shots easier. Because mini-focusing rails are small and lightweight, they are great to travel with. But they're not ideal for use with your DSLR, or larger cameras.

✔ **Ring lights** are great for creating even lighting in macro and close-up situations. Especially when using digital point and shoot and compact digital cameras, as these tend to have an extremely close effective focusing distance in macro mode.

✔ **Battery-powered flash units** can light your subject from off-camera, assuming your digital point and shoot or compact digital camera has the ability to sync with the flash. Look for a *hot shoe* (a space on top of the camera that enables you to fix a flash or flash accessory to the camera) to see whether your camera is compatible with off-camera flash.

Find out what accessories, if any, are available for your digital point and shoot in order to improve the overall quality of your macro and close-up images. And check out Chapter 6 to find out more about the wide world of tools.

To Zoom or Not to Zoom

Almost all point and shoot digital cameras are equipped with a lens that zooms. If you can zoom, you can more easily compose images and fill your frame with the amount of a scene you feel to be interesting.

Your digital point and shoot's macro mode works with the zoom lens in surprising ways, and so photographing macro or close-up shots means you need to understand more of the ins and outs of zoom. Point and shoot digital cameras (with the exception of a few newer models) enable you to get closest to your subjects when using the widest focal length. By using the zoom function while shooting in macro mode, you actually decrease magnification on your subject.

This section explains how and why to get very close to your subjects for macro and close-up photography, and how and why to pull back from your subjects.

Wide-angle close-up photography

In Chapter 4 I explain how you can use wide-angle lenses in macro and close-up photography to incorporate background details into your compositions. Doing so enables you to show your subject largely in your frame and still show much of the surrounding environment. Because most point and shoot digital cameras are best suited for close-up photography at their widest zoom, they tend to be most useful for this type of composition.

When shooting with a digital point and shoot, your subject is usually going to appear largest within your frame when you're shooting with your widest angle and at the closest focusing distance possible. As you zoom in and move your camera to the effective minimum focusing distance, your close-up abilities diminish. Figure 7-2 shows a subject photographed at the widest angle and closest focusing distance (1 cm). Figure 7-3 shows the same subject photographed with the lens halfway zoomed in and at the current closest focusing distance (5 cm). And finally, Figure 7-4 reveals the maximum zoom at its closest focusing distance (30 cm).

6.1mm, 1/15, f/2.8, 800

Figure 7-2: A digital point and shoot camera offers its closest focusing distance and highest level of magnification when used at its widest angle.

As Figures 7-2 through 7-4 show, the wider your lens on a digital point and shoot, the greater your macro and close-up capabilities. DSLR cameras function differently. In DSLR photography, you need additional equipment — extension tubes, tele-converters, or close-up filters, which I tell you about in Chapter 4 — to achieve wide-angle macro and close-up compositions.

10.8mm, 1/10, f/3.2, 800

Figure 7-3: As you zoom the lens, your closest focusing distance becomes less effective, causing you to move farther from your subject and making it appear smaller in your frame.

A good point and shoot digital camera can act as a quick and useful sidekick to your DSLR. Any time you desire a wide-angle, close-up perspective you can whip out the trusty digital compact, set it to macro, and start shooting.

Knowing when to zoom in and move out

Although point and shoot digital cameras become less effective for macro and close-up photography as you utilize the zoom feature, there are still times when zooming in is necessary. After all, it's not always just about how big your subject is in your frame. Sometimes you may want to provide more space in the frame for supporting elements or create a composition with less barrel distortion. You may want to keep from invading your subject's personal space, or back out in order to protect your camera or yourself from a threat. I don't know about you, but I'd prefer not to place my camera's lens within one centimeter of a wild poisonous snake or an open candle flame.

Zooming in with your point and shoot digital camera in close-up photography enables you to create more comfortable shooting situations, and produce various types of compositions.

30.5mm, 1/8, f/4.5, 800

Figure 7-4: Zooming all the way in causes the least effective focusing distance and the least amount of magnification.

Make sure that you get experience working with the different zoom levels of your camera and the focusing distances they provide. Here are some ideas to get you zooming effectively:

- ✔ If one centimeter is too close for comfort for you or your subject then you may want to zoom in and back off a bit. A venomous snake may not appreciate a camera poking it in the eye. If you find that the safest distance to take a picture doesn't provide the magnification you want, try adding a close-up filter to your camera if you can. For more on close-up filters read Chapter 6.

- ✔ Depending on your main source of light and the direction it's coming from, getting too close may cause you and your camera to cast a shadow on your subject. In this case, zoom in and back off a bit.

- ✔ Perhaps a wide-angle point of view isn't suitable for your subject or your scene. This perspective tends to distort the shape of things, making them appear more round (known as *barrel distortion*). Plus, the size of objects in the center of the frame is exaggerated compared to what's positioned at the frame's edges. If you find this to be unflattering for your subject, zooming in

and backing off can help reduce barrel distortion.

Figure 7-5 shows a subject photographed from a wide-angle perspective (with barrel distortion, left) and from a more normal perspective (without barrel distortion, right).

✔ If you determine that the background information in a scene isn't necessary for your message, or that it takes away from your subject, then zooming in can help. It reveals less of the background and focuses more on the subject.

6.1mm, 1/160, f/8, 100 10.8mm, 1/160, f/8, 100

Figure 7-5: Eliminate barrel distortion (left) by using a normal (halfway zoomed) perspective rather than a wide-angle perspective.

Figure 7-6 shows a wide-angle composition that reveals much of the background detail and a completely zoomed-in perspective. Notice how the zoomed-in perspective eliminates much of the distracting background.

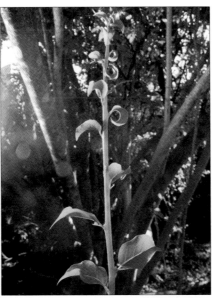 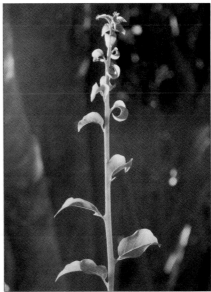

6.1mm, 1/125, f/5.6, 400 30.5mm, 1/125, f/5.6, 400

Figure 7-6: Eliminate distracting background details by switching from a wide-angle perspective to a telephoto (zoomed all the way) perspective.

Maximizing Close-Up Image Quality with Your Digital Point and Shoot

Many digital point and shoot cameras can produce high-quality macro and close-up images if you know how to use them. Forget the notion that you can use your point and shoot camera only for pointing and shooting.

You achieve the best macro and close-up images when you take the time to think about your intended message, camera settings, composition, and lighting. As if that weren't enough, you need also to consider how to keep your camera and subject as still as possible.

Having a composition checklist

Because you get less control from a point and shoot digital camera than from a DSLR, you need to master the art of composition in order to create images that capture the interest of viewers.

Good composition means that you reveal a subject in an interesting or aesthetically pleasing way. This can mean you've clearly gotten your message across to viewers through an image, your image draws people in as they view it, or that it just plain looks good. For more information on composition read Chapter 10, and for a thorough exploration into photographic composition read *Digital Photography Composition For Dummies* (Wiley). There's a lot more to good composition than seeing something you like, pointing at it, and shooting.

You can improve the composition of the macro or close-up photographs you take with your point and shoot digital camera by considering the following:

 ✔ **Point of focus** refers to the sharpest area of your image. You generally make your subject, or whatever you find to be most interesting in your scene, the point of focus. DSLR cameras enable you to control focus more quickly and precisely, but if your digital point and shoot offers control of your point of focus (refer to the section "Using the Macro Setting"), use it to direct your viewers to the subject in a composition.

✔ You use **exposure settings** to determine depth of field, adjust the brightness of your exposure, and to freeze motion in moving subjects. Chapter 6 tells you more about depth of field.

✔ **The distance of your camera from your subject** determines the size relationship between your subject and the background. (Refer to the section "To Zoom or Not to Zoom.") You use distance in combination with level of zoom to achieve the right balance of how large your subject appears in your frame and how much of the background you show.

✔ **Camera angle** plays a major part in the perspective at which a subject appears in a photograph. View your digital point and shoot's LCD monitor while adjusting your camera angle to ensure your subject fits into its background in a visually comfortable way.

Figure 7-7 shows how choosing the appropriate camera angle can greatly enhance your composition. In the image on the left, the subject merges with background elements; in the second image, the camera angle better suits the scene.

✔ Including **foreground and background elements** in your frame can add depth, interest, realism, and ambiance to an image. See Figure 7-8 for an example.

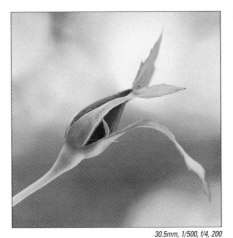 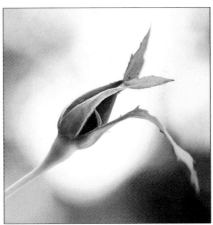

30.5mm, 1/500, f/4, 200 *30.5mm, 1/500, f/4, 200*

Figure 7-7: A proper camera angle helps separate the subject from the background.

30.5mm, 1/320, f/8, 250

Figure 7-8: Including foreground elements in your frame can add depth, realism, and ambiance to your image.

✔ The **rule of thirds** states that your subject, horizon lines, and other visual points of interest in a scene are best represented when placed on the thirds of a frame rather than in the center or at the far edges. Some camera models have a thirds grid that can be applied to the LCD monitor, helping you keep this rule in mind when composing your shots.

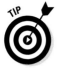

If your camera doesn't have the option to display the thirds grid on your LCD, then cut thin strips of gaffer's tape and place them along the thirds of your camera's monitor. Use them as a guide to help position elements in your frame as you compose a scene. Figure 7-9 shows an example of this technique in action.

Conquering issues with light

Some point and shoot digital cameras enable you to get as close as one centimeter from your subjects and still achieve sharp focus, but doing so can be problematic as far as light is concerned. When you're that close, your camera is likely to cast an ugly shadow on your subject and give you lousy results.

You can deal with shadows and unflattering light a number of different ways. The following options can help, whether you're a photographer on a budget or a gear junkie:

- Pay attention to the direction of your main light source. If your subject is lit from behind or from the side, you can move your camera closer without blocking the light directly. However, if your subject is lit from the front you'll get in the way of the light for sure. Figure 7-10 shows what happens when you get between your light and your subject.

- Macro-specific lighting attachments help you get control of the light in your scene. Some photographers prefer to use a ring light, which is a battery-powered flash that surrounds the lens and throws even light onto the subject. Others prefer a flash bracket system, which props a battery-powered flash on each side of your subject. Each option produces a fairly even light.

 In Figure 7-11, I used a ring light to compensate for the shadow cast by the camera onto the subject. This technique requires a camera that is compatible with macro-specific lighting gear.

- An ordinary battery-powered flash, which is propped up next to your camera, lights your subject from the side. This requires a camera that can sync with an off-camera flash (either through a sync cord or a wireless transmitter). Figure 7-12 shows the results of this method.

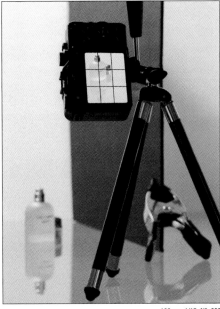

100mm, 1/15, f/8, 200

Figure 7-9: Set up a thirds grid on your digital point and shoot's LCD monitor to act as a guide for composing images.

6.1mm, 1/30, f/13, 100

Figure 7-10: Getting close to your subject can cause your camera to cast an unpleasant shadow into the scene.

If your camera isn't compatible with off-camera flash systems, substitute a flashlight for the battery-powered flash.

✔ A small piece of reflective material might be just the ticket for shining light onto your subject. A small mirror, for example, provides a strong reflective light, and a small white card provides a much more subtle light. Angle the reflector in the direction of the main source of light so that it bounces light toward the subject. See the example image in Figure 7-13.

Your on-camera flash is generally rendered useless when you're photographing at the closest focusing distance with your point and shoot digital camera. It's either blocked partially by your camera's lens, or it doesn't light your subject evenly because it's so close.

6.1mm, 1/160, f/13, 100

Figure 7-11: A ring flash ensures the camera doesn't get in the way of the light and provides flat, even lighting.

Tripods and point and shoot digital cameras

The term *point and shoot* isn't often associated with the use of a tripod, but your compact digital camera is capable of more than simply pointing and shooting. Chapter 6 shows you how a tripod can maximize image quality in DSLR macro and close-up photography by preventing camera shake and securing an accurate point of focus. Doesn't it make sense that the same would be true in digital point and shoot macro and close-up photography?

One of the benefits to using a point and shoot digital camera is that they're lightweight and easy to travel with, so I understand if you prefer not to carry your bulky tripod along. Doing so kind of defeats the purpose of your convenient camera. The great news is that digital point and shoots require far less support than DSLRs when fixed on a tripod. You can

6.1mm, 1/160, f/13, 100

Figure 7-12: Position a small flash beside your camera to light your subject from the side.

acquire a compact, lightweight tripod that's as convenient to travel with as your compact digital camera and never find yourself saying, "I wish I had my tripod for this shot."

When your point and shoot digital camera is fixed to the tripod, your hands are free to hold additional light sources (such as the reflector card or a battery-powered flash), hold unwanted or distracting foreground elements out of the way, or to block unwanted light sources from affecting your scene.

6.1mm, 1/160, f/13, 100

Figure 7-13: If you don't have a flash, use a reflector to bounce light into your scene from beside the subject.

Part III

Creating Successful Images: Light, Composition, and Exposure

The 5th Wave By Rich Tennant

"Get me 3 tungsten halogen lights and a 5000K strobe. I'm trying to do something real natural here."

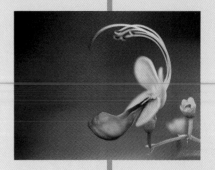

In this part . . .

Lighting plays a major role in all types of photography, providing a sense of aesthetics, mood, and story to images. In this part of the book, I introduce you to the different types of natural light and show you how to work with it and to manipulate it when it just won't cooperate with your vision. You find out about the artificial light sources that are useful in macro and close-up photography. Plus, I discuss the art of composition and exposure control from a macro and close-up standpoint.

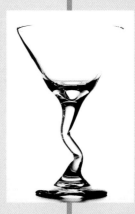

Making the Most of Natural Light

*N*atural light — light provided by the sun — is one of your most valuable resources as a macro and close-up photographer. It's free, provides many different qualities and intensities of light to work with, and when used correctly enables you to produce beautiful images that embody your own intended message or interpretation of a scene.

Different types of natural daylight affect your scenes and subjects in various ways that you can harness in your macro and close-up photography. This chapter provides a look into identifying different qualities and intensities of outdoor lighting and explains how each contributes to the message in a photograph.

Working with Different Types of Natural Light

The sun is the direct source of natural light on Earth, but that one light source doesn't mean just one kind of light. You might encounter natural light as

✔ **Direct sun,** or light that comes right through the atmosphere to your subject.

✔ **Open shade,** or ambient light, which bounces around in the atmosphere and illuminates the blue sky. This type of natural light is found in areas that are unaffected by the sun directly, such as the shady side of a building, or the shadow area under a tree. It has a more ambient effect on your subjects and scenes.

✔ **Diffused light,** which arises from cloudy conditions. Sunlight passes through haze or clouds and so affects your scenes more subtly, providing a softer look. The thickness of haze or clouds determines just how soft the sunlight becomes.

✔ **Dusk** or **dawn** lighting is sometimes referred to as the *magic hour* or *golden hour.* This type of natural light occurs just after the sun sinks below the horizon or just before it rises. You can expect a soft, colorful light at these times.

Getting to know each of these kinds of light is a vital part of taking beautiful macro and close-up images that are naturally lit.

Direct sunlight

Identifying this type of natural light is easy: When nothing is blocking the path between the sun and your subject, you're dealing with direct sunlight.

Direct sunlight is considered a "hard" light source, meaning it creates well-defined shadows with solid edges and is ideal for creating images with high contrast or for revealing texture in a scene or surface.

Unaltered hard light can provide dramatic, rigid, or vivid moods in your macro and close-up photography and works best with subjects that are dramatic, rigid, or vivid themselves. Matching subject and light ensures that both pieces tell the same story. For instance, a cactus, scorpion, or stone wall may make for an appropriate subject to photograph in the direct sun. Shooting a soft, delicate subject — such as a light pink tulip — in harsh lighting may not read as well.

On the other hand, a little creativity and a tool or two can enable you to use direct sun properly on just about any subject.

Dealing with contrast when working with direct sun

Mastering the art of photographing with direct sun means controlling the relationship between shadows and highlights. Too much contrast in a scene can lead to

✔ *Blocked-up shadows* — underexposed areas that provide little to no detail

✔ *Blown-out highlights* — overexposed areas that provide little to no detail

Your digital camera's sensor is less sophisticated than your brain and can deal with a much smaller range of tonalities at one time. Because your digital sensor can't compensate for scenes with such high contrast on its own, it's up to you to bring the shadow and highlight areas closer together in order to capture detail in both at one time.

My recommendation is that you expose for your highlights (making sure they don't get blown out), and fill in your shadows with additional light to better expose them, as well. This technique enables you to create images that appear to your digital sensor closer to the way you see them with your eyes.

The image on the left in Figure 8-1 shows how the camera deals with a lot of contrast. You see that it could not render information in the highlights and shadows. The image on the right shows the result of using a small reflector to bring up the luminosity of the shadows, allowing for a more natural-looking image. You can use your battery-powered flash, ring light, and other macro-specific lights on low settings to fill in shadow areas as well.

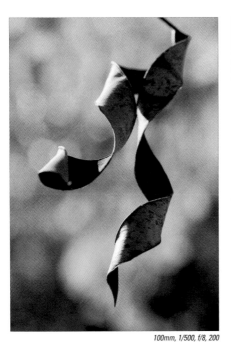
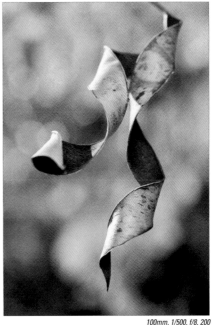

100mm, 1/500, f/8, 200 100mm, 1/500, f/8, 200

Figure 8-1: Control contrast in a scene by filling in the shadow areas with a small reflector card.

TIP

To ensure both your highlights and shadows are exposed properly, refer to your camera's *histogram* — a graph on your LCD monitor that shows the brightness distribution of an image with pure black on the left, pure white on the right and grey in the middle. If you notice that a lot of tones are pressed all the way against the left edge of your histogram, then your shadows are underexposed. If a lot of tones are pressed against the right edge, your highlights are overexposed.

Revealing texture

Because direct sun is a hard light source, it works great for revealing texture. To best reveal texture, choose a time of day when the sun is lighting your subject from the side. Sidelight casts shadows along the surface of the subject based on what type of texture the surface has. Direct sun can emphasize the coarse characteristics of a stone, or the systematic pattern of the scales on a snake.

Traditionally, photographers wait until the sun is going down to have a side-lit scene. In macro and close-up photography, however, you can often find side lighting at any time of day. In a large scene such as a field of flowers, the sun has to light the entire field from the side to achieve an image that reveals the overall texture.

In macro and close-up photography you concentrate on just one (or a few) of the flowers in your photo. Each flower in the field may bend and twist in its own direction, and so one of them might be lit from the side even though the entire field itself is not. If you bring some handy grip tools (equipment that enables you to reposition things in a scene; see Chapter 6) you often can manipulate the position of a subject in order to create side lighting on it. Just be sure to use grip tools that are appropriate for your subject and not to damage anything in nature simply for the cause of getting the shot you want.

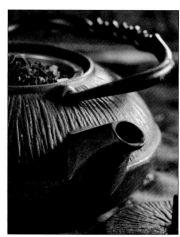
100mm, 1/8, f/8, 200

Figure 8-2: Direct sun from the side helps to emphasize texture in an image.

Figure 8-2 shows an image that was side-lit from the direct sun. The light shows off the texture of the teapot and the loose tea leaves inside it. The high contrast between the

shadows and highlights works well to emphasize the texture that's revealed by this type of light. Had the shadows been filled in with more light (creating less contrast), the texture would still be visible, but not as blatantly.

If you want to show a subject's texture, but prefer to do so with less contrast than direct sunlight naturally provides, simply use a reflector or a fill flash to balance out the brightness difference between the shadows and highlights. (The earlier section "Dealing with contrast when working with direct sun" tells you how to do so.)

Backlighting as a creative tool

Backlighting a subject generally is referred to as *silhouette lighting* because it tends to reveal the shape of something without providing much (if any) information on its front side. In macro and close-up photography, you can find interesting ways to represent the silhouette of a subject because of the blurry backgrounds shallow depths of field cause. Figure 8-3 shows an example of backlighting. Notice how the image becomes mainly about shape and color.

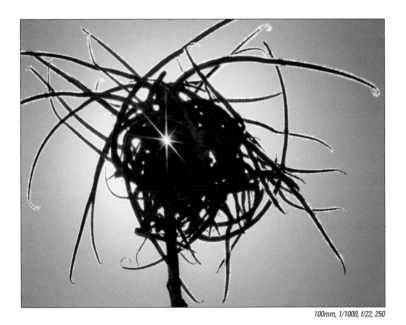

100mm, 1/1000, f/22, 250

Figure 8-3: Silhouette lighting helps to reveal shape in a subject.

Silhouette lighting is an old trick in photography and is a major cliché. There are correct times and places to utilize the technique, but backlighting is far more interesting when used creatively and with a greater purpose. Many subjects in macro and close-up photography tend to have transparent qualities, such as flower petals, leaves, water drops, glass surfaces, and the wings of insects. Recognize when you're dealing with one of these types of subjects and try the backlighting technique to see what you can come up with.

Because the spray produced when you cut a grapefruit is more interesting than the fruit itself, I backlit the subject in Figure 8-4. Combined with the dark background, backlighting emphasizes the transparent qualities of the spray and makes it stand out in the image. I also used a fill light in this image to make the surface area of the grapefruit visible.

Please use extreme caution when attempting to create action shots such as the example in Figure 8-4. Consider what you need to achieve the shot, such as timing, lighting, and precision; but make sure that you ensure a safe working environment.

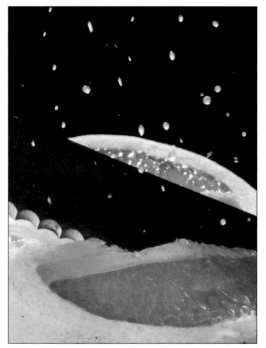

50mm, 1/640, f/16, 400

Figure 8-4: Backlighting emphasizes the spray caused when cutting through the grapefruit.

Some other instances in which you can use backlighting to add interest in an image include the following:

✔ When an insect is positioned on the backside of a leaf, backlighting causes the silhouette or shadow of the insect to be imposed onto the leaf's surface. Figure 8-5 shows what I mean.

✔ Subjects with fuzzy or furry textures (such as dandelions or caterpillars) have a bright glowing rim when backlit.

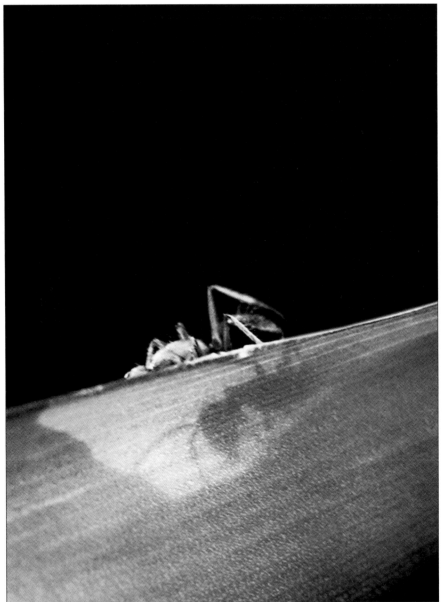

100mm, 1/160, f/4, 500

Figure 8-5: A backlit scene can reveal more to the story, such as a silhouette of what's on the other side of a surface with transparent qualities.

✔ Subjects with multiple, overlapping transparent layers may produce interesting results when backlit. For example, an orchid has overlapping petals; because light has to pass through two layers at these areas, they appear darker when the flower is backlit than the areas that don't overlap.

✔ Backlighting a subject with transparent qualities can reveal internal structures like the veins of a leaf, as Figure 8-6 shows.

100mm, 1/160, f/11, 400

Figure 8-6: For some subjects, backlighting can reveal internal elements, like the veins of this leaf.

Open shade

On a bright, sunny day with few clouds, you get a second type of natural light known as *open shade*. Any area that's exposed to the blue sky but not getting direct sunlight has open shade lighting.

Something that blocks your subject from direct sun but doesn't get in the way of the whole sky around causes open shade. You might get open shade from a tree, a fence, a building, or even from a piece of cardboard that you hold to block the sun intentionally.

The upcoming sections tell you about the three main things you need to know when photographing a subject in open shade: the color, quality, and direction of the light.

The color of open shade

The sun sends red, green, and blue waves of light toward earth — all of which affect your subject when you photograph in direct sun. The particles in the sky reflect mainly the blue and green waves of light. This is why the sky is blue (or cyan, to be technical about it).

Because the sky is blue and is the main light source for open shade lighting, it produces a blue tint in photography. In the film days, photographers used a warming filter to balance the color of the light so that it appeared more like that of direct sun. With your digital camera you can simply set your color balance to open shade mode and your images automatically are warmed up to compensate for the blue shift.

In Figure 8-7, I photographed the image on the left in open shade with the camera's color balance set for daylight. The image on the right shows open shade with the camera's color balance set accordingly. Notice how blue the scene appears in the image on the left, while in the other image the scene appears normal.

 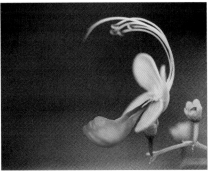

Both images: 100mm, 1/160, f/2.8, 400

Figure 8-7: Setting your camera's color balance to open shade compensates for the blue shift that occurs in open shade.

The reason your camera picks up on the blue light in open shade more than your eyes seem to is because you brain compensates automatically for the shift. This is the same reason that taking off a pair of orange-tinted sunglasses causes everything to appear blue for a short period of time. With the orange glasses on, your brain creates a blue shift to make things appear more natural. When you take off the glasses, the blue shift is obvious until your brain fixes the irregularity again to get rid of it.

Your digital camera can compensate for color shifts of all types, but you generally have to tell it to do so. Most digital cameras have an automatic color balance setting, but this setting is not always reliable. You're better off recognizing the color of different lighting types and manually controlling your camera's color balance.

The quality and direction of light produced by open shade

The sky is a much larger light source than the sun; therefore, the light produced by open shade is much softer. It is multidirectional and produces shadows with gradual edges rather than those with hard edges produced by direct sun.

Because open shade produces softer light, its direction is less obvious in photographs and contrast is minimized. The light spreads over a scene, creating a somewhat evenly lit environment.

Direct sunlight isn't ideal for all subjects; it can sometimes be too harsh, or overpowering. Certain subjects that require a softer mood lighting or a more even type of light photograph better in open shade. Some examples of these subjects include the following:

- **Flowers with soft, silky petals, or any sensitive, milky, or supple subjects.** Softer light helps to reduce contrast and provides a more even lighting that works better to represent fragile shapes, forms, and textures.

- **Complex subjects that have many shadowy areas, such as a patch of many blades of grass or any subject with deep cavities.** Hard light produces well-defined shadows, which can cause complex scenes to appear chaotic or confusing. A softer light helps to show objects with less shadow definition, making it easier to read the image. Figure 8-8 provides an example. I shot the image on top under direct sun and the image on the bottom in open shade conditions.

- **Subjects with broad reflective surfaces.** A larger light source provides a larger highlight than a smaller light source does. This can be ideal for revealing the shape of reflective subjects, such as a ripple in the water, a waxy berry, or a silver spoon.

Any time you determine that direct sun is an unsatisfactory light source for a subject, simply take out a piece of foam core or cardboard that's large enough to shade your entire scene, or at least your subject itself, and try photographing under open shade conditions.

Diffused sunlight on cloudy days

On days where the sun and most of the blue sky are covered by clouds, you get the opportunity to shoot with light that's less harsh than direct sun and slightly more directional than open shade. Depending on the thickness of the cloud coverage, the intensity and quality of your light changes on these days.

Diffused cloud light can be just a touch softer than direct sun (if there is a slight haze in the sky), or it can be much softer (if there is heavy cloud coverage). Read on to learn about dealing with light provided on cloudy days, and the color of this type of natural light.

The consistency of cloudy days

Some subjects may work best in a very soft light, such as flowers, feathers, liquids, or any subject with a reflective surface. (The section "The quality and direction of light produced by open shade" tells you more about subjects that work well in soft light conditions.)

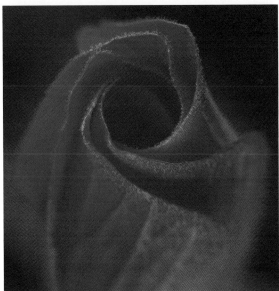

100mm, 1/60, f/11, 640
100mm, 1/30, f/11, 640

Figure 8-8: Softer light can help to reveal complex scenes with more clarity.

Other subjects may work better in light that's only slightly diffused, such as certain insects, or subjects that contain qualities of texture and delicacy. Many subjects can be photographed well in any lighting conditions, depending on how you as the photographer want to show them. Your message is as important to the quality of light you use as the subject itself.

Cloudy days sometimes offer inconsistencies that work to your advantage. As the clouds move through the sky, the quality and intensity of your light can change. As thinner sections of clouds roll through, you get light that's less diffused and more directional. As thicker sections come through, you can shoot with a softer light.

After you set up your shot on a cloudy day, try sticking around a while and waiting for the light to change a few times. See what comes of it and how the different types of light affect your subject. You may think you prefer the softest light possible for a particular subject, but after photographing it in less diffused conditions realize that it works better in harder light.

As the intensity of your light changes with the passing clouds, so does your exposure. Pay attention to your camera's histogram as you're shooting and make any necessary adjustments to your exposure settings. (Find out more about exposure in Chapter 6.)

I photographed the subject in Figure 8-9 on a cloudy day. The top image shows the subject under a thinner layer of clouds; some thicker clouds rolled in before I shot the image on the bottom. Notice the differences in contrast and the gradations between highlight and shadow areas.

The color of cloudy light

Light that is diffused through cloud cover casts a blue overtone in photographs just as open-shade lighting does. However, the blue shift in cloudy light is not as prevalent as that in open shade.

Just as the quality and intensity changes, so does the color of this type of natural light. The more directly the sun passes through the clouds, the warmer your light is. The more diffused the light is the cooler, or more blue, it appears.

Your digital camera offers a cloudy day color setting that provides a general compensation. This works well in most cases, but if you really want to create images with the correct color balance I suggest using a *white balance card* (a neutral-colored card that you use as a reference for your camera's custom white balance feature) and setting the color balance for a particular scene yourself.

Read your owner's manual to determine whether your digital camera has a custom white balance feature and how to locate it. It's usually available in the menu screen, or among the function settings.

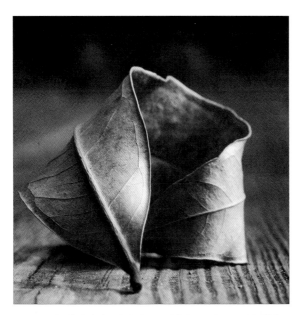

100mm, 1/30, f/16, 400
100mm, 1/30, f/16, 400

Figure 8-9: Inconsistencies in the clouds can provide various lighting opportunities.

Follow these steps to set a custom white balance:

1. **Place your white balance card in the scene you're photographing and position the camera so the card fills your entire frame.**

2. **Photograph the card with an exposure that reveals it as middle grey.**

 Try not to extremely over- or underexpose the card.

3. **Choose the custom white balance feature and select the image of the white balance card as your camera's reference.**

 This step tells your camera what it needs to do in order to adjust the color of your scene properly.

4. **Ensure that your camera is set to the custom white balance shooting mode.**

 This mode is sometimes in a separate area than the custom white balance feature. To operate your specific camera correctly, refer to your owner's manual.

You can use the custom white balance feature and white balance card in any lighting conditions to ensure a proper color representation in your images.

Capturing the soft, golden light at dusk and dawn

Nature provides you with fleeting moments of unique and beautiful lighting, both in the very beginning and the very end of each day. In the film days this was referred to as the *magic hour* or the *golden hour*. For the sake of a better future (one with less cheesy terminology), let's refer to it now as dusk and dawn.

This type of natural light occurs in the times before the sun rises above the horizon in the morning, and just after it sets in the evening. Its intensity, color, and quality changes quickly as the sun approaches or vanishes. And although dusk and dawn lighting tend to produce beautiful images, perhaps its scarcity rather than its practicality is what makes photographers see it as being so magical. You have to get the shot during those fleeting moments, or else it's gone.

Overall, dusk and dawn lighting tends to have low intensities. Bring a tripod so that you can shoot with slower shutter speeds if you need to.

The quality of light just before sunrise and just after sunset

The sunrise and sunset produce a direct, hard light source, but when the sun is behind the horizon, it produces a much softer type of light. And the lower it is beneath the horizon, the less directional it appears in photographs.

If you compose a shot at the end of the day and wait for the sun to set, you can begin shooting with dusk lighting. You'll notice as time passes that you gradually have to increase your exposure values (because the light continues to get darker), and the light on your subject continues to appear softer.

Figure 8-10 shows an example of an image taken just after the sun went below the horizon line and another image taken just five minutes later. Notice the differences in the two images. The quality of light becomes softer and less directional as the sun sinks. If you're a morning person, try this experiment in reverse at sunrise rather than at sunset.

The color of light at dusk and dawn

When you take pictures at sunrise or sunset, you capture images with a very warm color temperature. The angle at which sunlight passes through our atmosphere causes this warmth. When the sun is behind the horizon line, the light becomes cooler in color temperature (making it less orange, and more blue). The farther the sun is beneath the horizon, the bluer the light becomes. Refer to Figure 8-10 to see what I mean.

You can use the color of dusk and dawn lighting to your advantage to create images with specific looks or moods. However, if you're looking to capture the quality of this type of light without having the color shifts in your images, you can create a custom white balance to correct the colors, as I discuss in the section "The color of cloudy light."

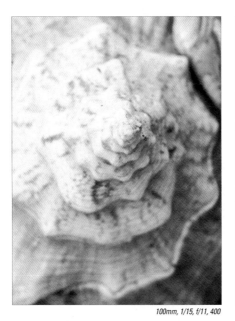 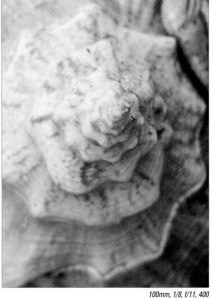

100mm, 1/15, f/11, 400 *100mm, 1/8, f/11, 400*

Figure 8-10: The quality and color of light changes quickly when photographing at dusk or dawn.

Creating the Natural Light You Want

In some cases the type of natural light you have isn't the one you want for your subject or message. This is nothing to worry about, so long as you're prepared with the field lighting equipment that I discuss in Chapter 6.

Natural light is a readily available source that's free, reliable, and beautiful. Too bad you can't always rely on the sun or the weather to do exactly what you want. This section shows you the tips and tricks that professional macro and close-up photographers use to manipulate, enhance, and redefine natural light so it works best for you.

Redirecting direct sun

If the sun is out and shining, but it's coming from the wrong direction for your subject (often the problem in the middle of the day when it sits high in the sky), you might need to block the sun from your subject and create a more flattering direction for it.

In this case, you need at least two pieces of equipment to redirect the sun: a piece of cardboard or foam core (known as a black flag, or a gobo) to block the sun from your scene and a reflective surface to bounce sunlight back into your scene. Chapter 6 covers a variety of surfaces you can use as a reflector.

If you're lucky enough to have a friend to help out, that person can hold the black flag and reflector in place. If not, you have to use grip (see Chapter 6 for more on the topic of grip) to hold these materials in position. If you're by yourself and have no grip to work with, then a third option is to set your camera's 10-second timer and handhold the two items in place.

You can use this same method (without having to block the sunlight from your subject) when your subject is positioned in open shade and you want to get some sunlight on it.

Creating a softer light without waiting for clouds

Clouds have a knack for coming when you don't want them and disappearing when you need them. In some parts of the world the weather may be fairly predictable, but even so, a professional never relies on the weather unless it's absolutely necessary.

To photograph a subject in soft, diffused light, you should never have to wait for the clouds. If the sun is out and shining, place a diffusion scrim (discussed

in Chapter 6) between the sun and your subject to soften the light. In macro and close-up photography a small scrim will suffice.

Diffusion materials come in a variety of strengths, enabling you to determine the quality and intensity of your light. A scrim with a thicker cloth produces a less intense and softer light, while a scrim with a thinner cloth produces a brighter and less diffused light.

Mimicking sunshine

Perhaps the most complex of all natural lighting techniques is creating direct sun on a cloudy day. You need a battery-powered flash or a strobe to make this happen. (Use either, depending on which you prefer.) Chapter 6 provides an introduction to these lights.

Figure 8-11 shows a subject that I photographed on a cloudy day to look as though it was basking in the sun. It looks realistic because I took all the steps I needed to emulate natural light.

When you want to mimic the sun with artificial light, keep in mind the following points to ensure that the light is flattering for your subject and appears realistic:

- ✔ **Avoid on-camera flash.** This style of light doesn't really happen in nature, and it provides flat, boring results. Instead, keep your flash separate from your camera and sync it by connecting camera and flash with a sync-cord or transceivers. (See Chapter 6.)

- ✔ **Consider the direction of your light.** Depending on your subject and your message, position the light in a way that makes it represent a certain time of day, or so it reveals something about your subject. For instance, place it low and to the side to mimic sunset lighting or to reveal the texture of a subject.

- ✔ **Address the quality of your light.** The closer you move the light source to your subject, the softer it becomes, and the farther you move it from the subject the harder the light becomes. If you want to give the appearance of direct sun, consider moving the light out. Move it in closer to create the appearance of hazy light and even closer for cloudy light.

- ✔ **Create the intensity of light you want.** Adjust the power on your flash or strobe to balance its intensity in regards to your ambient light. Setting the flash to be about three stops greater than the ambient light creates a realistic amount of contrast for direct sun conditions. A light meter can measure your different light sources, but if you don't have one, or don't know how to use one, simply look at the camera's LCD monitor to determine whether your key light needs to be turned up or down in power.

- ✔ **Consider the color of your light**. If you simply wish to create a normal daylight look, use the custom white balance feature I tell you about in the section "The color of cloudy light" or set your camera's white

balance mode to "flash." If you're going for a sunset look, try placing a warming gel over your flash or strobe to warm its color. This helps to mimic what actually happens as the sun passes through the Earth's atmosphere at low angles.

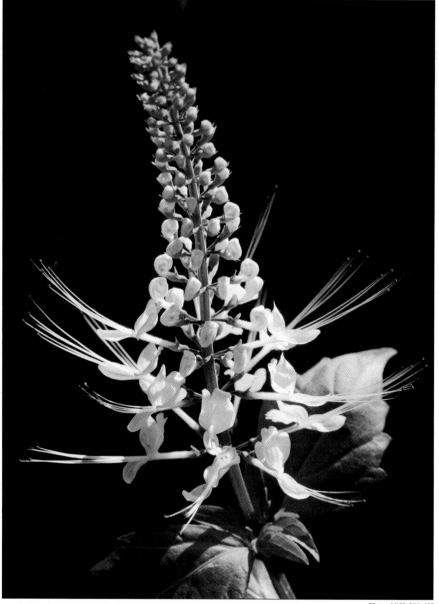

50mm, 1/160, f/11, 400

Figure 8-11: A strobe can mimic sunlight on a cloudy day.

9

Shooting in the Studio with Artificial Light Sources

*T*he studio can be a photographer's best friend. It's a totally controlled environment, meaning there's wind only if you choose to create it, light comes from whatever direction you wish it to, and the subject matter is as interesting as you yourself can provide.

Some photographers thrive in nature, finding beauty around every corner, but struggle when it comes to being creative in the studio. Perhaps they feel that the studio is too phony an environment and therefore produces fake-looking images. I suggest you look at the studio as a place of endless possibilities, an environment where the results of your macro and close-up photography are as natural or surreal as you wish.

Mastering the art of artificial lighting is a benefit when you're in the studio and in nature. This chapter covers which lights work best for your macro and close-up photography, how to use them most effectively, and how to combine artificial and natural light.

Finding the Best Artificial Light Sources for the Job

Although a creative approach can usually overcome any lighting obstacles, different types of photography are best approached with the correct lighting equipment for the specific job. In macro and close-up photography you're typically working with subjects and scenes that are very small, and your camera tends to be fairly close to the action. These factors are important in determining which lighting equipment is most suitable.

I'm a firm believer in making the most out of the equipment you have by improvising, modifying, and accessorizing it to work for your immediate needs. But, if you have a variety of lighting equipment to work with, you need to know what works best in specific situations. Read on to find information on how the size of a light source affects your macro and close-up photography and how to modify lights to produce the quality and intensity of light you need.

How the size and distance of your light matter

Two main factors determine the quality of light that a specific source produces: its size and its distance from the subject. Here's what I mean:

- ✔ A light source that's larger than your subject causes light to come from various points, wrapping around the surface of the subject and so creating a soft light with gradual highlight to shadow areas.

- ✔ A light source that's small compared to the size of the subject produces a hard light, which originates from fewer points. This type of light creates shadows with defined edges.

- ✔ If a light source is far away from your subject, its size is diminished in comparison to the subject. It therefore becomes harder than it would be up close. In Chapter 8, I tell you that the sun (despite its massive size in comparison to any subject or scene on Earth) produces a hard light because of its great distance from Earth.

The size of a light source and its distance from your subject work together to determine the quality of light that falls on your subject.

Because your subjects are typically small when you're shooting macro or close-up photography, you can use most lights to produce either hard or soft qualities based on their distance from your subjects. Even a battery-operated flash covers a larger surface area than most insects or small flowers. Move the flash close enough to your subject, and you can take advantage of this size relationship to create a soft light.

On the other hand, if you have a light source that's overwhelmingly larger than your macro and close-up photography subjects, you can move it farther and farther away to increase the hardness of its quality of light.

As you move a light source closer to your subject, its intensity increases. You may need to adjust its power levels to make it work for your particular exposure settings. If you can't lower the power settings of the light source in this situation, then try lowering your ISO or using a neutral density filter.

Accessorizing your lights

Accessories are attachments that fix to the front of the light, altering the size, shape, and/or direction of the light source. They're a great option for changing the quality of the light you get from a strobe or battery-operated flash.

Soft box

The most commonly used accessory for creating a larger surface for your lights is the *soft box*. This attachment forms an enclosure around your flash or strobe; it has reflective side and back walls and a large diffusing surface at the front of the light. Soft boxes come in varying sizes so they can be used effectively with subjects of many sizes. In macro and close-up photography, a small or medium size soft box probably suits your needs just fine.

A soft box increases the surface area of your light and diffuses the direction of the light. You end up with a softer light that tends to wrap around the edges of a subject, producing shadows with graduated edges. The closer you position a soft box to your subject, the softer the light will be.

Ring flash

A *ring flash* provides a light source that surrounds the lens of your camera, producing an even light that appears to have no specific direction. In macro and close-up photography, your built-in, on-camera flash is typically useless because it tends to light your scene unevenly and cast unflattering shadows. A ring flash works well to create light that illuminates your scene evenly at close distances when your on-camera flash can't get the job done.

In Figure 9-1, the subject is lit with a flat, front light from the ring flash. Your camera brand of choice most likely offers ring flashes that are designed to work with your camera. In macro and close-up photography, use the small units that are designed for shooting in close, rather than the larger ring flash units that are used in fashion photography.

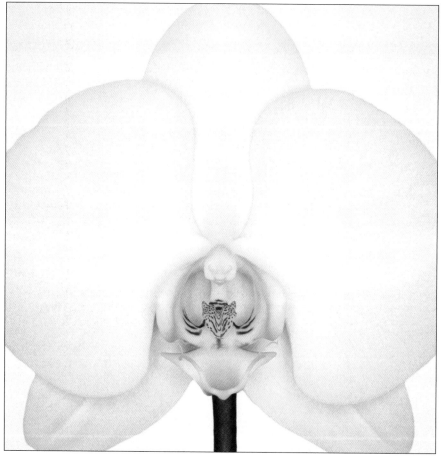

100mm, 1/160, f/14, 500

Figure 9-1: A ring flash produces an even light that appears to have no specific direction.

If you have a battery-operated flash for you camera already and don't wish to purchase a separate ring flash, look into getting a ring light adapter for your flash. This accessory connects to the flash as it sits on top of your

camera and redirects the light to a ring that's fixed around your lens. Be sure to research what's available and compatible with your specific camera and flash.

Macro flash bracket

A *macro flash bracket* enables you to position one or two flashes to the side of your camera and very close to your subject. You mount your camera to the center of the bracket and fix the lights to each arm.

You can adjust the arms to tweak the exact position of each light. This comes in handy for creating side light patterns in your scenes and for the convenience of having your lights move when your camera moves.

Making Good Lighting Happen: Position and Balance

Artificial light can create beautiful results in macro and close-up photography, but it can also cause your images to look unpleasing, forced, cheap, or unreal. Learning to position your lights goes hand in hand with understanding how to balance the intensities of lights to control how your subjects appear in your images.

When working in the studio (that is, any space that gives you control over your lighting and backgrounds), the lights you use and the positions you set them in determine exactly how your subjects are represented in your photographs.

Read on to find out how to control your lights in order to maintain a natural look in your images, or to find creative uses of studio lighting.

Keeping a natural look

In the natural world the sun provides directional light while the open shade (or any sunlight that's bounced, reflected, or scattered) provides an ambient light. These two work together to create a key light and a fill light. The *key light* determines how shadows are cast in a scene, and the *fill light* determines how dark those shadows are. In order to create a natural-appearing light in the studio, you need both a key light and a fill light.

Creating the key light

You can create a key light by positioning a strobe or battery-powered flash in a way that casts shadows in your scene. The position and direction of the light determine the size and direction of the shadows in your scene:

- ✔ Position a light source farther to the side of the camera, and more of your scene is covered in shadow.

- ✔ By bringing the light source closer to the camera, you can decrease how much of your scene is covered in shadow.

- ✔ The height of your light source determines how long the shadows will be in your scene. For example, the sun is low to the horizon at sunset, and so creates very long shadows. At high noon, the sun is high in the sky and produces shadows that barely stretch at all.

Scenes that include more shadow coverage tend to have dramatic and mysterious qualities and reveal texture. Scenes that have little shadow coverage have more ambient qualities and minimize the appearance of texture. By choosing one of these styles or positioning your key light somewhere between these two extremes, you can find the light that best suits your scene and message.

Figure 9-2 shows four examples of how the key light affects shadows in a scene. The top two images represent the subject in a much more dramatic way because the shadows have a greater presence (caused by positioning the key light far to the side of the camera). This type of key light helps to emphasize the texture of the baseball. The top left image uses a low sidelight to create a long shadow, and the top right uses a high sidelight to create a shorter shadow.

As the key light is positioned closer to the camera, and more in front of the subject, the drama is greatly reduced, and more information in the scene can be seen clearly. In the bottom left image, I positioned the key light between the far side of the scene and the camera's position; this is known as a ¾ lighting position. A ¾ lighting setup provides an idea of the subject's texture, but it emphasizes the ball's form. The bottom right image provides an example of a front-lit situation. The shadow area is minimized. Neither texture nor form is emphasized; instead, the subject's shape takes center stage.

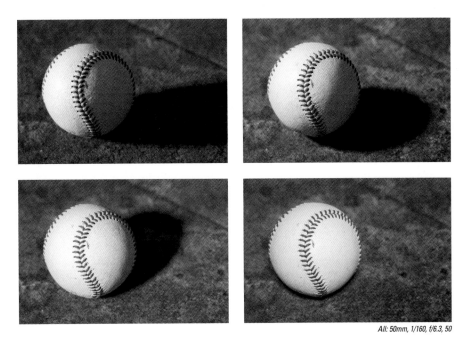

All: 50mm, 1/160, f/6.3, 50

Figure 9-2: The position of your key light determines how shadow and light affect your subject.

Creating a fill light to control detail in shadows

After you've analyzed your subject and scene and positioned your key light to create the shadows and highlights you want, set up a fill light to control how much detail shows in the shadows.

You can create a fill light with a second flash positioned very close to the camera. Ring flashes work well as fill lights, because they tend to create flat or nondirectional lighting. Another option is to use a *fill card* — any reflective surface that you can position to catch light from the key light and bounce it into the shadow areas of a scene.

The trick to using a fill light successfully is positioning it so that it casts a minimum amount of shadows in your scene; the closer the light source is to the scene, the better. A proper fill light works to fill in shadows with light, not to create shadows of its own.

You can find more information on working with fill lights in the section "Balancing the intensities of your lights."

Achieving that natural look with artificial lights

Understanding the purpose of a key light and a fill light — and their relationship to one another — is the first step in creating natural-looking light. From there you simply have to analyze your particular scene and create lighting that makes sense for your message.

Keep in mind the following when creating your lighting setup:

- The **position** of your key light relates to the time of day you'd like to create. If you want to mimic sunset lighting or dusk/dawn lighting, then position your key light low. To mimic cloudy lighting conditions, raise your key light up high above the subject.

- The level of your fill light's **intensity** in relation to that of the key light determines how dark your shadows appear. If you're attempting to mimic a bright sunny day, then your shadows should be exposed about three stops darker than your highlights. To mimic cloudy lighting conditions or dusk/dawn lighting, you can raise the level of your fill light's intensity so your shadows expose at about one stop darker than your highlights.

- The **quality** of your key light determines how hard or soft your shadows appear. Remember that direct sun is a hard light source. Cloudy light is soft, and dusk and dawn provide varying levels of softness, depending on how far beneath the horizon the sun is.

Being more creative with your lighting

After you master the basics of creating a two-light system for a more natural look, perhaps you'd like to try getting more creative with your photographic style. Doing so can benefit macro and close-up photography by drawing viewers in with more interesting and surreal concepts.

Adding a third light source to your setup is one way to accomplish more creative lighting. Use the third light to form a rim light on your subject in order to help separate it from the background. Figure 9-3 shows what this scene looks like when photographed with the fill light alone, with a key light to provide dimensionality and, finally, with a rim light to add interest and help separate the subject from its background. You might also use a third light to backlight a subject that has transparent qualities, making it glow.

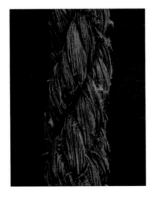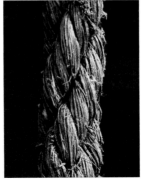

All: 100mm, 1/60, f/16, 1600

Figure 9-3: A key light and fill light accompanied by a rim light create dimensionality and separate the subject from the background.

Another way to be creative with light is to introduce color. You can produce various effects by covering studio lights with gels of various colors. Use an orange gel on your key light to simulate sunset tones, for example, or put a red gel on your key light to produce a more moody, surreal look.

Using multiple lights with varying colored gels can create effects that grab the attention of viewers. Figure 9-4 shows this technique in action. The contrast in colors provides more visual stimulation than this particular scene would normally offer.

Use a ring flash creatively by positioning it extremely close to your subjects. Light falls off in brightness as it travels through a scene and spreads out. Therefore, it affects closer objects more significantly than farther objects.

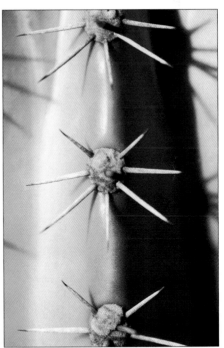

100mm, 1/500, f/5.6, 200

Figure 9-4: Using color gels on your lights can help create interesting macro and close-up photographs.

The closer a light source is to a subject, the quicker it falls off, meaning the elements behind your subject become darker (or less exposed). This effect can help create the illusion of depth, or three-dimensionality.

Take a look at Figure 9-5; note how the rose petals closest to the camera appear the brightest and how the petals become darker as they grow farther in distance from the camera. The background appears very dark in this image because of the light falling off based on the distance relationship from light to rose to background.

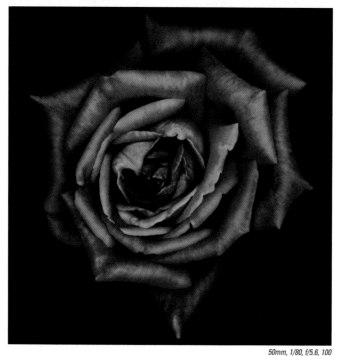

50mm, 1/80, f/5.6, 100

Figure 9-5: Three-dimensionality depicted through the creative use of a ring flash.

Balancing the intensities of your lights

When working with multiple light sources, you need to balance the intensity of your lights in order to control the level of contrast you want in your images.

Two factors determine the brightness of a light source: The light's power setting and how close it is to the subject.

- If one light is set to be much brighter than another and they are at an equal distance from the subject, the brighter light has a greater effect on your exposure.

- If two lights are set to the same brightness and are at an equal distance from your subject, then they have an equal effect on your exposure.

- If two lights are set to an equal power setting, the closest light to the subject appears brighter in your exposure.

To control the shadows and contrast in an image you must expose for your key light and adjust your fill light accordingly. The brighter your fill light is in relation to the key light, the brighter your shadows will be.

If you want to maintain some mystery by having dark shadow areas, try to ensure your fill light is at least three stops dimmer than your key light. You can tweak the settings of battery-operated flash units and strobe lights to control their intensity. If you're using lights that don't have a range of power settings, simply move them away from your subject to make them dimmer.

Increasing the intensity of your fill light in relation to that of your key light brightens your shadow areas and provides less drama in a scene. Notice in Figure 9-6 how the subject is represented in three separate ways simply by changing the intensity of the fill light. The first image provides a dramatic look with three stops of contrast between the key and fill lights. (The fill light is underexposed by three stops when your camera exposes for the key light source.) In the middle image, raising the level of the fill light by one stop reduced the contrast, and in the last image, the intensity level of the fill light was raised another stop.

All: 100mm, 1/15, f/16, 50

Figure 9-6: Contrast is determined by the intensity relationship between your key light and fill light.

Artificial Light, Natural Light, and Your Exposure

In many situations (especially outside of the studio), you'll find yourself working with both artificial and natural available light sources. How you approach each situation is up to you. Whether you use your lights to over-power (and eliminate the effect of) natural light or combine it with your lights can depend on factors such as the look or style you're going for, the type of subject you're photographing, or the type of natural light that's present.

The relationship between strobe (or flash) lighting and natural light (in regards to how much of each is visible in your images) depends on a balance, which is controlled by you. The exposure settings you choose, the intensity of your artificial lights, and the intensity of the available light work together to determine how the resulting photograph appears.

The benefits of using artificial light

You, me, or any other photographer cannot control natural light. Sure, we can alter it (as I show you in Chapter 8), but we can't tell the clouds to move, or the sun to change its position. When it comes down to it, if you rely on the natural light to serve a specific purpose or to create a specific look, there's always a possibility you'll be let down.

Luckily for us, there are artificial light sources, such as strobes and battery-powered flash. These provide light we can control, and they were designed specifically for photography (and debatably discos). Artificial lights can be relied on to create a series of images with a consistent look, and their intensity levels can easily be controlled, enabling you to choose the exposure settings that work best for your desired composition.

Producing images with a consistent look

Using multiple artificial light sources offers total control of your lighting and is ideal for producing consistent imagery. Unlike natural light, which produces shifts in color and intensity every time the sun goes behind a cloud, or as it moves throughout the sky, artificial lights produce the same color and intensity of light over and over again.

If for example you wish to photograph numerous items for a catalog and prefer the images to maintain uniformity, using artificial light sources helps to produce perfectly consistent color and contrast qualities in your images.

Keeping the same lighting setup throughout the duration of your shoot means that you don't have to worry about coming across inconsistencies between images after the shoot is completed. Professional studio photographers for products and jewelry often practice this method.

You can leave a specific studio lighting setup in place for long periods of time, and as long as nothing changes throughout that time (such as a light getting moved out of place, or a new light source being introduced), your images will continue to have the same look every time you use that setup.

Controlling depth of field and length of exposure

When photographing with strobes or battery-operated flash units, you have total control over which exposure settings you use for your shots. Simply set the camera to your preferred exposure settings and adjust the power and distance of your lights accordingly. (Chapter 6 tells you more about exposure settings.)

Smaller apertures (which are represented by a higher f/stop number and produce a greater depth of field) and faster shutter speeds require higher intensities of light. Larger apertures (which are represented by a lower f/stop number and produce a more shallow depth of field) and slower shutter speeds may require lower intensities of light.

Because you can control the intensity of light produced by your strobes and flashes, they're ideal for enabling you to control exactly how much depth of field you have in an image and for maximizing the speed of your shutter to avoid motion blur from a shaky camera or a moving subject.

If you use the *modeling light* (a continuous light that operates between shots to give a sense of how the strobe affects your scene and to aid with focusing) on your strobe in conjunction with a slow shutter speed, then the modeling light might affect your exposure. This can cause issues with color or can cause your subject to appear blurry if you're handholding the camera. Some photographers use a slow shutter speed with the combination of the strobe and modeling light to achieve creative effects. For instance, you can capture a still image of your subject when the strobe pops and leave the shutter open while the modeling light reveals the motion of the subject.

Combining artificial and natural light

Available, natural light (like that coming in from a window) can sometimes be very dim and require large apertures and slow shutter speeds to capture a correct exposure. This combination causes images to have a shallow depth of field, and slow shutter speeds often lead to motion blur.

A well-lit studio with large windows or skylights can provide enough natural light to eliminate your need for an artificial fill light. Combining the natural, ambient light (as a fill) with an artificial light source (as your key light) can provide beautiful results. This combination is referred to as a *one-light setup*.

Cutting out some of the lighting equipment on your set can simplify shooting in some macro and close-up situations. Doing so means you can get your camera in close to the subject and more easily make changes to your scene (such as removing dust with a small brush, adjusting the position of elements in a scene, or replacing one subject with another). Using available, natural light to fill your shadows in a studio shoot is a good choice in the following situations:

- **Consistency in your images is not a major concern:** As the sun changes by rising, setting, or passing through clouds, the color and intensity of your fill light changes with it. Be prepared to adjust your exposure settings to compensate for these changes.

- **You don't have to worry about motion blur:** If your camera is on a tripod, you can capture sharp images with slower shutter speeds — as long as your subject isn't moving. Consider using a cable release (see Chapter 6) or your camera's self-timer to reduce camera shake during your exposure.

- **You want a shallow depth of field:** To create an image with a shallow depth of field, you can open your aperture very wide. Doing so lets in more light during your exposure, so you shouldn't have any worries about the intensity of the natural light.

- **You're short on light sources:** If you have access to only one artificial light source, then natural light may be your only option for filling in shadows.

How aperture affects natural and artificial light

Your aperture controls how much light comes in through the lens during a given period of time by adjusting the size of the opening in your lens. A larger aperture (determined by a lower f-stop number such as f/2.8) allows more light in than a smaller aperture (determined by a higher f-stop number such as f/22).

Changing your aperture affects how bright your artificial light and your natural light appear in an image equally. So, if you close down one stop (change your aperture setting from f/8 to f/11) you allow in one stop less light from both your artificial key light and your natural fill light. The relationship between the two remains the same in your image, but your overall exposure is reduced by one stop.

In a one-light setup using an artificial key light and the available, natural ambient light as a fill, you can adjust your aperture to change your overall exposure without affecting the intensity relationship between the two lights.

Notice how the exposure was affected in Figure 9-7 (a photograph taken with an artificial key light and a natural fill) as the aperture was changed between exposures:

- ✔ In the first image, I photographed the scene with an aperture value of f/2.8 and overexposed it in the highlight areas.

- ✔ To bring down the exposure, I set the aperture to f/5.6 in the middle image. Doing so causes both the shadow areas (whose brightness is determined by the natural fill light) and the highlight areas (whose brightness is determined by the artificial light) to come down in exposure equally.

- ✔ In the last image, I set the aperture to f/11, and again, both the shadows and highlights were affected equally.

The role of shutter speed in manipulating your exposure

Your shutter speed affects your exposure differently than your aperture does, and this difference is especially important to understand when you use a one-light setup with natural fill.

Because a strobe and a battery-operated flash emit light only for an instant, the length of your exposure isn't a factor in determining its brightness. The full impact of the strobe or flash is captured based on your aperture and ISO settings at the moment when the light is emitted. You can't adjust the brightness level of this type of light by adjusting your shutter speed.

In a one-light setup, you use shutter speed mainly to change the intensity relationship between your key and fill lights. If you determine that an image has too much contrast, slow down your shutter speed to brighten your shadow areas. Doing so enables the natural ambient light to affect your camera's digital sensor for a longer period of time, increasing the intensity of your fill light without substantially affecting your highlight areas.

The natural ambient light affects both your shadow and highlight areas in an exposure. To avoid over-exposing the highlights, you may need to lower the intensity of your artificial key light when the shutter speed is slowed down significantly.

If you determine that an image would look better with more contrast between the shadows and highlights, increase your shutter speed to allow less of the ambient fill light in. Your artificial key light (assuming it's a strobe or a flash) isn't affected, but your shadow areas become darker.

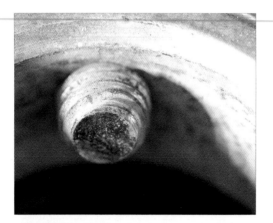

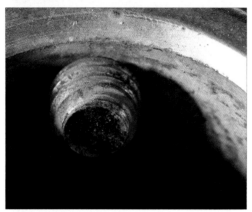

100mm, 1/15, f/4, 400
100mm, 1/15, f/8, 400
100mm, 1/15, f/11, 400

Figure 9-7: Changing the aperture affects the brightness of both your shadows and highlights.

Changing the shutter speed between each exposure altered the levels of contrast in Figure 9-8 images. The first image has a high level of contrast because of its fast shutter speed. In the middle and last images, just slowing down the shutter speed reduced the contrast.

 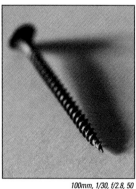 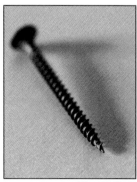

100mm, 1/160, f/2.8, 50 *100mm, 1/30, f/2.8, 50* *100mm, 1/5, f/2.8, 50*

Figure 9-8: Adjusting the speed of your shutter can alter the level of contrast when you combine an artificial key light with a natural fill.

Most Digital SLR cameras have a maximum sync speed between 1/160th and 1/250th of a second. Any shutter speed that's faster than your camera's maximum sync speed won't be able to capture the light emitted by the flash in its entirety. Be sure to check your owner's manual to find out what your camera's syncing ability is.

Overpowering daylight with artificial light sources

Strobe and flash lighting aren't just for the studio. You can use artificial light outdoors following the same guidelines that you find in this chapter. The main difference is that the daylight is typically much brighter outside than the available daylight indoors.

In macro and close-up photography you commonly position your lights very close to your subjects. Doing so enables you to overpower the daylight with even the weaker battery-operated flash systems. Here are some examples of situations in which you might consider using your artificial lights outdoors:

✔ Thick clouds are covering the sun or your subject is in the shade, but you prefer to have contrast in your scene with directional light. Using the daylight as a fill and adding an artificial key light can provide the

lighting you desire. Use a fast shutter speed to keep the daylight from competing with the intensity of your key light.

✔ If the sun is affecting your subject in an unflattering way, you can overpower the daylight completely by using two artificial lights (one for the key and one for the fill light). Move them in close to your subject, and use the fastest shutter speed based on your camera's max sync speed.

If the daylight is still too bright to be overpowered, increase the intensity of your artificial lights, decrease your ISO settings, and use a smaller aperture. If this still is not enough to block out the sun, try attaching a neutral density filter (see Chapter 6) to your lens and increasing the power of your light to compensate for the loss of light.

✔ If the sun is positioned nicely and is affecting your subject in a flattering way, but you prefer to have less contrast in a scene, you can brighten the shadow areas by adding an artificial fill light. Power the flash down so it produces just enough light to eliminate some of the contrast.

Composing Macro and Close-Up Images to Suit Your Subjects

*I*n combination with your choices in lighting, how you compose an image and what your subject matter is determine the level of enthusiasm others have when viewing it. For most people the process of looking at a photograph takes place mainly on subconscious levels; they don't know why they like or dislike an image, they just sense it.

As a photographer, you need to understand why people like images and why they dislike them. This chapter provides an introduction to composition, showing you how to apply those techniques to macro and close-up photography.

In the following sections you find out about the art of selecting subjects based on the design elements they offer, choosing which elements in a scene are necessary for your message, and producing images that are guaranteed to get and keep people's attention. When you're ready to find out more about composition, pick up a copy of *Digital Photography Composition For Dummies* (Wiley).

Paying Attention to Detail in Macro and Close-Up Photography

You might take macro and close-up photographs for any number of reasons. No matter your purpose, that intent directly impacts how you choose a subject. Ask yourself, "What am I trying to say?" Are you trying to sell something, create a piece of fine art, document an interesting aspect of nature, produce images for stock photography, or simply trying to have fun?

Your purpose for taking a photograph should determine whether you represent something in a literal or symbolic sense, or whether you mainly want to emphasize interesting visual characteristics in a subject. Regardless of your motivation, understanding which elements make a subject appear interesting and drawing attention to those elements enables you to successfully conquer any macro and close-up photography challenges.

Noticing elements of interest

Elements of interest are details that make a subject eye-catching. These draw you to the subject and appear in just about anything from a rusty nail to a smooth, curvaceous flower petal. As a novice photographer you may not know exactly why you are drawn to a certain subject (just like most viewers don't know why they like an image). This section makes you aware of the elements of design associated with particular subjects so you can share with viewers what you found to be so interesting in a particular scene.

The first element of design that affects how people see an image is the literal sense of the subject matter. From early childhood on, humans use sight to identify various items. For example, when you see a photograph of a cactus, you think cactus. But your goal as a photographer should be to get more from viewers, and to enable them to see more. By understanding which elements of design exist in, on, and around a subject, you can achieve a better response than, "Hey, there's a cactus."

Below is a list of the major elements of design that deserve attention when you're searching for the perfect subject:

- ✔ **Shape** refers to the outline of a subject, and it plays a basic and important role in photographic composition. Most people can probably identify a mushroom, a key, or an apple core (to name a few) by shape alone.

- ✔ **Form** is similar to shape but refers to the entire three-dimensional depiction of something. An orange is circular in shape and spherical in form.

✔ **Size** is a relative element. You can photograph an anthill to look like a mountain, or you can reveal its size by including an ant in the frame. You can use size to compare two subjects of equal or differing dimensions. Size can also refer to how you present a subject within your frame — that is, whether it takes up a lot or a little of the frame.

✔ **Lines** are very important elements of design; they can suggest direction, guide viewers through a frame, and even present the overall attitude of a subject. Notice the lines in a scene: Are they vertical, horizontal, or diagonal? Are they straight or wavy?

✔ **Texture** is the surface quality of a subject. Use it correctly, and it becomes something viewers can almost feel in a photograph.

✔ **Repetition** can refer to patterns, reflections, or similarities among multiple elements in a scene. It gets viewers involved with an image to compare the similar elements.

✔ **Color** is a very important consideration when composing an image. This can determine how a person feels (consciously or subconsciously) about an image. Color plays a major role in determining the overall mood associated with photographs.

Emphasizing elements of interest

Noticing more than just the literal sense of a subject or scene is your first step in selecting what and how to photograph. After analyzing your surroundings and taking note of the elements of design, you're faced with the challenge of composing an image in a way that emphasizes the elements you feel are most important to your message.

Through lighting and composition you can tell your viewers a lot about a subject, such as how old something is, whether it's rigid or supple, energetic or mellow. The following sections prepare you to use elements of design to your advantage, mixing and matching, emphasizing and deemphasizing in order to suit your intended message in a photograph.

Shape: Your subject's outline

You might consider shape the foundation for your subject. It defines how something is represented in a two-dimensional space (such as a photograph). A Coke bottle was designed to have sex appeal no matter what angle it's viewed from. Not all subjects were crafted in this way, so it's your responsibility to seek an angle that shows the shape of a subject in the best way. View a subject from various angles before determining your camera angle in order to gain an idea of which angles work best.

Figure 10-1 shows the difference between a composition that emphasizes the subject's shape in a good way and one that does not. The unique design in the shape of this glass' stem is what sets it apart from other martini glasses. The first image reveals this aspect of the subject, but the other does not.

 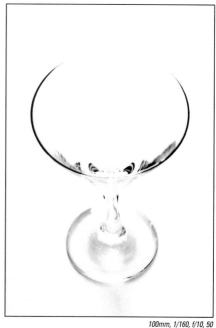

100mm, 1/160, f/10, 50 *100mm, 1/160, f/10, 50*

Figure 10-1: Your camera angle determines how the shape of a subject is depicted in a photograph.

Revealing form through lighting and composition

While keeping the shape of a subject in mind, also consider how its form is represented in your composition. How much depth are you revealing? A low angle can cause a subject to appear taller (drawing emphasis on its lower portion), while a high angle can cause it to appear shorter (drawing emphasis on its upper portion). Whatever part of the subject is closest to your lens gets the most emphasis in your composition.

When analyzing the form of a subject, think about what direction and quality of light will work best for your message. Use side lighting to reveal three-dimensionality, and use flat, frontal lighting to do the opposite. (Find out more about these lighting techniques in Chapters 8 and 9.)

A soft light spreads out the shadow lines, which is more suitable for delicate, dreamy, or beautiful subjects. A hard light gives shadows solid edges and is more suitable for rigid, tough, or dramatic subjects.

In Figure 10-2, I chose the camera angle and lighting to best suit the subject's form.

Size and your composition

To use size as a compositional element, you first need to figure out what you want to say about your subject. You can use a size relationship between two objects to clue viewers in on how big your subject is, create a sense of depth by having one object appear much larger than another in the frame, or give a sense of size to your subject by making it take up a lot or a little of the frame's space.

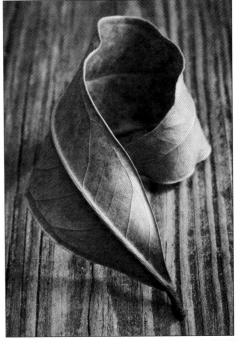

50mm, 1/15, f/16, 400

Figure 10-2: Your camera angle and lighting choices determine how a subject's form is depicted in an image.

If your subject is commonly known (such as a penny), then your viewers already have an idea of its size without any extra information. If your subject is not commonly known, you may have to include something known (like that penny again) in your frame to give viewers an idea of the size of your subject. They can compare the size relationship of the unknown subject to that of the familiar object and draw a conclusion.

If you include two objects in your frame that viewers know to have the same or a similar size, you can use their size representations in the frame to show distance, or depth. When the two appear to be similar sizes, viewers know that they are very close to one another. When they appear to be two very different sizes, viewers know that there is distance between the two. This helps to give the illusion of three-dimensionality to a two-dimensional photograph.

When working with a single subject and no supporting elements to use for scale, you can control how large the subject appears by how much space you grant it in your frame. Leaving your subject very small in the frame and

surrounding it with a lot of space gives viewers the sense that the subject is less significant or less dominant. By showing your subject largely in the frame and minimizing the space around it, you cause it to appear significant, or dominant. Figure 10-3 shows one subject presented in a significant sense and an insignificant sense. In the first image, you can tell that this scene is about the connection, or the bond between the two chain links. The second shot makes the message appear to be more about the chain as a whole, and less about that one specific connection.

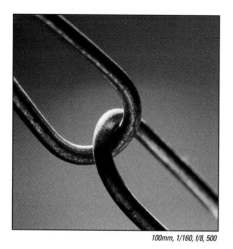

<div align="right">100mm, 1/160, f/8, 500 100mm, 1/160, f/8, 500</div>

Figure 10-3: The size of your subject in your frame determines how significant it appears to viewers.

Lines: Helping viewers read an image

After you start noticing the lines that exist in a scene, it'll be hard not to compose your images based on them. Lines can connect various elements to one another and they can steer viewers away from the edges of your frame, keeping their eyes inside the image.

Some general rules to keep in mind when composing your macro and close-up images include the following:

- ✔ **Pay attention to where your compositional lines begin and where they end.** You can use lines to lead viewers subconsciously from one area of the frame to another, or from one element to another. If a compositional line leads to no point of interest in a frame, you've wasted the line as a compositional tool.

- ✔ **Avoid merging lines, tangents, and awkward intersections.** Compose images in a way that causes your compositional lines to work together comfortably rather than in a conflicting way. When two or more lines

merge, they can cause a composition to appear cluttered or unclear. Sometimes lines must intersect in your frame; ensure that they do so at areas that contain no specific points of interest. A *tangent* occurs when two lines touch but don't intersect. This can create awkwardness in a composition. Avoid tangents by ensuring elements either intersect or are separate.

✔ **Keep a viewer in your frame by avoiding the edge.** If possible, compose an image so no lines lead a viewer out of your frame. To do so, make sure your compositional lines start and end within your frame, never extending all the way to the edge. This isn't always possible, such as when there's a horizon line or any line that's too big to keep within the frame. In those cases refer to the rule below.

✔ **Control the edge of your frame by keeping compositional lines from exiting at the corners.** A line leaving the corner of your frame takes the attention of a viewer with it. If you must let a line lead out of your image, have it do so away from the corner, as the corner represents the farthest point away from your frame's center. The best way to bring the viewer back into the image is to have another line near the point of exit to catch their attention and lead them back into the frame.

Figure 10-4 shows the difference between a comfortable composition and a tense composition with distracting lines. In the first image, the leaves are distributed through the frame evenly, and there's a harmonious relationship between the lines in the scene and the leaves themselves. In the second image, the leaves are heavily weighted to one side of the frame, and they make awkward intersections with the scene's compositional lines.

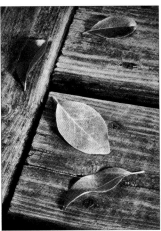 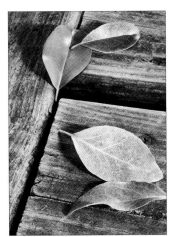

100mm, 0.6, f/22, 400 *100mm, 0.6, f/22, 400*

Figure 10-4: The way lines intersect and merge determines how comfortable a composition appears.

You can create lines by using just about anything, such as the edge of an element or a shadow, the area where two elements conjoin or overlap, markings, indents, or any element alone that is thin enough to be considered a line.

Vertical lines can suggest a feeling of pride, sturdiness, stiffness, or frailness depending on the subject they're associated with. Likewise, horizontal lines can convey laziness, relaxation, tranquility, or strength. Diagonal lines are often related to action, instability, and excitement, while curvy lines are associated with beauty, sex appeal, and dreaminess.

For example, a flower that stands up straight may seem to be at its peak, giving it the sense of strength and pride. If it were cut from the stem and lying horizontally in an image, it would seem to be in a state of rest. If the flower were diagonally positioned it may seem that it was reaching for the sunlight, giving the sense of action. A flower with a curvy stem or petals could seem more interesting or beautiful than one with a straight stem or petals.

Some exceptions to the rules occur, which is why it's important to make judgment calls as to what lines mean based on your subject and the other elements in a scene. A subject that's standing erect in a vertical line can seem strong and proud, but a row of subjects standing erect may seem more powerful and proud, even though that row adds up to a horizontal line. In this case, a horizontal line represents strength rather than tranquility.

Adding interest and information with texture

Photographers are often drawn to texture in macro and close-up photography. Something about the effect nature has on a surface through time, or the intricate details revealed when viewing things close-up causes people to stop and take photographs.

Macro and close-up photography can reveal the condition of a subject or provide a sense to viewers that they can almost touch the subject. These tips help you emphasize texture:

- ✔ **Lighting** is everything when it comes to revealing texture. A sidelight is usually ideal to produce the most contrast and to define the characteristics of a specific texture. To maximize the separation of shadow and highlight areas even more, shoot with a hard light as opposed to a soft light. (For more about lighting read Chapters 8 and 9.)

- ✔ Your **camera angle** can help emphasize the depth in a subject's texture. Shooting parallel to a surface works in some cases, but an angle that's more perpendicular to a surface offers a more interesting approach to

revealing texture. Imagine you're looking straight down onto Earth's surface from very high in the sky. You'll see the texture of trees and mountains, or buildings, but you won't get much of an idea as to how tall these things are. Now imagine you're much lower in the sky and you're skimming over Earth's surface, looking through the trees, mountains, or buildings. You'd be able to see differences in height between specific trees, mountains, or buildings. Each provides a much different interpretation of the texture on Earth's surface.

✔ Play with your **depth of field** to reveal texture in different ways. Greater depth of field shows more depth of texture, while a shallow depth of field enables you to focus on one specific area or detail. Each has a different effect and works well in certain situations. Analyze your subject to determine whether a great or shallow depth of field better emphasizes its texture.

The macro image in Figure 10-5 emphasizes texture. Notice how the side lighting, depth of field, and the camera angle draw you into the texture as if you could touch it yourself.

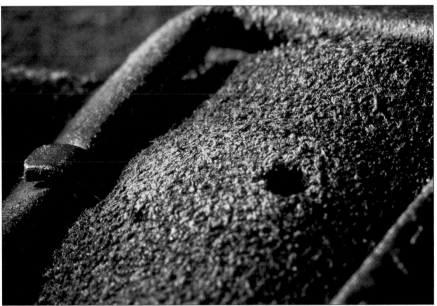

100mm, 2.5, f/22, 200

Figure 10-5: Texture is revealed through lighting, depth of field, and camera angle choices.

Repetition, patterns, and reflections

Whenever an image includes repeating images, viewers stop and stare for longer periods of time. It's natural for people to compare and analyze elements of similarity.

When composing images that include repeating or mimicking elements, make sure you know what your subject is. Sometimes a pattern, reflection, or twin element can be used in a composition to support the subject. But sometimes these can actually be the subjects.

Compose your frame in a way that makes clear what your subject is. For example, position an object in a dominant area of the frame (according to the rule of thirds, which I discuss in Chapter 7) to make it the subject or provide dominant placement for its reflection to make the reflection the subject. By placing both with equal dominance in the frame, you can cause both to act as the subject. Figure 10-6 shows how utilizing a reflection makes a rather boring subject captivating. In the image on the left, the bottle and its reflection play an equal role as the subject. However, because I changed the camera angle, only the bottle itself acts as the subject in the second image, and the reflection takes a minor role as a supporting element.

If you seek out subjects or scenes that involve patterns, reflections, or similarities then you'll have an easy time creating interesting macro and close-up photographs.

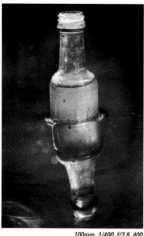 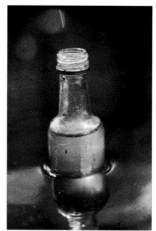

100mm, 1/400, f/2.8, 400 100mm, 1/400, f/2.8, 400

Figure 10-6: Changes in composition can determine a reflection's role in an image.

Color

Color plays a major part in how viewers see an image. It can draw people in to certain areas of an image, intrigue people based on their color preferences, and even create various moods.

Your eyes are naturally drawn to areas with contrasting colors (colors that exist on the opposite ends of the color spectrum, such as green and purple, red and cyan, and yellow and blue). Use this knowledge to your advantage when composing images, or when seeking subjects to photograph. Maximize the visual contrast of a purple flower by choosing a camera angle that positions it in front of the green leaves rather than the blue sky.

If you want to create an image with a more subdued message, then perhaps placing the purple flower in front of the blue sky is more appropriate than in front of the green leaves. Colors that exist closely on the color spectrum work together to provide a mellower, less dramatic visual impact.

By understanding the feelings associated with colors, and how they work together visually, you can more easily control how people feel when viewing your images. Seek out scenes that are made of interesting color combinations, or make the most out of every scene by knowing which colors to include in your frame and which to crop out.

Feeling blue, and other color associations

Color	Common association
Blue	Coolness, comfort, relaxation, calm, depression
Red	Love, energy, vitality, anger, hunger, sex
Orange	Warmth, stimulation, hunger, optimism
Yellow	Optimism, self-confidence, reason, clarity, energy, fear
Green	Nature, stress relief, balance, comfort, laziness, sickness
Purple	Imagination, intuition, royalty, compassion
White	Peace, cleanliness, purity, freedom, coldness, separation

Include What You Want in a Frame; Exclude What You Don't

The best way to compose images with clear messages that are interesting and meaningful is to eliminate distractions. Some elements take away from your subject or your message more than they add to it.

Your frame should include all that you want to record from a specific scene and should exclude all that's irrelevant to your message. This is the only way to ensure viewers see exactly what you want them to see when they look at your macro and close-up images.

When composing an image in macro and close-up photography, you need to determine just how much of a scene should be cropped out of your frame and whether your subject is better suited to a horizontal or vertical format.

Determining how much magnification you need for the crop of your choice

In macro and close-up photography, the more magnification you have the less of a scene you see in the frame. Using a macro 1:1 magnification ratio may be ideal for showing a great deal of detail in certain subjects, but this level of magnification doesn't work in scenes that require you to show more of the surrounding environment. You have to ask yourself what's important to your message in a scene and then determine just how close you'll stick your lens to the action.

Sometimes you get in extra tight to eliminate distracting elements from your frame, and sometimes you want to pull back a bit to tell viewers more about the subject's surrounding environment. If you choose a wider composition for a certain scene and there are some distracting elements in your frame as a result, then try downplaying their appearance with a shallow depth of field. Notice the images in Figure 10-7. A wider composition gives a sense of environment, but the branches and leaves in the background take away from the subject in the first image; a shallower depth of field in the second image creates a more pleasing image.

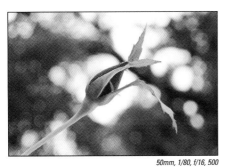 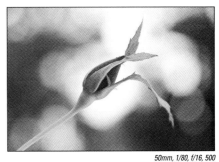

50mm, 1/80, f/16, 500 *50mm, 1/80, f/16, 500*

Figure 10-7: Use a shallow depth of field to downplay the appearance of distracting elements.

Always pay attention to the elements that exist in your scenes and keep in mind the elements of design in the section "Paying Attention to Detail in Macro and Close-Up Photography." Don't go for the maximum level of magnification every time you shoot. Instead, think like an artist and create beautiful and interesting compositions that tell a story.

Selecting a vertical or horizontal frame

The difference between a vertical or horizontal format in macro and close-up photography can determine the success of your compositions. Knowing which to use in a particular situation can be based on a number of factors, such as the height and width of a subject, the type of environment it's in, what you want to say about the scene, and in many cases, your own preference.

Choosing a frame based on the subject

A horizontal frame in its most basic sense is most suitable for subjects that are wider than they are tall. The opposite is true of a vertical frame. If a subject literally fits better in one type of frame than the other, it makes sense to choose that type of format.

The first question you ask yourself when deciding which format to use is, "Which does my subject fit into the best?" Fitting your subject into the frame in the way that makes the most sense helps to eliminate wasted frame space and awkward compositions.

The subject in Figure 10-8 fits more comfortably into the vertical frame. In the horizontal format, much of the frame's space is wasted and you can't see the subject in as much detail as in the vertical format.

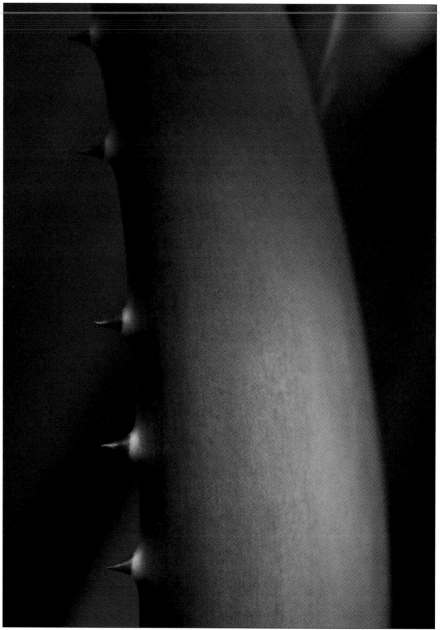

100mm, 1/250, f/8, 400

Figure 10-8: A subject that's vertical in nature fits best into a vertical frame.

If you have multiple subjects in a scene, you must determine the best way to fit them into your frame based on how they're oriented to one another. If the subjects are lined in a row, use a horizontal format to suit them best. If they're lined in a column, a vertical format makes more sense.

Selecting your frame based on the background

The shape of a subject won't always determine whether you shoot with a vertical or horizontal frame. In some cases you want to include specific details of the surrounding environment that are important to your theme or message.

If you notice that the foreground and background details are both important to your message, you may be able to maximize how much of those areas are included in a photograph by selecting a vertical frame. This enables you to include much of the foreground area, while still showing information from the background. View Figure 10-9 for an example of this technique.

If you notice that the span of your scene contains important details, select a horizontal format. This enables you to maximize how much of the scene can be shown from left to right. Figure 10-10 provides an example in which this is the case.

Certain cameras (such as many medium-format models) produce images in the square format. Some photographers utilize this format as a preference, or when a scene or subject simply fits best into a square rather than a vertical or horizontal format.

50mm, 1/30, f/2.8, 800

Figure 10-9: A vertical format helps to maximize foreground and background detail in an image.

100mm, 1/250, f/8, 400

Figure 10-10: A horizontal format helps to reveal the span of your scene.

Keeping Viewers in Your Frame with Tonal Contrast

Similar to lines, *tonal contrast* (the difference between the light and dark areas in a photograph) can guide viewers through a frame. The first place a person looks in a photograph is the point where the greatest level of contrast exists.

In most cases you want your subject to exist at the point of highest contrast. That way you can assure that your viewers look at the subject and subconsciously see it as being important. You can also ensure that your viewers' eyes are pulled toward the subject as they move into other areas of the frame (especially the edges). A successful composition causes people to view the entire frame, coming back to the point of interest (the subject) multiple times.

The edges of your frame represent a threat, as they are the natural exiting point for viewers. In order to keep people's eyes from wandering out of the frame, photographers often darken the edges of their frames, or compose images in such a way so the edges are covered in shadow.

By making your edges the darkest area of your frame, you attempt to draw the viewer back to the lighter areas within the frame. Figure 10-11 shows this technique in action.

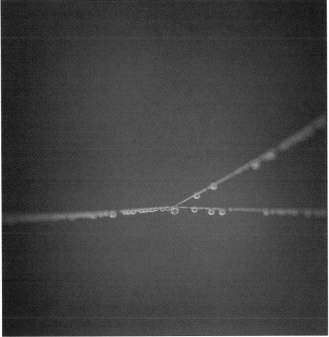

100mm, 1/200, f/4, 200

Figure 10-11: Dark edges in a frame help to draw viewers toward the lighter areas of the image.

To darken the edges of your frame, try

- Using the vignette tool, available in most photo-editing software.
- Placing a vignette filter in front of your lens. You can make one by darkening the edges of a UV filter with a marker or spray-paint, or by cutting a hole (slightly smaller than your lens) in a black piece of foam core and positioning it in front of your lens while shooting. The farther you hold the foam core from your lens, the more apparent the vignette will become in your image.
- Using black flags to cast shadows into your scene, affecting the specific areas that make up the edges of your frame.

11

Choosing the Appropriate Exposure Settings for Your Subjects

In This Chapter

▶ Controlling the depth of field in your images

▶ Maximizing sharp detail when dealing with moving subjects

▶ Choosing exposure settings that suit all of your compositional needs

Controlling your exposure settings is one skill that can help reveal your message, showcase your artistic vision, and give your images a professional look. Your camera, whether it's a digital SLR or a digital point and shoot, is equipped with automatic and manual settings. In this chapter you find out how to use the priority shooting and manual modes in order to gain control over the look of your images.

The information in this chapter enables you to analyze a scene and make decisions about which shooting mode is most suitable for it and which settings will produce the ideal results for your intended message.

When Aperture Should Be Your Priority

Aperture determines how much light enters your lens during an exposure, but it's mostly known for its ability to control *depth of field* (how much of an area is in sharp focus) in photographs. If you determine that controlling the amount of focus in a scene is important to your message then you need to have control of your aperture setting.

As I show you in Chapter 6, a large aperture (indicated by a lower f/stop such as f/2.8) produces an image with a shallow depth of field. A small aperture (indicated by a higher f/stop such as f/22) produces an image with a great depth of field.

Your camera most likely offers an *aperture priority* shooting mode, which is identified with the symbol *A* or *Av*. This mode enables you to select the appropriate aperture setting for your shot, while the camera chooses a shutter speed based on the exposure reading taken by the in-camera light meter.

Multiple types of meter modes are built into most digital cameras. To find out what your camera offers and which mode works best for your style of photography, refer to your owner's manual.

The camera decides on a shutter speed to match your selected aperture in order to produce an image that's exposed correctly. In the aperture priority mode, you can concentrate on creating an image with a specific depth of field without having to worry about getting the exposure right. This shooting method is ideal for situations with inconsistent lighting that require you to grab shots as you go.

Pay attention to the shutter speeds your camera selects when shooting in aperture priority mode, and make sure you're shooting at speeds appropriate for handholding the camera. If your shutter is too slow for capturing sharp results, then fix the camera to a tripod or increase your ISO.

Maximizing sharp detail in an image

Some subjects (or scenes) work best when photographed with a great depth of field, while others work best when photographed with a shallow depth of field.

When you wish to reveal as much detail in a subject or scene as possible, a great depth of field is ideal. The smaller your aperture is, the greater your depth of field will be. In Figure 11-1, the background was an interesting part of the scene and so I wanted to show detail in it. This image was photographed at f/22 in order to maximize depth of field.

A lens provides the optimum sharpness when used with an f/stop from the middle of its range. The lens' smallest aperture (such as f/22) may produce the most depth of field, but the lens will produce sharper results at f/8 or f/11. When choosing to maximize your depth of field, understand that you'll be increasing how much of the scene is in focus but sacrificing the quality of sharpness in your image.

100mm, 1/15, f/22, 400

Figure 11-1: Use a small aperture setting such as f/22 to maximize your depth of field, showing more detail in a scene.

Here is a list of scenarios in which you'd be likely to use a small aperture to maximize depth of field in an image:

- **When photographing a product,** you generally need to show the entire subject in sharp focus. That way potential clients can see the details of the item they're considering to buy.

- **If the background details in a scene are important to your message,** you want to show detail in them. A great depth of field will enable you to capture the subject in sharp focus while also revealing informative details in the background.

- **When photographing multiple subjects,** the best way to ensure they're all in focus and can be seen clearly is to use a great depth of field.

- **In macro conditions such as a 1:1 magnification ratio or greater,** your depth of field tends to become very shallow. The greater your level of magnification is, the shallower your depth of field becomes. Sometimes you need to use a small aperture just to show a moderate level of sharp detail in a scene.

Macro and close-up photography naturally produces images with shallow depth of fields because of the closeness of your camera to the subject and the level of magnification associated with this genre. Therefore, you'll often be forced to use very small apertures that let in very low levels of light to obtain results with high levels of sharp focus. Here are some things to consider when your aperture is *closed down* (when you have a small aperture setting):

- **Keep your shutter speed in mind.** Shooting with a small aperture setting can increase your exposure time, allowing more time for motion blur to affect your images. Keep an eye on your shutter speed (especially when using the aperture priority mode) to ensure it's not too slow for your subject.

- **Use your tripod.** Using a small aperture often causes your shutter speed to be rather slow. This can make it difficult to achieve sharp results while handholding the camera. Use a tripod to steady your shot.

- **Seek well-lit scenes.** Because small apertures provide a small opening for light to enter through a lens, lowlight scenarios present certain difficulties when using one. Try seeking scenarios with bright conditions or using artificial lighting when necessary. For information on artificial lighting, read Chapter 9.

- **Boost your ISO.** If you can't increase the level of light in a scene, raise your ISO to increase the sensitivity of your camera's digital sensor. Keep in mind that this also increases the amount of *noise* (digital artifacts similar to film grain) your images will have. Newer and higher-quality cameras enable you to shoot at extremely high ISO ratings (such as 1600 to

3200) without encountering a great deal of noise. If you're shooting with an older or lower-quality camera, try using the camera's noise-reduction feature (if it has one) or reducing noise in postproduction.

If you know you'll be making postproduction enhancements to your images, you want to shoot in RAW mode, rather than JPG. Doing so fills your images with more information (or detail) and makes them easier to process on the computer without losing quality.

Using selective focus to drive your message

In certain scenarios, a shallow depth of field works well to draw a viewer's attention to one specific area of an image. This technique is referred to as *selective focus.* It's ideal for pointing out one specific element in a scene while blurring everything else to minimize distractions.

Figure 11-2 provides an example of selective focus in action. Notice how easy it is to see the photographer's message in this image.

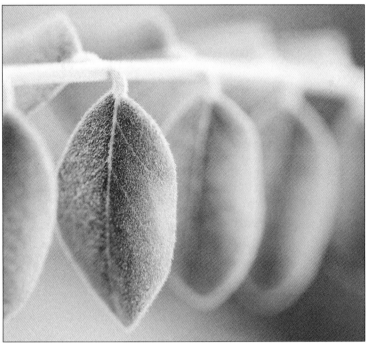

100mm, 1/250, f/2.8, 400

Figure 11-2: Selective focus helps to eliminate distracting elements, drawing maximum attention to what you want viewers to see in a photograph.

You can create a shallow depth of field by getting very close to your subjects, as macro and close-up photography already requires you to do. But you can use a large aperture to really minimize your depth of field, and to truly isolate your point of focus. Some of the benefits of using this method include:

- ✔ **Large apertures are ideal for shooting in lowlight situations.** This exposure setting enables you to use faster shutter speeds (ideal for reducing motion blur), and low ISO ratings (great for minimizing digital noise in your images).

- ✔ **Distracting background elements are blurred when you photograph with selective focus.** This enables you to worry less about what's happening in the background and concentrate more on the subject at hand.

- ✔ **Viewers are attracted to the contrast caused by a sharp element surrounded by blurry elements.** Selective focus therefore causes people to look at your image for a longer period of time.

When working with a shallow depth of field, you absolutely need to position your point of focus exactly where you want it in your frame. Otherwise, it'll be very obvious that you missed your mark. People notice mistakes in composition even quicker than they notice successful executions.

If you're photographing a small animal up close, for example, be sure to get the eyes in focus. If instead you have the neck area in focus, or the ear, people will be distracted and will wonder why you focused where you did.

In a selective focus composition, where you place your focal point is the most important decision you face. In most cases, you place the focus in the area you find to be most interesting, or in the area that makes the most sense to you.

To select your point of focus with precision you can use the manual focusing ring on your lens. This requires you to judge with your eyes to ensure the focal point is placed exactly where you want it. In macro and close-up photography, manual focus is relatively easy because your subjects appear so large in your frame. However, if you prefer to use the auto-focus controls on your camera you can perform this technique to ensure proper focal-point placement: Make sure your lens is set to auto-focus, position your focal point in the center of your frame, press and hold the shutter release button down halfway, recompose your frame and press the shutter release button down all the way. This technique locks focus on the element of your choice even after you readjust the composition.

If your subject moves after you lock in focus and before you take the shot, your focal point may no longer be positioned correctly. Camera movement can also affect your focal point if you're handholding rather than using a tripod. Take multiple shots when using selective focus to ensure at least one of them has a proper focal point that gets your message across.

Photographing Moving Subjects and Avoiding Motion Blur

The ability to freeze the action in a scene is important in macro and close-up photography. The slightest breeze can cause lightweight subjects such as flowers to sway in and out of your frame, and some subjects such as living creatures move quickly and spontaneously. As if that weren't enough, handholding your camera can cause more than enough motion to blur your images.

The first step to ensuring your images have crisp and clear sharpness is using a fast shutter speed (such as 1/250 of a second). The faster your shutter speed, the less motion blur appears in your images.

When you notice movement in a scene, your shutter speed becomes a priority. Most digital cameras offer a *shutter priority* mode (symbolized either by a *Tv* or an *S*). In the shutter priority mode, you can select the shutter speed that's most appropriate for your subject, while the camera automatically adjusts your aperture to expose a scene properly. This is ideal for situations with inconsistent lighting conditions in which you are dealing with movement and you wish to shoot quickly.

Your shutter speed plays a part in determining your overall exposure along with aperture and ISO, so the faster you set it, the less it contributes to the exposure. When dealing with lowlight situations, keep in mind that choosing an extremely fast shutter speed may cause issues. In some cases you may need to slow down your shutter to capture a proper exposure.

Freezing motion with a flash

If you find that a scene is too dim for the shutter speed you wish to use, you need to increase the level of light in order to get the shot. The most efficient tool for this job is the battery-operated flash. A flash is lightweight, easy to use, and a good size for most macro and close-up subjects. (I talk in detail about flashes in Chapter 6.)

A battery-operated flash can help freeze motion in an image. Not only does the flash emit enough light to capture an image with a fast shutter speed, but because the flash emits light for just a short instant, the image captured on your digital sensor represents that short instant, as well.

The maximum shutter speed at which a flash can be synced varies from camera to camera. Refer to your owner's manual to learn the max sync speed of your camera. Find out more about flash lighting in Chapter 9.

Using your shutter speed to emphasize movement in a scene

You normally want to avoid motion blur in macro and close-up photography, but when used creatively, it can provide interest and aesthetic quality to your images. A moving subject depicted in a streaking way helps viewers identify that it's in motion. Moving elements such as water or swaying reeds can provide interesting effects when you apply motion blur techniques to a composition. The key to using motion blur successfully is to do so in a way that adds to your message.

Revealing motion in a subject

To give the sense of movement in a composition, you can select a slow shutter speed (such as 1/15 of a second) when photographing a moving subject. Results vary when using this technique, and you won't always get the shot on your first attempt. Be sure to experiment with different shutter speeds, as the one that works best will vary based on the speed at which your subject is moving.

In most cases you need to shoot multiple images before you capture one that you feel comfortable with. The way a subject moves affects how it looks in your images:

- ✔ If something moves from side to side, it creates horizontal streaks when you photograph it with a slow shutter speed.
- ✔ If the subject moves toward the camera during your exposure, it'll appear to have distorted edges.
- ✔ If the subject moves in various directions, try capturing as many of those as possible, as each will look different in your images.

Creating interesting effects with motion blur

An interesting approach to macro and close-up photography is to select a still subject and include background elements that are moving. By using a slow shutter speed you can alter the look and feel of the subject's surrounding environment while depicting the subject itself in a normal fashion.

In order to set yourself up to use a slow shutter speed, minimize the amount of light entering the lens during the exposure. To do so, you can either shoot in very lowlight scenarios, or do the following:

- ✔ Mount your camera on a tripod and place your focal point on the subject.
- ✔ Choose a small aperture setting (such as f/16), which lets in less light and enables you to use a slow shutter speed.

✔ Use a very low ISO rating to help increase the time of your exposure.

✔ Use a cable release (see Chapter 6) or the camera's self-timer in order to minimize camera shake during the exposure.

Figure 11-3 shows an example of this technique. Notice how the subject's stem is depicted with sharp detail, while some of its feathery limbs blow in the wind and are affected by motion blur.

 If you're using the smallest available aperture and the lowest available ISO but your exposure is still too long for the effect you're trying to achieve, you can use a neutral density filter (see Chapter 6) to block some of the light from entering your lens, or you can use a black flag or piece of cardboard to block some of the light from your scene.

50mm, 2 sec, f/11, 50

Figure 11-3: Moving elements can provide interesting qualities to an image photographed with a slow shutter speed.

When Aperture and Shutter Speed Are Equally Important to Your Message

If you're like me and prefer to have maximum control over your images at all times, keep your camera set to manual mode. The automatic aperture and shutter priority modes are nice to have, but using them too often may make you lazy.

 The more often you shoot with the manual setting on your camera, the better you become at analyzing your results, which in turn makes you better and quicker at choosing the best exposure settings for any scene.

Many situations require you to control both the aperture and shutter speed in order to achieve the compositional results you are looking for. And to prove a point, I shot Figure 11-4 on a windy morning, which shows how altering your exposure settings can represent a scene in extremely different ways. I photographed the first image with a large aperture and a slow shutter speed (using a neutral density filter to cut the brightness of the scene). This caused my depth of field to be shallow, the sunlight in the background to take a rounded, blurry shape, and the subject to be blurred by motion. I shot the second with a small aperture and a fast shutter speed, which caused my depth of field to be greater, the sunlight to take the shape of a sharp burst, and the subject to be still.

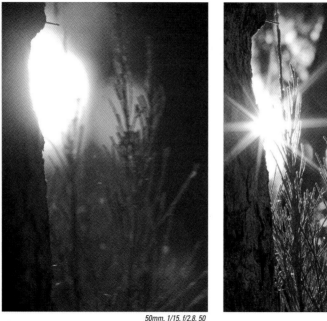
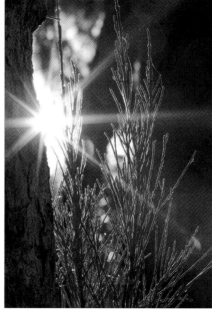

50mm, 1/15, f/2.8, 50 *50mm, 1/250, f/11, 800*

Figure 11-4: Changing your exposure settings can have a drastic effect on the outcome of an image.

Below are some scenarios in which you might need to have control over both your aperture and your shutter speed:

✔ **When your subject is in motion and your background is distracting,** you want to select a fast shutter speed to freeze the action, and a large aperture to blur out the background by using a shallow depth of field.

✔ **When your subject is in motion and your background contains elements of interest,** use a fast shutter to freeze the motion and a small aperture in order to include the background details through a greater depth of field.

✔ **When you wish to include motion blur as a creative tool in an image and also want to include background detail,** you can select a slow shutter speed based on how much blur you'd like to include then select an aperture that suits the amount of sharp detail you want.

✔ **If you're handholding the camera,** you generally want to use a quick shutter speed to minimize camera shake during your exposure. Therefore, any time you handhold the camera and want to manage how much depth of field an image has, you need control over your shutter speed and aperture.

✔ **When using an artificial light source (such as a flash) in combination with natural light,** your shutter speed and aperture each affect your exposure differently. Chapter 9 gives you details about shooting with artificial and natural light.

In situations that require a specific aperture and shutter speed to provide the compositional results you want, you need to adjust your camera's ISO to achieve the appropriate exposure.

Adjusting your ISO

Aperture and shutter speed are both important in determining the look of an image, but they can't always be relied on for providing the exposure you want.

A composition that requires a large aperture and a slow shutter speed lets in a lot more light than one that requires a small aperture and a fast shutter speed. Your camera's ISO setting helps to bridge the gap between these two scenarios.

As I show you in Chapter 6, ISO determines the sensitivity of your camera's digital sensor. A low ISO (such as 50) causes the sensor to have a slower, but more reliable reaction than a high ISO (such as 3200). When I say that the low ISO is more reliable, I'm talking about the quality of the image it produces in comparison to the higher ISO.

Use a low ISO when a scene has adequate light based on your exposure settings. This produces an image with minimal *digital noise* (red, green, and blue specks found in digital images, similar to film grain). If a scene lacks adequate light for your exposure settings, you need a high ISO. This produces an image with a more visible digital noise.

As your camera's sensor becomes more sensitive to light, it becomes more likely to pick up digital noise in the process. Noise appears mostly in an image's shadow areas. Figure 11-5 shows the difference between an image taken with a low ISO (left) and one taken with a very high ISO (right). Notice how detail is lost in the darker areas in the image on the right, and how the color appears distorted.

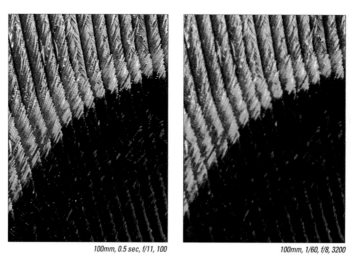

100mm, 0.5 sec, f/11, 100 100mm, 1/60, f/8, 3200

Figure 11-5: A high ISO can produce a proper exposure in lowlight situations, but comes at the cost of digital noise in your images.

Each of the three exposure settings on your camera has its own effect on the look of your images. Aperture determines depth of field, shutter speed determines how motion is depicted, and ISO determines the level of noise. Consider all three of these factors choosing the combination of settings for a specific scene.

Manipulating your exposure with artificial light sources

In some cases, you just don't have enough light in your scene to accommodate the aperture and shutter speed settings of your choice without causing you to resort to a very high ISO (and therefore a lot of digital noise). To keep the freedom of selecting the exposure settings of your choice, you can always brighten a scene with an artificial light source such as your flash or a strobe (or any of the light sources I talk about in Chapter 9).

The battery-operated flash is an ideal artificial light source for macro and close-up photography because it's lightweight, small, and lets you control how much light it emits. Having control of the flash's level of brightness is important; this feature enables you to add just enough light to a scene to manage a perfect exposure at the aperture, shutter speed, and ISO of your choice.

Rather than changing your exposure settings to meet the needs of a certain scene and its level of brightness, you can select the exposure settings that work best to convey your message, and then illuminate the scene in the proper amount to work with your exposure settings. To do this you need to become familiar with your battery-operated flash. Refer to your owner's manual to find out how to increase and decrease its level of brightness.

If you use a *TTL sync cord* (an accessory that enables your flash to automatically emit the proper amount of light based on your camera's settings and the flash's distance to the subject) to synchronize your camera and flash, you don't have to worry about setting the power levels manually. Be sure that your camera, flash, and TTL sync cord are all designed to work together. Otherwise, the flash's ability to read the camera's settings is disabled.

If you don't own a TTL cord, you can synchronize the camera and flash with an ordinary sync cord, or with wireless transceivers. In this case, you're responsible for setting the flash's power levels manually. You can do so with a light meter by testing the output of the flash and adjusting its power to match the aperture of your choice. If you don't have a light meter or don't know how to operate one, you can always use the trial and error method to create a perfect exposure. To do so, set up your flash, sync it to the camera, take a shot, analyze the results on your camera's LCD display, and determine whether you need to raise or lower the power of your flash. Repeat this process until you get the results you prefer.

As I tell you in Chapter 9, your aperture (and not your shutter speed) determines the effect a flash has in an image. A larger aperture lets in more light and requires a less intense flash than a smaller aperture requires. After using your equipment a few times you should become familiar with which flash settings work best for a particular aperture setting.

Shooting at the appropriate time of day based on your exposure settings

You may choose not to use artificial light sources in your macro and close-up photography. Maybe you don't like the quality of light you get from a flash, don't own one, or just like to keep things natural.

The most natural approach to photography requires the long lost art of patience. If you come across a subject that you want to photograph but the lighting isn't quite bright enough for your preferred exposure settings, then you may have to come back at a different time of day to avoid resorting to a very high ISO (resulting in high levels of digital noise).

If your subject is in an area of shadow and is too dark to photograph with your preferred exposure settings, analyze your surroundings to determine whether the sun will be making an appearance any time soon. You might have to wait a few minutes or even hours, depending on the situation. Or you may determine that the sun is positioned best for your subject earlier in the day and that you need to come back the next day to get the shot.

If the weather itself is causing a scene to be lit improperly based on your exposure settings, you may have to come back another day when the sun is shining. Earlier in this section I mentioned that the settings you use to photograph a scene can make all the difference as to whether your message gets across or not. Having patience and returning another time to get the shot you want can be very rewarding and can provide the opportunity to say you did it your way.

Part IV
Techniques for Shooting Subjects of All Types

The 5th Wave — By Rich Tennant

"I was told to always use a sturdy tripod when shooting close-ups."

In this part . . .

*T*aking a close-up of a human subject is much different from photographing a tiny insect. Different scenarios call for different equipment and techniques. In this part of the book you find tips on photographing macro and close-up subjects in nature, taking close-up portraits of people, shooting small products and still-life subjects, creating beautiful images of jewelry, and exploring the usually overlooked world of tiny subjects. I also show you how to improve your macro and close-up images in postproduction.

Macro and Close-Up Photography in Nature

The natural world is home to limitless macro and close-up photographic opportunities. Whether you wish to document new species in the rain forest, find interesting subjects to photograph right in your own backyard, or create detail shots for a photo essay you're working on, this chapter helps you prepare for and accomplish your goals.

I show you how to spot interesting details in seemingly ordinary scenes, and how to turn those interesting details into beautiful images. You find out which tools are absolutely necessary for macro and close-up photography in nature, and which tools are handy to have around. Plus, I give you ideas for creating photographic opportunities and the dos and don'ts for staging shots in nature and manipulating natural subjects.

Finding Inspiration at the Crack of Dawn

The very beginning of the day has a certain energy to it that's experienced only by those willing to be present for it. As light enters the sky, details that were concealed by shadow are uncovered and everything seems new.

Flowers begin to wake up, spiders' webs are in perfect condition, and nobody has walked on the grass. Living creatures start to go about their routines as the weight of the night is lifted, and if you're lucky, dewdrops are present, providing interesting photographic opportunities everywhere you look. Being up and prepared to photograph at this time can enable you to capture things that are unavailable at any other time of day.

A photographer might wake up early in the morning to photograph the sandy beach before it has footprints all over it. As a macro and close-up photographer you can have the same motivation for being the first to reach your destination. Get there before the wind arrives, making it difficult to achieve focus on your swaying subjects. You want to have your composition set up on a flower waiting for it to bloom with the light's arrival. This way you can capture the moment at which it looks best.

The day's first light represents an ideal time for nature photography. This is especially true for macro and close-up photographers. Not only does the early morning offer beautiful lighting, but it also reveals the beginning of the daily cycle and enables you to photograph scenes that haven't yet been disturbed by humans.

The results you get from taking advantage of these aspects of early morning photography will make you glad you set your alarm.

Early morning light

The light created at dawn is ideal for photography because of its soft quality and subtle directionality. This type of light seems to wrap around subjects, producing a three-dimensional look with a level of contrast that's easy to work with (meaning images have detail in the shadow and highlight areas when exposed properly).

You can take advantage of this beautiful, soft light, but remember that there's not much of it. You need lengthy exposures (so bring a tripod), and the lighting changes very quickly at this time of day because it's a transitional period. If you want to use the dawn lighting, work quickly enough to capture some shots before the sun breaches the horizon. Figure 12-1 shows a subject photographed at dawn.

When the sun comes up you're greeted by a whole different kind of light that works great for photography. Sunrise light is ideal for revealing texture in scenes and subjects because it comes from low in the sky and so provides great opportunities for side lighting. Take advantage of the sunrise by including the long shadows it casts, by creating dramatic images with high contrast between light and shadow areas, and by showing the warmth of the day's first light as it touches a scene for the first time.

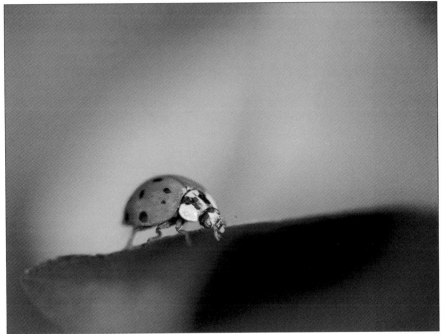

100mm, 1/250, f/2.8, 640

Figure 12-1: The soft light created at dawn is ideal for producing images with a quiet message.

The pristine quality of sunrise light typically lasts about fifteen minutes to a half hour depending on the time of year and your location. After it passes, you're left with a sunlight that's similar to the light at sunrise in direction and brightness but with less warmth in its color. This type of light is great for photographing just about anything and can produce beautiful images, but it lacks the freshness of sunrise and is less ideal for side lighting. The best thing about this light is that it sticks around for at least an hour or two. Of course it changes slightly as the sun rises in the sky, but the look of your images will remain consistent within this time period.

When the sun gets very high in the sky it lights everything from above, casting undesirable shadows. When you notice that the sun is too high to produce nice direction of light and shadows in your images, refer to the techniques in Chapter 8 for enhancing and manipulating natural light.

If you're not a morning person, you can achieve a very similar photographic experience by going out at the end of the day rather than the beginning. Keep in mind that the order of events is reversed in this case, and you most likely won't have any dewdrops in your scenes. One trick is to carry a small spray bottle with you to create your own dew whenever and wherever you want it.

Elements that add to your message

Certain elements present in the morning help reveal the time of day in your images and so lend a sense of narrative to a photograph that causes viewers to read into it.

One of the main giveaways that an image was photographed in the morning is the lighting. But many other elements add to your story:

- **Dew** is one of the best friends a macro and close-up photographer can have. It can add interest to just about any subject, and it helps viewers pin a time of day to your image. When photographing a subject with dewdrops, pay attention to the reflections in the water itself. Not only can dew help give a sense of time in a photograph, but it can also help to reveal bits of the surrounding environment. Notice in Figure 12-2 how some supporting elements that were not included in the composition appear in the dew's reflections. Using dew like this can work as a more interesting way to reveal information about a subject.

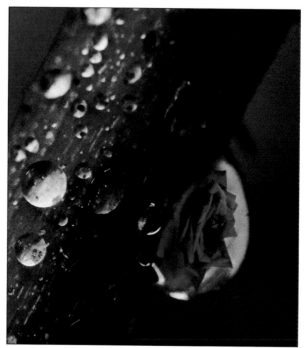

100mm, 1/15, f/8, 800

Figure 12-2: Reflections in dewdrops can reveal information about a subject's surrounding environment.

✔ **Frost** is the frozen version of dew. It doesn't work as well for showing reflections, but it makes for an interesting complement to most subjects, giving a sense of cold and crispness. Apart from telling the time of day, frost can reveal information about a subject's whereabouts, telling viewers the photograph was taken in a cold climate, or on a mountain, or during winter. Waiting for the frost to melt from direct contact with sunlight can produce out of the ordinary opportunities for a macro and close-up photographer.

✔ **Mist** in the air sometimes occurs in the morning (caused by evaporation from the cooling ground surface during the night, or warm air passing over a cool surface such as snow or ice). This provides soft, low-contrast scenes with muted colors and a sense of dreaminess. The farther a subject is from your camera, the less visible it becomes. This creates an opportunity to make your subject stand out the most (by having it closest to the camera) while elements in the background gradually fade. Figure 12-3 shows an example of this type of composition.

50mm, 1/200, f/4, 200

Figure 12-3: Early morning mist can give a soft and low-contrast look that helps to make your subject stand out from the background.

The early morning represents a transitional period. Get there before the changes take place to capture interesting shots, like the perfect imprints left in the sand by a bird, or a raccoon, before they're destroyed by human footprints or covered by the wind. By removing a leaf from a dewy scene, you're left with the dry area in the shape of the leaf, which went unaffected by the build-up of moisture. Figure 12-4 shows an example.

TIP

If you're in nature, and photographing macro and close-up subjects in the middle of the day, then your lighting won't produce results as flattering as the early morning (or late afternoon) light will. The sun is most likely very high in the sky, causing harsh shadows that are cast straight downward. This can work fine in some cases (depending on your subject's position and your camera's position), but generally the light produced in the middle of the day is not the best for creating beautiful photographs. Refer to Chapter 8 for information on enhancing natural light to give it the look you want.

50mm, 1/250, f/8, 200

Figure 12-4: The dry area in this image tells the story of what used to be.

Photographing in Nature During the Midday Hours

If you've outlasted the morning light, or you just happen to set out photographing in the middle of the day, then you may have a more difficult time finding light that has the direction or the quality you'd like. The sun rests high in the sky for a good portion of the day, beaming straight down on your subjects in a way that's most likely unflattering.

Fear not, though, because a well-equipped photographer with knowledge of *key shifting* (techniques designed to alter the direction, quality, and intensity of your natural key light source) can create beautiful macro and close-up images at any time of day.

Advantages to shooting macro and close-up images at midday

In Chapter 6, I explain that magnifying subjects through macro and close-up photography causes a loss of light to occur, increasing your exposure times, ISO ratings, or aperture size. Because the middle of the day is typically the

brightest portion of the day, capturing images with the exposure settings of your choice should never be a problem (unless you're photographing in a dark, shadowy area). Because shadows aren't as long in the middle of the day as they are at the beginning and end, you should easily be able to find areas with bright conditions to work with.

Another advantage to midday shooting is that the light tends to remain consistent for longer periods of time. In the beginning and end of the day, light color, quality, and direction change rapidly as the sun rises or sets. Once the sun reaches a higher point in the sky, it produces a consistent color, quality, and intensity (assuming it's a clear day).

Try out the techniques in the upcoming section "Handy items for enhancing the light" when shooting macro and close-up subjects at this time of day. Doing so helps you create fairly consistent lighting for your images for hours, depending on the weather. This way, if you find a lighting style that you're interested in working with, you can practice it on various subjects as you go about your day.

Handy items for enhancing the light

The ability to enhance the daylight to suit your subjects is entirely dependent on having the right tools for the job. You can find a list of the available tools in Chapter 6 and the techniques for altering natural light in Chapter 8. The purpose of this section is to inform you of the specific tools and techniques that work best in the field, assuming you don't wish to bring your entire studio with you on a nature hike.

By carrying a small amount of extra gear, you can ensure your images will always have the lighting of your choice. Here's what you need:

- A **scrim** can be used to diffuse the quality of sunlight, creating softer shadows in your nature scene. This tool is placed between the subject and the sun and can be made from any material (such as a white cloth) that allows light to pass through. A thicker material provides more diffusion than a thinner material. Small diffusion discs are available for purchase at most photo equipment outlets; they can be folded down to a very small size and are very lightweight.

- A small piece of black foam core can be used as a **black flag** to block the sunlight from your scene.

- If you're not happy with the sunlight's direction in a particular scene, then change it. A small piece of reflective material enables you to redirect sunlight, creating the key light direction of your choice. This is know as a **reflector,** or a **bounce card,** and can be used in conjunction with the black flag to shift your key light. Simply block the sunlight with the black flag, and bounce it into your scene from the direction of your

choice with the reflector. A small, lightweight, retractable reflector can be purchased at most photo supply outlets, or you can make your own from a small piece of white foam core, a mirror, or any shiny surface material.

✔ Similar to the reflector, a small **battery-powered flash** can mimic the sunlight. One advantage to the flash over the reflector is that it provides just as much light in cloudy conditions as it does in sunny conditions. You can use your flash to create the appearance of sunlight even when there is no sun to work with.

Figure 12-5 shows the differences between a scene that was photographed in the middle of the day using available light, and using key-shifting techniques. In the image on the left, the direct sun at high noon causes unflattering shadows in the image. By blocking the sunlight with a black flag and using a reflector to create a new direction for the sun, I was able to create a more flattering image.

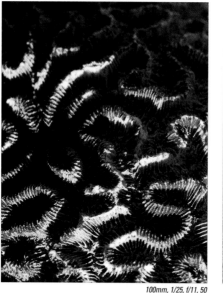 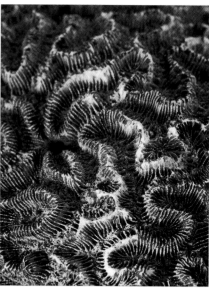

100mm, 1/25, f/11, 50 100mm, 1/25, f/11, 50

Figure 12-5: Key-shifting techniques create a nicer light in the middle of the day.

Being Prepared for Anything

When setting out to take macro and close-up photographs in the natural world, you're sure to come across certain obstacles. Your subject might be in a tight spot that your tripod isn't capable of reaching, your subject may

be swaying in the wind, making it difficult to place a focal point on it, or your subject might not be open to letting you shove your lens in its face.

Whatever the case, this section's purpose is to help equip you for overcoming these obstacles without overpacking your camera bag, and to help you get the shots you want in nature.

Equipment list for dealing with the elements

As someone who's been there, and continues to go there, I assume you prefer to pack light when setting out on a nature shoot. Considering most essential photo equipment (such as the camera body and lenses) is made of heavy glass and metal, there's not much more you wish to add to the gear list.

Here's a list of items to consider that should help you pack for success, without putting the last straw in your camera bag:

- A **versatile tripod** is essential for avoiding limitations as to which shots you're capable of getting. Chapter 6 discusses various tripod head and leg options, including the features associated with each. Ensure that you bring a tripod into nature that's stable, small, and lightweight. You want one that enables you to get down very low to the ground, legs that you can stabilize on uneven terrain, and good height variation.

- **Flexible tripods** are a lightweight alternative to typical types of tripods. These are made with joints that enable you to bend the legs for positioning into extremely uneven areas, or for wrapping around trees or rocks. Flexible tripods are great for traveling and for creative or improvisational camera stabilizing techniques, but they aren't as sturdy as normal tripods, and may not keep heavier camera models as still as you would like. In any case, you can use flexible tripods to position other pieces of equipment, such as propping a flash to a tree, or hanging a scrim above your scene.

- A **right-angle viewfinder** is ideal for viewing scenes through a camera that's very low to the ground. It enables you to look through the camera from above rather than getting down on the ground with it.

- **Bendable wire** is very lightweight and easy to store. You can use it to prop small scrims and black flags, or to temporarily reposition small branches and plants to better suit your composition.

- **Clamps** work well for holding things in place (such as scrims, black flags, or reflectors), or temporarily holding distracting elements out of the way. When combined with a tripod socket, clamps can be used to position a flash anywhere that the clamp can be fixed to.

Diversifying the capabilities of your lens

Subjects in the natural world have varying tendencies, requiring various photographic approaches. What enables you to get the shot for one subject may not be appropriate for another.

For instance, a 50mm macro lens requires you to get very close to your subjects to capture a 1:1 magnification ratio. You can capture beautiful detailed shots of spiders in their webs with this lens, but a lizard isn't likely to let you get close enough to do the same. Instead, you need to use a lens (or lens accessories) that enables you to capture the same level of detail from farther away.

To diversify your macro and close-up abilities, you can carry multiple macro and close-up lenses (with varying focal lengths and magnification abilities) into nature with you. But doing so can be expensive and potentially heavy. Instead, bring accessories that enhance the abilities of your favorite lens.

Here is a list of the accessories to bring and the results they provide:

- **Tele-converters** are secondary lenses that you place between the camera body and your lens. They increase the magnification of your subject without requiring you to move closer to the subject. Tele-converters are ideal for creating macro and close-up shots of subjects that scare easily, or those in hard-to-reach areas. They come in varying magnification levels but cause *aberrations* (flaws in image sharpness) at higher levels. Keep in mind the higher the magnification, the lower the overall quality of sharpness in your image.

- **Extension tubes** are hollow tubes that you fix between your camera body and lens. They enable you to achieve focus on subjects at closer distances. Because these don't contain any glass optics, they don't decrease image quality in the way that tele-converters do. A 50mm extension tube combined with an ordinary 50mm lens can provide a 1:1 macro level of magnification. A 25mm extension tube combined with a 50mm lens provides up to a 1:2 (or half-size) magnification level. You can combine an extension tube to your fixed macro lens to increase its magnification abilities to beyond 1:1 (or greater than life-size). Keep in mind that extension tubes require you to move in closer to your subjects in order to increase magnification.

- **Close-up lenses** (or filters) are accessories that you can attach to the front of your lens. Similar to extension tubes, these enable you to achieve focus on your subjects at closer distances in order to increase magnification levels. Unlike extension tubes, however, close-up filters use glass optics and therefore decrease the quality of sharpness in

color (mostly blue, violet, white, and yellow) of certain flowers. Patience is a key factor in capturing great shots of bees, as they tend to move very quickly and spontaneously. The only time a bee seems to become still is when it's inspecting a flower to find pollen.

By paying attention to the flowers the bees are going to, you can choose a spot and wait for a bee to come to you, rather than trying to chase the bee (making it less likely that the bee will be scared off by your presence). This tactic enables you to set your camera on a tripod, compose your shot nicely, manually position your point of focus (based on where you expect the bee to land), set your aperture and shutter speed properly, and take the shot when a bee settles in its place.

Take multiple shots while the bee is present, while looking through your viewfinder, shifting your point of focus and observing its effect on the bee. The goal is to capture an image in which the eyes are your main point of focus. This can be difficult and may require a few tries.

To capture a bee in flight is even more difficult in regards to getting it in sharp focus. Use a very fast shutter speed. You may have better luck stalking the bee rather than waiting for it to come to you. This means you'll be hand-holding the camera and most likely relying on auto focus to manage your focal point. Shoot several frames and hope that your trigger finger is a match for the speed of a bee in flight.

Flies

Flies are very similar to bees in that they can be spontaneous and scare easily. Perhaps the best way to attract a fly is with a dab of honey (or some tasty treat).

The fly's eyes seem to be the main point of interest in most macro and close-up photography. This is because of the interesting patterns and colors within them. Maximizing magnification enables you to emphasize this detail, so it may be best to use a macro lens that's more on the telephoto side (100mm and above), paired with a tele-converter (see Chapter 4) when photographing flies.

Butterflies

Butterflies move more quickly when it's warm out. Try photographing them early in the morning to catch them when they're moving a bit slower than normal (or you can go out on cooler, overcast days for a similar result).

If the sun is out, try to avoid casting your own shadow on a butterfly. This can cause it to fly away to another spot since butterflies are fond of the sun.

your images. The greater the level of magnification, the less sharp your images will appear.

✔ **Reversing rings** can increase a lens's ability to create macro and close-up images. You use them to fix a reversed lens to your camera, altering the way the lens produces an image to the camera's sensor. When reversing lenses, remember that reversed wide-angle lenses produce the most magnification, and reversed long lenses provide the most flexibility in magnification possibilities. (See Chapter 4.)

Seeking and Photographing Natural Subjects

Nature provides many elements that are suitable for macro and close-up photography, such as insects and other small creatures, flowers, plants, foliage, berries, water, snow, textured surfaces, spider webs, and much more. Some of these elements may be readily available in your area, while others are more difficult to find. A certain level of knowledge or discipline could be required to capture great macro and close-up shots of some elements.

This section discusses some of the possibilities for finding and photographing living subjects in nature.

Working with living creatures

The types of living creatures available for photographing depends on where you live. Some types are easier to work with than others in that they're less finicky and more willing to cooperate with the camera. The best way to learn tendencies of a certain type of subject is to spend time photographing it, gaining firsthand experience. Consequently, here is a list that may help get you started.

When photographing living creatures that have a tendency to move, it's usually a good idea to use a flash (mounted to a bracket or positioned off-camera) or a macro-specific ring light. Doing so lets you use a fast shutter speed in any lighting conditions, and the pop of the flash helps to freeze the motion of your subject. For more on flash lighting, read Chapters 6 and 9.

Bees

Bees can most likely be found on warm, sunny days and in the vicinity of flowers as they are an essential factor in pollination and are attracted to the

Be patient with these creatures. Just like bees, butterflies will go from flower to flower in search of nectar. If one flies away from you, realize it won't go far from the flowers it's feasting on. You can either wait for the butterfly to come back to your area, or slowly make your way to the new batch of flowers it's found.

A monopod comes in handy for subjects that move quickly and often. It gives more stability than handholding a camera, and it enables you to change your camera angles and positions easily.

Dragonflies

Dragonflies are a wary bunch, but some species become very trusting if you have the patience to earn it. If you begin photographing a dragonfly from a distance and slowly move closer, it may become comfortable with your presence and allow you to move in for a macro shot without flying off.

The easiest way to get shots of this type of creature is to locate a group of dragonflies. This way you have options and can choose one that's resting rather than one that's moving around swiftly.

Search in areas near water to find dragonflies, or in areas with varieties of plants, such as a botanical garden, or even your own backyard.

Ladybugs

Ladybugs are very small, so you usually need to get in very close to get good photographs of them. Even a 1:1 ratio will leave plenty of space in your frame surrounding a ladybug.

These bugs are pretty hard to scare off, which makes them an ideal subject for macro and close-up photography, and they can be found early in the summer in most areas. They prefer climates that aren't too dry and areas with abundant plant growth. Wheat and cornfields are home to many ladybugs, or any crops that are known to have aphids.

The morning sun warms aphids and they immediately begin to munch on plants. The ladybugs are close behind to munch on the aphids. This is a great time to capture ladybugs in photographs, and if you're lucky you might even catch one taking a sip from a dewdrop.

Praying mantis

Mantids are typically found in tropical climates, but some species are found in cooler climates as well. (I remember seeing a few praying mantises in New Jersey as a child.)

These guys usually look very similar to their surroundings, making them difficult to spot but awesome for photographing. They don't move too quickly, and don't scare off that easily. So, if you're lucky enough to find one, you should have an easy enough time getting some shots of it.

Try to tell the story of a praying mantis when photographing it. For instance, by composing a shot in a way that the creature blends into its surroundings, you reveal how well its camouflage works. By including another insect in the same frame, you show the purpose for the praying mantis's camouflage. They are predators, and if you're really lucky (or patient), you'll capture a shot of the predator catching its prey.

Ants

Ants are easy to find but not as easy to photograph as you might think. They're almost always on the move, making it difficult to compose the frame of your choice or to position your point to focus exactly where you want it.

Some tricks for photographing ants include:

- **Taking many images.** When a subject is moving in macro and close-up situations, it's difficult to lock down your focus exactly where you want it. Be swift in achieving focus and snapping the shot, giving little time for error in between. I captured Figure 12-6 with precise, sharp focus on the ant's eyes, but there were at least 15 outtakes in which this was not the case.

- **Finding the entrance to their nest and staking it out.** By doing so, you can tell something about an ant's life through your image and take advantage of a rare moment in which an ant actually stays still. Some ants will pause for an instant after exiting their nest. Maybe they're affected by the brightness of the outside world and need a second to adjust. This is a great time to get your shot.

- **Enticing them with a tiny drop of honey.** Nobody (especially not an ant) turns down a free meal. A drop of honey or something similar will buy you some time to capture a sharp image of an ant that is relatively still. You can also seek out scenarios in which ants are feeding on natural sources of food, such as plant nectar.

- **Going with the flow.** This technique helps to tell the story of how ants work and move about. Some ants march in lines, following each other's scent trails, collecting food and bringing it back to the nest. This provides a continuous shooting opportunity that's interesting and informative. You can also capture the chaos of some ants as they are treading over each other in a frantic group, trying get at some sort of food supply.

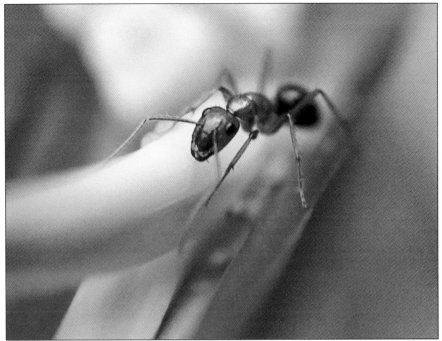

100mm, 1/160, f/4, 500

Figure 12-6: Take a bunch of shots when dealing with moving subjects to ensure your point of focus is dead on in at least one of them.

Frogs

You can find many species of frogs, with many different behaviors. Perhaps the best way to know what's available to you is to research the local frogs in your area. Some frogs are found down by the water, and can be seen in the daytime, while others are found in trees and mostly at night.

You can usually find frogs after a good rain. They work as excellent macro and close-up subjects as long as you don't make any sudden movements to scare them off.

When photographing frogs at night, bring a tripod, a flash (or a ring light) and a flashlight. You can use the flashlight to spot the frogs, and to achieve focus on them. Then use the flash to light them. I captured Figure 12-7 at night, and I was able to achieve focus exactly where I wanted due to the light from my flashlight. By using a flash, I was able to get the shot with a fast shutter speed, ensuring no sign of motion blur.

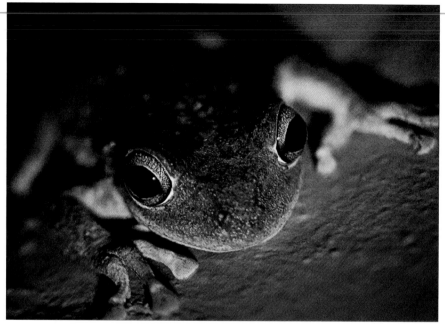

100mm, 1/60, f/2.8, 800

Figure 12-7: A flashlight helps you achieve focus in a nighttime scene.

The early morning works as a good time to photograph frogs by a lake or other body of water. Frogs breaching the surface by the water's edge make for interesting subjects. To capture these you need a longer macro lens (100mm or higher), and perhaps a tele-converter to optimize magnification from longer distances.

Lizards

When photographing lizards, you most likely want to keep some space between you and them. They scare off easily (depending on the type), so consider using a longer macro lens combined with a tele-converter. Doing so enables you to get in close without having to actually get in close.

Move slowly when approaching lizards, capturing shots from farther out and making your way in for the close-ups. If you move slowly you should be able to get fairly close, but be careful: A lizard that sees its own reflection in your lens might launch an attack.

You can find these creatures sunning themselves in pretty much any area that has a thriving insect population. They are most likely to hang out above ground in months that are warmer, and on sunny days.

Snails

Snails are an ideal macro and close-up photographic subject because they're one of the slowest moving creatures on Earth. This gives you some room to work with slower shutter speeds, and it's easy to place your point of focus and set up your composition.

Snails are most often found at nighttime or in heavily shaded areas. When photographing snails, be prepared with a flash (or a ring light) and a tripod. The tripod mainly helps to free up your hands so you can hold a flashlight while achieving focus, or hold the flash in the position you want it during the capture.

Consider the fact that snails have a slimy, reflective surface when positioning your light. By placing the flash very close to the snail, you'll achieve bigger highlights on the reflective areas. By moving it farther away, you'll get smaller highlights.

Spiders

Spiders make for very interesting subjects, both in and out of their webs. You should have a fairly easy time getting close to a spider in its web, but on the ground they may be a bit less approachable. By using a longer macro lens with a tele-converter you can keep a safe distance, and a flash (or ring light) helps to freeze the motion of a spider on the move.

When photographing a spider in its web, be cautious of the wind, as it will blow your subject in and out of your plane of focus. This can become very frustrating after a few attempts to lock focus on your subject.

The best way to photograph spiders in webs is to do so when there is no wind. But if you see something you really want to shoot, and it happens to be windy, you can attempt to block the wind with a piece of cardboard or foam core attached to a light stand. (Refer to Chapter 6 for information on tools you can use in the field.)

Because the spider's web tends to be delicate and difficult to see in some scenarios, be aware of your background when composing a shot of a spider. Dark backgrounds help to make the web more visible. The background in the first image in Figure 12-8 blends in with the spider's web, and so the web barely shows up. I chose my camera angle to maximize the web's visibility in the second photograph.

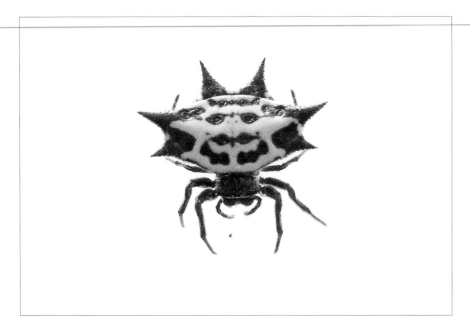

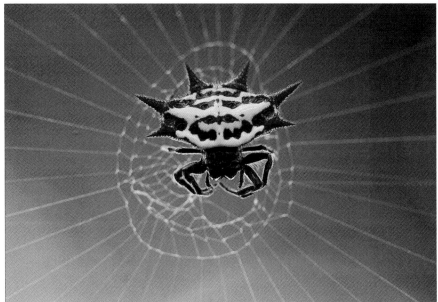

100mm, 1/160, f/8, 800

Figure 12-8: Avoid distracting backgrounds, as they make it more difficult to see the spider's web.

Flowers and plants

Flowers and plants are commonly used as subjects in macro and close-up photography, and rightfully so. In many cases flowers and plants depend on their attractiveness for reproduction. So it's only natural that photographers are attracted to them when looking for something to photograph.

Flowers and plants in nature are typically cooperative subjects, being that they don't move very fast on their own, and they can't be scared off like living creatures can. The main issue you come across when photographing flowers and plants is their tendency to sway in the wind. The best way to avoid issues with wind is to go out shooting at times when there is no wind. Going out early in the morning can usually buy some time before the wind starts to become an issue (depending on where you are shooting).

You can prepare yourself for blocking slight amounts of wind by bringing a light stand, a piece of cardboard or foam core, and clamps to hold the board to the stand, but if the wind is heavy, then you may want to try coming back another time when it's calmed down.

Lighting is the most important factor in creating beautiful images of flowers. Most photographers use a soft light to accentuate and emphasize the delicate nature of a flower itself. Generally the early morning and late afternoon provide excellent light to photograph with, but if you find yourself shooting in the middle of the day, certain techniques optimize light based on your subject, and what you wish to say about it. Chapter 8 provides a compete guide to working with natural light to get the look you want.

Figure out what most interests you in the subject to determine what kind of lighting suits your message. If the plant has interesting texture and form, then sidelight is ideal. Figure 12-9 shows an example. If the plant has delicately shaped leaves, soft light is a good choice, as you see in Figure 12-10. To create a dramatic look for a plant, a lighting situation that's high in contrast is appropriate. For information on manipulating daylight, refer to Chapter 8, and for information on creating your own light by combining artificial light sources with daylight, refer to Chapter 9.

Plants often look healthy and fresh in the spring or early summer months. It's usually a good idea to photograph plants on the first sunny day after a good day or two of rain has passed. This is when they really show their color and liveliness.

100mm, 1/250, f/8, 400

Figure 12-9: Side lighting helps to reveal a plant's interesting texture.

50mm, 1/40, f/8, 1600

Figure 12-10: A soft light quality works well when photographing plants with delicately shaped leaves.

Taking advantage of available resources

Walking about and waiting for things to jump out at you is one method to capturing macro and close-up shots of natural subjects, but if you prefer to have more control over your destiny, then there are some ways to ensure you have the specific opportunities you want.

By doing some research and finding out what's available in your area, you may find that you can gain access to exotic and interesting subjects for a fee. The resources in your area can include botanical gardens that grant you access to a variety of flowers, plants, and wildlife for a small entrance fee or a membership fee. You can find these gardens all over the country, and even in metropolitan areas, providing natural macro and close-up opportunities to photographers who are surrounded by urban environments.

One downside to botanical gardens is that you have to go by their hours of operation. This may keep you from getting those shots at dusk or dawn, but make the most out of the situation and get in there as early as possible or try to stay up until the very last minute.

Some other options to look into are whether your area has a butterfly garden, a zoo, or an aquarium, and to see what nature hikes are available to you. Find out whether there are any gardening clubs in your area. The members most likely have a treasure chest of species to photograph and would be happy to receive beautiful close-ups of their prized flowers and plants.

There are certain companies that take in exotic creatures that are unwanted by their previous owners or have been injured in the wild. In some cases these companies will bring the creatures into classrooms to provide a close-up experience with them to the students. You can hire the company for a similar experience, which enables you to photograph exotic insects, reptiles, spiders, and whatever else they have available in the presence of a knowledgeable handler who informs you of just how close you can get to each creature and how to approach them.

This can be a bit pricey, but it provides a unique opportunity and a great experience. If you know of other photographers in the area, or are a part of a group or class, perhaps you can convince everyone to pitch in and make it a group experience to lighten the cost.

With direct access to these subjects it's easier to spend quality time getting out-of-the-ordinary shots, and you can even stage shots based on a concept you've wanted to try, or a stock photo you've been looking to create.

Close-Ups of People (And Other Animals)

A *close-up* — a portrait in which your image is cropped in tight so that the subject takes up most or all of the frame — is a crafty tool in a photographer's bag of tricks. Camera-shy subjects dread close-ups. Part of the success of a close-up portrait relies on trust between the subject and the photographer. People generally don't like to have a camera too close to them, for the fear that the image will reveal too much. This chapter explains ways to earn the trust of a subject so they are as excited about creating interesting shots as you are.

The rest of a close-up portrait's success relies on technical abilities and decisions that you make. Read on to gain a working knowledge of close-ups that are guaranteed to please.

Knowing When to Shoot a Close-up Rather than a Typical Portrait

A good portrait can tell many things about a person by revealing her expression, the details in her surrounding environment and background, and by the

design elements in the image. A close-up portrait can also tell a lot about a person, but it focuses on specific details to tell a story.

By leaving certain elements out of a frame, you can produce detail-oriented images with clear messages and interesting compositions. The close-up portrait is an ideal photography method for drawing attention only to what you want people to notice in an image. If your entire message can be told in the subject's eyes, then why include anything else in your frame? If you're most interested in the texture of someone's skin, instead, then move in close to capture that detail.

Close-ups can be used for:

✔ **Headshots:** A head-shot is a tightly cropped portrait meant to show a person's facial features and attributes. It can be used in conjunction with an actor's resume or on the front of a model's or dancer's comp card. This type of portrait is either cropped to show the head and shoulders, or cropped into the face and head in order to reveal the facial features prominently. Figure 13-1 provides an example of a headshot.

100mm, 1/160, f/5.6, 100

Figure 13-1: A headshot is a portrait that frames mainly the subject's face.

✔ **Intimate portraits:** An intimate portrait (in regard to close-up photography) is one that reveals personal, delicate, or special details about someone. This can be the wrinkles on a person's face, the point of contact between two body parts (such as licking the lips), or a tear in someone's eye. Figure 13-2 shows an intimate portrait of a woman brushing her hair aside with her fingers to have a necklace unfastened.

100mm, 1/160, f/2.8, 50

Figure 13-2: Close-up photography can be used to reveal intimate information about a subject.

✔ **Abstract images:** Abstract photographs don't represent anything in a literal sense. The actual nature of a subject is unknown, and the feelings or impressions a viewer gets from an abstract photograph are created by design elements such as colors, contrast, lines, shapes, forms, and textures. In macro and close-up photography you can take away the literal sense of a subject by getting in close enough that a viewer can't recognize

what they're looking at. Try using an extremely shallow depth of field, or photographing from acute angles to help abstract a scene. Figure 13-3 contains no literal representation and therefore can be considered abstract.

✔ **Detail shots**: A detail shot can consist of any detail or feature you find to be interesting. This can mean filling your frame with someone's eye to show what the iris looks like up close, or photographing someone's smile alone. Figure 13-4 shows an example of a detail shot.

100mm, 1/125, f/2.8, 50

Figure 13-3: A close-up image that doesn't literally represent anything can be considered abstract.

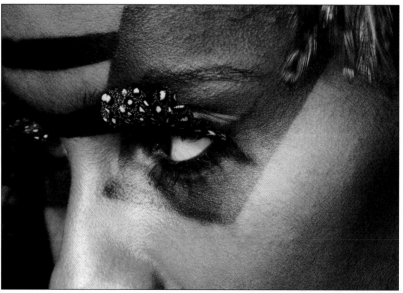

100mm, 1/125, f/11, 200

Figure 13-4: Filling your frame with one detail helps draw specific attention to it.

Preparing Subjects for Close-Ups

The close-up portrait can be nerve-racking for some people, and as a photographer you need to be respectful of an individual's limits and concerns. Most people prefer not to have a camera positioned very close to their faces for fear that undesirable details will be revealed in the resulting photographs.

Earning a subject's trust is critical for taking effective photographs. Any discomfort your subject has with you or the situation is going to show up in your images. Follow the precautions and steps explained in this section to ensure that a subject trusts you and feels comfortable — even during a close-up.

Explaining your creative vision

To keep your subject from assuming the worst about having her close-up taken, share your ideas and creative vision with her. Doing so gives the subject a chance to feel comfortable in knowing what's happening when the shutter clicks, rather than having to guess.

If your goal is to photograph a detail shot of just the eye, then you have to move your camera in very close to a person's face. Be sure that she knows you're basing the shot on the eye and that you chose to photograph just the eye because of how beautiful it is. Explain why her eye deserves to appear as the star in a photograph. Is it the color, the long lashes, the shape, or the wisdom that can be seen in the eye?

The same respect applies when photographing an intimate close-up of someone. Explain to him what you're interested in photographing, and why it requires you to position your camera in his personal space. If you find his dimple to be charming or his brow to be expressive, then enlighten him to these qualities and justify your creative vision. Let your subject know that a close-up helps to isolate the intimate expression.

To create an abstract photograph is to eliminate all literal representations. Perhaps explaining this to a subject will help to eliminate any discomfort. After all, no one's going to recognize what's in the image anyway.

If you try to explain your creative vision to your subject and she's still uncomfortable with having a camera too close to her face or body, then you can simply drop the whole idea, or use equipment that enables you to get the close-up shot from farther away.

Using a lens that lets you keep your distance

Using a longer lens that enables you to maintain a greater distance while shooting close-ups can help keep your subjects more comfortable.

A headshot is considered a close-up, but the typical headshot crop enables you to stay a comfortable distance from your subjects (assuming you're not using a wide-angle lens). A normal or telephoto lens works best for shooting headshots as they keep you at a distance, and these lenses don't distort the shape of your subject's facial features.

If your shot requires you to capture a very small detail, then a longer lens (such as 100mm or greater) will work best for putting space between the camera and the subject. To create an even greater distance, combine your longest macro lens with a tele-converter. The tele-converter magnifies the image created by the lens, enabling you to capture the level of detail you want at a greater distance.

Considering Light's Effect on Your Subject

The direction of your light affects how subjects are depicted in a photograph. When shooting close-ups of people, be aware that the texture of their skin becomes very visible. For some subjects this may add to your intended message, but for others it may cause problems. Most people don't wish to make their pores and hair follicles visible in a photograph.

Use a flat light source, such as a ring light (see Chapter 9), or open shade (see Chapter 8) to minimize how much texture can be seen in a subject's skin. Flat light is light that comes from the camera or has no obvious direction. It casts minimal to no shadows, and therefore hides texture. Figure 13-5 shows a close-up portrait taken with a ring light.

If your subject is an older person, or a salty sea captain, and you wish to emphasize texture in the skin to help tell his story, then you want to use a side-light. Doing so maximizes the amount of shadows cast over a textured surface, creating a dramatic depiction of your subject. Notice in Figure 13-6 how the lighting causes the subject's life experience to come out in the photograph.

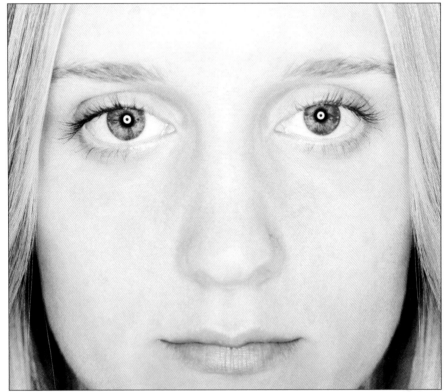

100mm, 1/160, f/11, 100

Figure 13-5: A ring light (or any flat light source) helps to minimize texture in a person's skin.

Of course, you don't have to be so extreme in either direction when it comes to lighting human subjects for their close-up portraits. Each person is unique, and your lighting direction needs to fit the subject and message.

A ¾ light is between flat and sidelight. This style of lighting shows some texture, but is not as harsh as side lighting. Just remember that the farther your light source is to the side of your subject, the more it reveals texture. The closer the light source is to the camera, the flatter the light becomes.

For more information on lighting, refer to Part III of this book. And, for a complete guide to lighting people for portraits, refer to *Digital Photography Composition For Dummies* or *Digital Photography Lighting For Dummies* (Wiley).

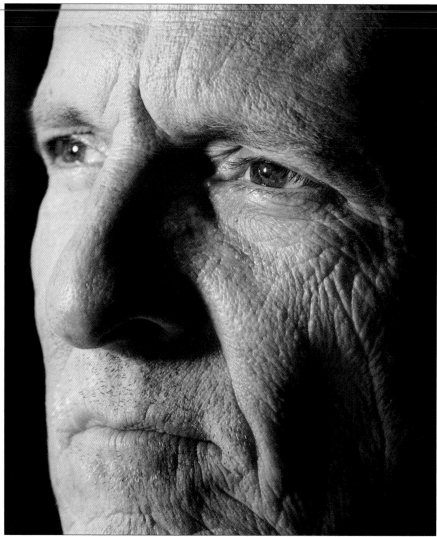

50mm, 1/60, f/8, 400

Figure 13-6: You can use side lighting to show texture in the skin's surface.

Selecting Your Focal Point

In macro and close-up situations, depth of field generally becomes shallow, so it's critical that your focal point is exactly where you want it to be. Getting your focal point right helps to get your message across and to draw viewers to the point that you find to be most interesting in the frame.

When composing an image and selecting a point of focus, you're choosing the point at which you want viewers to notice the most. With people, this usually means the eyes. We make eye contact with each other naturally to make a connection, and so photographers attempt to draw viewers to the subject's eyes to make a similar connection.

In a headshot, or a portrait of someone's face, you most likely want to make the eyes your point of focus. Otherwise, something will seem wrong to viewers when they look at the image. They'll wonder why the person's nose or ear is in focus, making it difficult to connect with the eyes. Of course, you can choose to keep the eyes blurred as an artistic decision, but you need some good reason for doing so.

If you find that the smirk a person has says more about her than the look in her eyes does, then maybe you can place your focal point on the mouth area rather than the eyes. Or, you could compose your image so the eyes are cropped out of the frame completely, drawing even more attention to the mouth area.

When photographing an intimate detail, you most likely want to place your point of focus at the area of interest. For instance, if your subject's hand is gently touching her shoulder and you wish to show this in your frame, then compose your image to emphasize the relationship between the two, and position your focus at the point of contact. Doing so helps viewers to see exactly what you want them to see, as Figure 13-7 shows.

50mm, 1/160, f/2.8, 50

Figure 13-7: Your focal point helps to tell viewers where to look in an image.

Addressing Movement

The closer you get to a subject, the greater motion's effect on the position of your focal point, and the sharpness of your images. The slightest movement by the camera or the subject at such a close range can cause the focal point to be displaced, or the subject to be blurred during the exposure.

In order to produce sharp images with a controlled point of focus, you must address two factors, movement in the camera, and movement in the subject.

Minimizing camera shake

An unstable camera is not ideal for creating sharp macro and close-up photographs with the point of focus placed perfectly where you want it. But when photographing people, you may sometimes prefer to take the camera off of the tripod and into your own hands to better engage your subject. Keep in mind that you'll be responsible for stabilizing the camera enough to get a steady shot.

This section covers methods of keeping a shaky camera from ruining your focal point and the sharpness of your images.

Keeping your point of focus in the right area

If your camera shakes, or moves in the time between positioning the point of focus and taking the photograph, then your focal point may shift and end up in the wrong spot during the time of your exposure. Handholding a camera at very close distances can often cause this to happen.

Using a tripod is the best way to ensure that your camera doesn't move on you before or during your shot. However, there are times when you won't have your tripod, or your subject is easier to work with when handholding the camera (for instance, a moving subject). Here are some tips to minimize the effect camera movement has on the position of your focal point:

- ✔ **Set your focus and quickly take the shot.** The longer you wait to take the shot after positioning your focal point, the more time there is for error. As soon as you achieve focus where you want it, take the shot to minimize the possibility of movement.

- ✔ **Stabilize yourself as much as possible.** Press your elbows in to your body while holding the camera to create more support. By doing so you can hold the camera in one spot for longer periods. Also, let the camera lens rest in your palm rather than holding it up with your fingers. That way, your arm provides support, which is much more stable than your fingers. Try to sync your breathing with your shots as well. As you breathe in and out your camera moves. Don't hold your breath for a shot, but plan to focus and take the shot in-between inhaling and exhaling.

✔ **Try setting your auto-focus mode to "servo" rather than "constant."** The servo auto-focus mode is designed to lock your focal point on a moving target. This should also be beneficial in situations where either your subject, or your camera is moving.

✔ **Use a smaller aperture setting (such as f/16).** Doing so helps to provide a little more room for error by creating a greater depth of field.

Making sure your focal point appears sharp

If your camera shakes or moves during the time of your exposure, then your subject may come out blurry in the image. Again, using a tripod is the best way to eliminate camera shake, but if you're handholding the camera then these techniques help to minimize its effect on your images:

✔ **Use a fast shutter speed (such as 1/250 or faster).** The less time your shutter is open during the exposure, the smaller the effect of camera shake becomes.

✔ **Take advantage of your lens's Image Stabilization mode.** Image Stabilization (or IS) is designed to keep what the camera sees steady, even when the camera itself is shaking. Chapter 6 tells you more about this feature.

✔ **Stabilize yourself as much as possible.** The section "Keeping your point of focus in the right area" tells you how to do so by squeezing your elbows into the body for support and resting the lens in your palm rather than in your fingers.

Dealing with your subject's movement

An unstable camera is just one of the factors that affects your focal point's position and sharpness. On top of that, you have to consider the movement of your subject.

Following the techniques you find in the section "Minimizing camera shake" does away with most movement issues concerning your camera and your subject. However, you might need to take some extra measures to ensure your images are as sharp and correctly focused as possible.

Even with your camera positioned steadily on a tripod, if your subject moves closer or farther from your camera between the time you lock focus and the time you take the shot, then your focal point is no longer consistent with the position of your subject. Here are some tips for preventing this dilemma:

✔ **Communicate with your subject.** If you're posing someone for his close-up, then explain to him that too much movement will affect your focus. Ask him to remain as still as possible while you're shooting. But, if you're trying to capture a more natural look by letting the model move

about during the shoot, have him make movements that are parallel to the camera's digital sensor. Parallel movements occur along the *focal plane* (the two-dimensional space parallel to the digital sensor that appears sharp in an image) and remain consistent with your point of focus. Movements toward or away from the camera cause the subject to move out of your plane of focus and become blurry.

✔ **Find the auto-focus mode that works for you.** Most digital SLRs are equipped with an auto-focusing mode designed to produce sharp images when dealing with moving subjects (usually labeled as auto-servo, or AI Servo). Your servo auto-focusing mode causes your selected point of focus to track the subject as it moves (between the time you lock focus and release the shutter). Refer to your owner's manual for information on locating and setting your auto-focusing modes.

✔ **Pose your subject comfortably.** If you'd like to minimize movement in your model, then pose her in a way that's comfortable and stable. The less awkward the pose, the more likely she'll be able to stay still for her close-up.

Achieving focus when shooting a close-up self-portrait

Achieving a perfectly placed focal point can be difficult when creating a self-portrait. You have to deal with all of the factors discussed in this chapter, without being behind the camera. A certain amount of control is taken away from you as a photographer in this situation. The good news is there are a bunch of options to successfully get the shot you want without having someone else operate the camera for you.

The first thing you need to do is to place your camera on a tripod. This keeps it stable, and frees up your hands to enable you to pose for your shot. Secondly, choose the option that works best for your shot:

✔ **Use an inanimate object as a stand-in.** To do so, place something (like a light stand, lamp, or a cactus, etc.) in the area where you want to take your close-up. Compose your shot and place your point of focus on the stand-in object (if you used auto-focus then switch to the manual mode once focus has been achieved so it doesn't move around when you press the shutter again to take the shot).

Now tie a string to your tripod head and stretch it out to the stand-in at the point in which you placed your focus. Mark the string where it touches the object, and that will let you know exactly how far your face should be from the camera when you're having your close-up taken. Use the camera's self-timer to give yourself some time after pressing the shutter, and get into position. You can use a cable release if you have one. After using the string to get your exact distance, drop it before the shutter is

released. Re-measure your distance with the string before each shot to ensure you're positioned correctly. You can now worry about your expression rather than focus.

✔ **Use your cable release or remote shooting device in order to auto-focus.** Be sure to set your camera to focus in the center of the frame. Position yourself in front of the camera with the cable release in one hand.

If you want your focal point to be positioned on your eye, then place your eye in the center of the lens. Use the cable release to auto-focus and to take the shot. Your eye should be in focus. By allowing some extra edge room in your frame, you can crop the image off-center so the eye is no longer placed right in the middle of your composition.

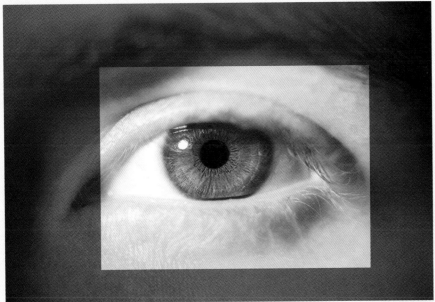

100mm, 1/160, f/2.8, 100

✔ **Use a flashlight.** Most cameras offer an option for all auto-focus hot spots to be active at once. This causes the lens to focus on the nearest object, or the area with the most contrast. By holding the flashlight right next to your eye and shining it directly at the

camera, you should cause the auto-focus to pick up on that spot. With this technique you can auto-focus on yourself without having to be in the center of the frame. When you achieve focus, remove the flashlight from your frame and take the shot.

Taking Close-Up Images of Your Pets

Pets are a great macro and close-up photographic subject, but their level of cooperation in posing for images can vary quite a lot. If your pet sits in one spot for long periods of time, or moves slowly, such as a bird or a snake, then you should have an easy time photographing it. However, other pets might not be so willing to cooperate.

Curiosity is a big factor in adding difficulty to pet close-ups. When you stick your camera in a cat or dog's face, they want to know why you're doing such a thing. They may think there's something you expect them to do with it, and this can cause them to sniff at it or lick it.

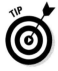 Be sure to use a lens hood or a UV filter (a clear glass filter placed on the front of a lens) to protect the surface of your lens from the animal's wet nose and tongue.

When photographing your pets, follow the techniques for dealing with movement that I discuss in the section "Addressing Movement." But, have patience since animals are less likely to listen to your direction, and many times they move more quickly and sporadically than humans do.

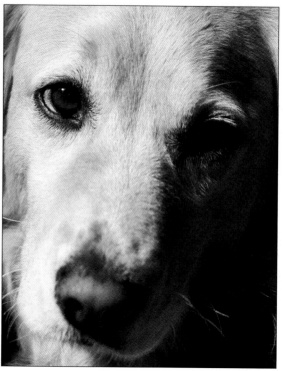

100mm, 1/500, f/4, 100

Figure 13-8: Close-up photography of a pet can be fun but may require patience to get the shot you want.

By giving the animal some time to get used to the environment and the camera, you may get some opportunities to capture great images after it's calmed down and grown less curious. The image in Figure 13-8 was captured once the dog grew less suspicious of my lens.

14

Small Product and Still-Life Photography

Skill and knowledge in macro and close-up photography can come in handy when photographing a product or a still-life subject that's pocket-size or smaller. Getting in close helps to bring out the details by filling more of your frame with the subject, and the smaller your subject is, the closer you have to get to it.

Ordinary photography equipment may not enable you to reveal important details in subjects smaller than your camera's digital sensor. When you're shooting something that small, you need a macro ratio of at least 1:1 to reveal a proper amount of detail.

Small products and small still-life subjects are similar in size, and neither is going to move around on you. But the way in which you photograph each can vary greatly. Product photography requires certain factors that help to show the literal sense and functionality of a subject, while artistic still life photography allows you to determine what should be revealed and what should be concealed.

In this chapter, I examine these two similar but separate styles of macro and close-up photography. I fill you in on what clients expect when having their small products photographed, how to meet those expectations, and how to make your own visions come to reality in artistic still-life photography.

Uncovering the Intentions of Product Photography

Product photography is meant for selling products. This means the appearance of the subject and the message told in the image need to be truthful in order to avoid false advertising.

Photographers who want their images to stand out visually commonly use creative lighting styles, composition, and postproduction techniques. In product photography, you need to limit these practices to make sure that the subject remains realistic (relatively speaking, of course). You want to idealize the appearance of something, but you don't want to make it appear to be something that it's not.

Showing a subject for what it is

There's no sense in providing a photograph of a product if viewers can't understand what the product is in the photograph. In the most basic sense of product photography, your job is to provide a literal representation of a subject. The best way to do so is to produce a photograph that represents the product clearly, without any discolorations, distorting angles or lenses, size or shape distortion, or misrepresentations, and with few to no distractions.

Including as much subject detail as possible

Including details about a product is important because viewers want to know as much about what they're looking at as possible. If you're shopping online or out of a catalog, then the image is one of your only sources for making a decision about whether the product is right for you.

Artistic, blurry representations of a subject are great and all, but they don't help anyone make purchasing decisions. A sharply focused image that reveals true texture, shape, form, and color is much more helpful. However, if a product has been around for a while and has already established itself in the market, companies will allow it to be photographed in a more artistic manner because people are already familiar with its look and function. If you really want to get creative with a small product, feel free to do so, but I recommend producing a shot that shows it for what it really is.

The closer your camera is to a subject, the shallower your depth of field becomes. In macro and close-up product photography, you often need to use small apertures (like f/22) in order to achieve focus on the entire subject.

However, when your subject has a lot of depth, a small aperture isn't always sufficient to produce sharpness throughout. A couple techniques help maximize sharpness when you're using a small aperture:

✔ **Minimize the depth of your subject.** If the product you're photographing has a long side and a short side, be sure to position the long side to be parallel (or somewhat parallel) to your camera's digital sensor. This causes it to be parallel with your plane of focus ensuring that your depth of field can cover the entire product and so reveal it in sharp focus.

Notice how the subject in Figure 14-1 appears clearer when it's photographed parallel to the camera (left) as opposed to when it's photographed at an angle to the camera (right).

✔ **Use postproduction processes to maximize sharp detail in your images.** Thanks to photo-editing software, you can now take multiple photographs of a subject with varying focal points, mash them together, and produce an image with sharp focus throughout. Chapter 17 gives you the details about using this technique.

✔ **Back up from the subject (reducing magnification) and crop your final image as desired.** Showing your subject smaller in your frame will increase your depth of field and cause more of it to appear sharp. I recommend this method only if you're using a camera with very high resolution, and if your subject doesn't have extremely fine details that you need to show.

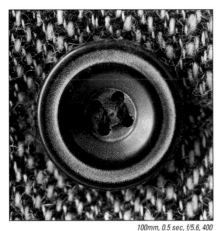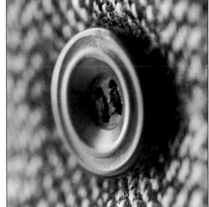

100mm, 0.5 sec, f/5.6, 400 *100mm, 0.5 sec, f/5.6, 400*

Figure 14-1: Minimizing a subject's depth can help to show more of it in sharp focus.

Getting your colors right

Controlling the color in your photographs is critical to creating realistic representations of your subjects. Begin by selecting the appropriate color balance based on the lighting you're dealing with. Different types of light produce different color shifts when picked up by your camera's digital sensor, and these shifts can affect how the color of your subject appears.

Your camera is equipped with various color balance settings: daylight, open shade, cloudy conditions, flash, tungsten (indoor) lighting, fluorescent light, and a custom function. Shooting with the cloudy setting on a cloudy day gets your colors close to where they need to be, but not all cloudy days are the same, and your results vary from one to the other. The preset color balances are great for most photographic situations, but for product photography I recommend using the custom function to ensure your colors are spot on.

The custom white balance (or color balance) feature on your camera enables you to photograph a *white balance card* (a card that's known to be neutral in color) and use it as a reference for your camera to balance the color of light in a scene. You can use the white balance card to balance color in camera, or in postproduction. To find out more about color balance and using a white card for custom color balance, flip over to Chapter 8.

Color management becomes more and more difficult as your images are sent to different media. For instance, the colors in a photograph may appear differently on one computer screen compared to another. Also, a printed version of the image may have different colors than the image on your screen, and each printer prints the colors a little differently from the next. For a more complete guide to color management refer to *Color Management for Digital Photographers For Dummies* (Wiley), by Ted Padova and Don Mason.

Eliminating or minimizing distractions

If your main goal in creating an image is to provide a literal depiction of a subject to your viewers, then choose a background that contains little to no distractions. Products are often photographed on plain white, grey, black, or colored backgrounds in order to draw complete attention to them. The plain background enables you to show the shape of a subject clearly and present it in a clean manner. Figure 14-2 provides an example of this style of product photography. The bobby pin would be difficult to see so clearly in most other situations.

100mm, 1/160, f/11, 200

Figure 14-2: A plain background works to eliminate distractions in product photography.

Here are some things to keep in mind when photographing on a plain, solid background:

- ✔ **Light the subject and the background.** Sometimes lighting the subject alone leaves a muddy-looking background. Your solid white environment appears grey and unevenly lit. Always pay attention to your entire scene when photographing macro and close-up subjects, even when that scene consists of plain old nothingness.

- ✔ **Choose a lighting style for your background.** Lighting a solid background evenly provides a clean look, as if the subject were floating in midair. Causing the light to gradually fall off the solid background can provide a sense of depth and keep the image from appearing too flat and halting.

- ✔ **Include your subject's shadow** to give a sense of space or grounding in an image. Lighting your scene so there is no visible shadow causes the subject to have no sense of place — to float.

- ✔ **Choose a camera angle that displays what you wish to reveal.** The angle you shoot the subject from determines what viewers will see in that subject. Different angles serve separate purposes, and sometimes more than one is appropriate for the subject. Analyze where the most descriptive detail can be found on a subject to determine the best shot(s) for it. In Figure 14-3 the subject was photographed from a high angle, revealing the features, functions, and controls on the topside of the camera. In Figure 14-4, I chose a low angle to reveal the subject as if you were face to face with it. This angle serves as more of a portrait, or a hero shot of the particular subject, rather than a descriptive image.

50mm, 1/15, f/16, 400

Figure 14-3: A high angle reveals detail on the top of your subject.

If you're shooting outside of the studio and don't have a plain background to work with, then you can try one of these techniques to minimize distracting elements in a scene:

✔ **Keep a great distance between your subject and any background elements.** The farther your background from the subject, the blurrier it'll appear in your photograph. Rather than placing a product right in front of a wall, or in the vicinity of other elements, find a space that enables you to pull the subject away from anything that may be distracting. Then, let the distractions become blurry to minimize their effect on your composition. In this situation, select an aperture that provides the depth of field required to show sharp detail in your subject, while keeping the background as blurry as possible. Shoot at varying apertures to compare the results and choose the one that works best for the product.

✔ **Seek out a camera angle that minimizes distractions.** If there are distracting elements behind your subject, then rotate your camera position or change the height of it. Shooting from a high angle provides a view of

the subject and the ground it sits on, helping eliminate distractions in the background. By using a low angle, you can block background distractions with the subject itself. The closer you position your camera to the subject, the more of the background it'll cover. By getting extremely low, you can compose your shot so that sky is the only thing visible behind your subject.

✔ **Light your subject with a strobe or flash to make it appear significantly brighter than its background.** Doing so helps draw attention to the subject and downplay the background.

50mm, 1/15, f/16, 400

Figure 14-4: A lower angle (from the point of view of the subject) provides a perfect front view of the subject.

Telling the story of a product

In some cases, product photography requires you to give more than just a literal depiction of the subject. Of course, you still need to show the product in a clear, descriptive manner (which I tell you about in the section "Showing a subject for what it is"), but also in a way that gives it a sense of personality. A good product shot can tell viewers how something is used, where it's from, the feeling it's meant to provide, and who's expected to use it.

Apart from the product itself, the main factors that help to tell its story are the environment, photographic composition, and lighting choices you make.

Choosing an environment

A small product's environment consists of supporting details that help viewers to make associations with the product. In the most basic sense, you might use a colored background; color plays a key role in providing suggestions for moods and feelings in photography.

For example, a razor blade photographed in a light blue environment can appear smooth, cool, and refreshing to viewers. The same subject photographed in a red environment can cause viewers to feel threatened and possibly associate the razor with blood.

The color scheme of your subject's surroundings should help to say something good about the subject.

Other factors that make up the environment are supporting details. These can consist of props, or background elements. A razor blade photographed in the presence of a brush kit would suggest that the razor is for a man who takes his time shaving, and considers himself to be refined or classy. The same razor photographed in the shower might appeal to someone who's more efficient or on the go.

You can also use props and background elements to provide scale for a product. A subject photographed on a plain white background doesn't present any information on the size of the subject. However, when you place elements of a known dimension near the subject, they help to determine its size. In Figure 14-5 the props give a sense of size to the subject.

Effective choices in composition

When composing a small product shot, consider the size of the subject in your frame. Having it take up a dominant portion of the frame draws more emphasis to the product itself, causing it to stand out as the main subject and helping to provide maximum detail.

In Figure 14-6, the product's dominant size in the frame helps it to steal the show. The background details give you information on the subject's purpose but play a minor role in the overall composition. It's very clear who's the star in this scene.

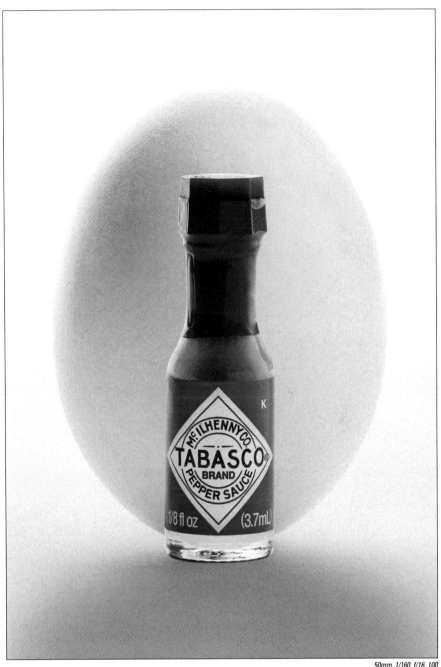

50mm, 1/160, f/16, 100

Figure 14-5: Supporting elements can clue viewers in to the size of a subject.

100mm, 1/15, f/11, 100

Figure 14-6: A subject that takes up a large portion of the frame tends to grab most of the attention.

Not all products have a visual appeal. Consider a piece of cheese. Would it look more appetizing surrounded by a solid white environment, or surrounded by crackers, wine, and fruits? If you feel that a specific subject is weak on its own and requires the help of its environment to look its best, then allow more of the frame's space for the supporting elements. By doing so, you create less emphasis on the subject and more on its associations.

When using this type of composition, try to arrange your shot so viewers can easily know what the subject is. Figure 14-7 reveals the main subject clearly by following these techniques:

DIY: Creating a small product studio set

Small product photography is often created in the studio and on a tabletop set. There are a few ways to go about constructing this type of set.

A roll of white, grey, black, or colored paper can provide the seamless background you need. The paper is raised above the tabletop (held up by two light stands with a crossbar), and swept across the top of the table, creating a vertical and horizontal space with no seam in between. This setup offers plenty of space to work with in positioning and making changes to your subject, and enables you to use various lighting techniques.

Another way to create a seamless background is to use a *light tent* (a cube-shaped structure with white fabric walls and a seamless interior.) You can purchase them at reasonable prices, and they work well for subjects that require soft lighting and those with reflective surfaces, because the fabric walls provide clean reflections. The downside to light tents is they don't provide much space to work with, and they limit the lighting styles you can use.

Photographers typically use studio lights (strobe or flash) to light a tabletop set. To do so, you need some light stands to hold the lights in place, and some *grip* (materials used to clamp, prop, and style equipment and elements in a studio set) to position any reflectors, *gobos* (black cards used to block light from certain areas of a scene), or props in a set.

You can use a large window as a soft light source by positioning your tabletop set near it. Doing so is a great option for photographers who don't have much studio lighting equipment. Just be conscious of the fact that the window light is less consistent than studio lights. If the sun shines directly through the window, then the quality of your light changes. And anytime there's a change in weather outside, the color and intensity of the window lighting is affected.

Position your camera on a tripod in the studio in order to maximize sharpness and to free up your hands.

✔ **Arrange the leading lines to lead to your subject.** *Leading lines* are design elements that tell viewers subconsciously where to look in a frame. Anything that creates a visual line can be used as a leading line, such as the crease where two objects meet, the edge of an object, the horizon, or a row of objects.

✔ **Position the subject in a strong area of the frame according to the rule of thirds.** By imagining vertical and horizontal gridlines that break the frame into thirds, you can locate the most visually striking areas for placing a subject — the points where the lines of thirds intersect.

✔ **Create visual contrast in the area of the subject.** The highest contrast area in a frame draws a viewer's attention. Placing a bright subject in front of a dark background or a dark subject in front of a light background helps to create this contrast.

100mm, 1/160, f/5.6, 100

Figure 14-7: Leading lines, strategic positioning, and contrast help to reveal the subject in this photograph.

↙ **Leave room for copy.** If you're planning on placing text in a product image to help describe or sell it, then you need to compose the image in a way that leaves space for that text. Commercial clients often provide a layout that specifies where the product should be positioned, its size in the frame, and where the copy will ultimately be placed.

Lighting a product

Light determines what viewers see and do not see in a photograph. In small-product photography, you generally want to provide detail throughout the subject so viewers have a clear view of what you're selling. This means you must have control over your shadows and highlights.

Creating a lighting setup that works for your specific subject requires that you consider the direction, quality, and intensity of your light sources. To begin the process:

1. **Position your subject in the scene and compose your frame.**

2. **Position your key light so that it provides the type of shadows you're looking for.**

 A sidelight works best to reveal texture and to create an even amount of shadow and highlight areas in the scene.

 A three-quarter light is best for revealing form and is suitable for most subjects.

 A flat light (positioned on or near the camera's position) is commonly used on two-dimensional products, such as stamps, and provides an even illumination on the subject.

3. **Adjust the quality of your key light.**

 A key light source that affects the subject directly is considered a hard light source. A scrim, umbrella, or soft box can soften the light.

 Remember, hard light sources produce shadows with hard edges and create smaller highlights in reflective surfaces. Soft light sources produce shadows with softer edges and create larger highlights in reflective surfaces.

4. **Introduce a fill light to show detail in the shadow areas.**

 A fill light is an ambient or flat light source that brightens the scene without casting shadows. The relationship between the intensity of the fill light to the intensity of the key light determines how dark your shadows are.

 Increase the power of your fill light to create images with less drama and more shadow detail. Decrease the intensity of your fill light to add drama and mystery.

5. **Bring in a third light source if you prefer to use one.**

 A third light can create a highlighted edge on a subject, or it can light the background. Some photographers create a spotlight on the background directly behind the subject in order to draw attention to it.

 If you prefer to have a highlighted edge on your subject and to light the background, then use a four-light setup.

Taking an Artistic Approach to Product and Still-Life Photography

The process for setting up and photographing a small still-life subject is similar to the one you use for a small product. The difference between the two

can be something of a grey area, since you can be artistic with your approach to product photography as well as still-life. The most defined difference that separates the two is that you don't have to tell the story of the subject in a realistic or straightforward manner when you're not creating a product shot. You're in control as the photographer and the artist in deciding how to depict the subject.

Determining your message

When creating personal, artistic photographs, you're not confined to the purpose or function of a still-life subject. Instead, you're granted full creative license to create images based on what you have to say about something.

If you come across a piece of ginger that resembles a dancer in motion, or you're particularly inspired by the translucent qualities of a sliced kiwi fruit, then you already know what your message is. Whatever inspires you to photograph something is what you ultimately want to get across to viewers in the final image.

You could be inspired by the way light comes in through the bedroom window at a certain time of the day. In this case the light is what you wish to photograph and whatever still-life subject you place in the shot is simply there to help tell the story of the light.

When you know what your message is, the next step is to reveal it through photographic technique.

Executing your message through technique

Executing your message can be as simple as composing an image that reveals what you want people to see and capturing a proper exposure of it. But those steps aren't always enough. Sometimes the picture just doesn't come out as good as you see it in your head.

The way to bring your vision to life is to use technique. Light your still-life subjects in a way that brings out the properties and features that you find to be interesting, and remember that amazing composition requires more than simply placing the subject in the center of your frame and snapping a shot.

To determine the techniques that work best, first think of what you want to emphasize in a subject. Then choose the techniques that help you do so. Here's a list of things to keep in mind:

✔ **Light direction:** Sidelighting (which comes from the side of the camera) can bring out the texture or create dramatic shadows in a scene. Flat lighting (coming from the direction of the camera), or backlighting (coming from behind the subject) can be used to emphasize the shape of a subject. Three-quarter lighting (somewhere between side and front lighting) is ideal for emphasizing a subject's form.

✔ **Light quality:** Hard light creates well-defined shadows, while soft light (produced by a larger light source) creates gradual shadow edges. Consider hard lighting when creating a dramatic distinction between shadow and highlight areas. Consider soft lighting when you want to show off a subject's form or create smoother highlights.

✔ **Camera angle:** Choose camera angle based on how you want viewers to see a subject and what details you want to make visible. Also, consider how the subject fits into its surroundings when choosing the best camera angle.

✔ **Subject size:** The size of the subject in your frame helps reveal information to viewers. Larger representations give the subject a bigger impact. Smaller representations give room for supporting elements. Consider the use of props to provide a sense of scale to viewers.

✔ **Color and tonality:** The colors and tones in your frame tend to manipulate how viewers see the image. Does your product photograph better with a light background or a dark one? Should the background consist of a certain color to provide a specific mood or feeling? (See Chapter 10.) Do the colors of your supporting elements support the mood or feeling you'd like to associate with the product?

✔ **Depth of field:** Is your goal to show as much sharp detail as possible or to draw viewers to one specific detail with selective focus? Do you wish to reveal sharp detail in supporting elements or blur out the distracting background?

You may notice that the techniques used to create artistic representations of still-life subjects are similar to those used to create product shots. It's how you use the techniques that separates the two. While you may be forced to use a great depth of field when photographing a subject as a product, feel free to use a shallow depth of field when shooting the same subject as an artistic still-life. Take the steps necessary to reveal the subject how you want it to be seen.

In Figure 14-8 I was interested in using the transparent qualities of a kiwi to create a unique photograph. I had to backlight the subject to make that happen; therefore, I did the following:

✔ Propped the kiwi upright in front of a black background. The dark background works best to emphasize the glow from the backlit subject.

✔ Positioned the key light source behind the subject.

✔ Situated the camera directly in front of the kiwi.

✔ Used a black flag to block the key light from hitting the background, and to prevent it from casting the subject's shadow onto the foreground.

✔ Chose a small aperture setting to ensure I could capture sharp detail in the kiwi's seeds, pulp, and fuzzy outer rim.

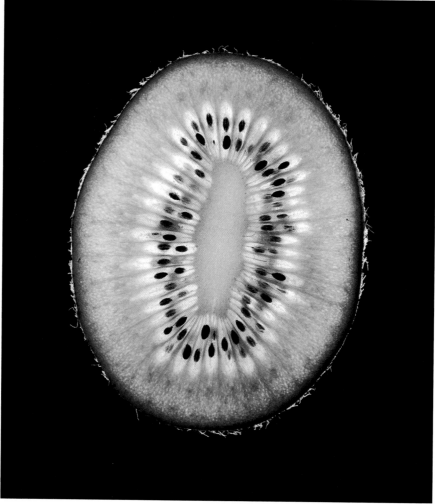

100mm, 1/160, f/8, 400

Figure 14-8: This photograph highlights the transparent quality of a sliced kiwi.

Tricks of the Trade for Jewelry and Other Reflective Subjects

In This Chapter

▶ Discovering how light affects reflective subjects

▶ Controlling the background to get the shot

▶ Making glass and other transparent subjects pop

*J*ewelry can make for a great-looking subject, but it can also be one of the toughest for beginning photographers to photograph. Take it from me, the process can be frustrating and time-consuming; but the better you are at applying proper techniques and the more experience you gain with the subject, the easier the process becomes.

Discovering the steps for lighting reflective and transparent subjects enables you to create stunning jewelry shots without breaking a sweat. This chapter shares the techniques, tips, and secrets used by professional photographers for producing clean, crisp macro and close-up photos of jewelry and other reflective and transparent subjects.

Lighting Reflective Subjects

To understand the properties of reflective materials, stand in a dark room and look at your face in a mirror. Without light, you see nothing; if you shine a flashlight directly at the mirror you see the reflection of the flashlight. In order to see your face, you need to shine the light on your face, not the mirror.

Lighting reflective subjects is mostly about controlling what appears in the reflections. This section explains methods for doing so, and helps you understand how different types of lighting affect reflective subjects.

Creating smooth highlights

A smooth highlight is one that helps to emphasize the form of a subject by bending, flowing, and warping in the same manner as the subject. A smooth highlight on a wedding band is one that wraps around the band, providing a sense of its roundness.

You can create this type of highlight by using any of several techniques, but the general rule is that highlights are made from what appears in the reflective subject. How you produce the highlight, its size, and where it's positioned in relation to the subject determine the look of the highlight.

Using a soft box

Soft box lighting accessories (see Chapter 9) are designed for use with reflective subjects. They provide a large surface area of light that's ideal for getting smooth highlights on subjects of varying shapes and sizes.

The larger you want your highlight to be, the larger (or closer) your soft box has to be to the subject.

Figure 15-1 shows a reflective subject photographed with a smooth highlight created by a soft box and the same subject photographed with a larger soft box, creating a larger highlight.

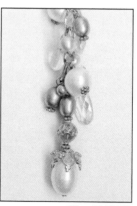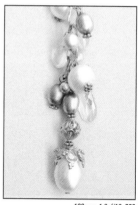

100mm, 1.6, f/16, 320 100mm, 1.6, f/16, 320

Figure 15-1: With a larger light source, you can create a larger highlight in reflective subjects.

As you move the soft box around your subject, the highlight's position and shape change (in accordance with the subject's form). Your main goal should be to portray the subject in the most flattering and descriptive way possible, so choose a position for the soft box that gives viewers a sense of the subject's true form.

Using a scrim

You can use a *scrim* (a ligh-modifying diffusion material that I discuss in Chapters 6 and 8) to perform the same job as a soft box. Clamping one to the table and shining a flash or strobe through it creates a large light source that's very near to the subject. This helps to maximize how much of the subject's reflective surface is affected by the scrim.

Scrims can also be propped (or handheld) directly above the subject, or at any position and angle necessary for creating the highlight you want.

You can buy a scrim at most photo supply shops, or you can make your own from a canvas frame with any thin, white fabric stretched over it. Doing so is a great, cheap way to turn any light into a soft box.

Using a light tent

Some small product and jewelry photographers prefer to use a *light tent* (a cube-shaped structure with white fabric walls and a seamless interior) for lighting their subjects. Light tents provide a pure white surrounding that eliminates unwanted reflections in a reflective subject. They're also light-weight and collapsible, making them easy to travel with and set up anywhere.

After positioning your subject inside, you can light one side of the tent to create a dominant highlight on that side of the subject, but light tends to bounce around inside the tent, producing a somewhat even and flat lighting on the subject. This even lighting tends to create images that appear flat or boring. The section "Adding lowlights" provides information on adding interest to subjects photographed in a light tent.

Bouncing light with foam core

Foam core, which you can find at any hobby or art-supply store, is another option for adding light to your reflective subjects. When you light the surface of the foam core, the reflective surface of the subject reveals the foam core as a smooth highlight.

You can use a piece of foam core to create highlights by directing light onto the foam core rather than the subject itself. The size and position of the foam core determines the type of highlight it creates. By moving the foam core closer to your subject, you create larger highlights that cover more of the subject's surface area. Move it farther out to reduce the size of the highlights. A thin strip of foam core creates a thin highlight, and a wider piece creates a wider highlight.

The angle of reflection is equal to the angle of incidence, meaning that the angle at which you shoot a reflective surface determines what your camera sees in the surface's reflection. If your camera is positioned at a 45-degree angle to the subject's surface, then the foam core shows up best in the reflective surface when it's positioned at the opposite 45-degree angle. If your

camera is positioned at a 90-degree angle (looking straight on) to the reflective surface, then you'll see the camera's reflection in the surface.

You can also use a piece of foam core to add secondary highlights to a subject. In Figure 15-2, I used a soft box to create the highlight in the first image. In the other, I used a piece of foam core to create a more interesting photograph by adding a secondary highlight.

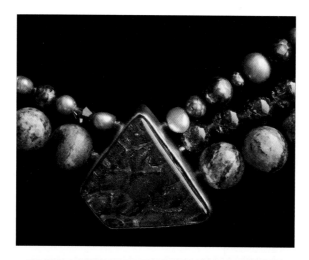

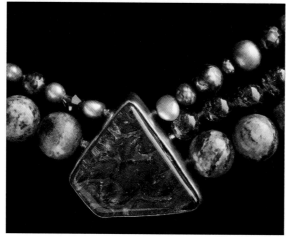

100mm, 1/160, f/22, 400

Figure 15-2: Place foam core around your subject to create secondary highlights.

Avoid a fire hazard when using the modeling light on your strobes or when working with continuous light sources. (They're also called *hot lights* for a reason — they heat up while lighting a scene before, during, and after you take the shot.) Be sure not to position these lights too close to any fabric or flammable material.

Adding lowlights

Just like it reveals light sources as highlights, a reflective surface also reveals dark areas. You can use this effect to add aesthetic interest to a photograph.

Positioning a piece of black foam core so it appears in the subject's surface lets you add contrast to the highlights. You can use this technique to help separate your subject from the background or simply to create a more dramatic depiction of your subject.

Check out the example in Figure 15-3; notice how adding the black lowlight causes the piece of jewelry to pop. Experiment with adding lowlights by looking through the camera's viewfinder as you move the black foam core around the subject. Position it in a way that adds to revealing the form of the subject.

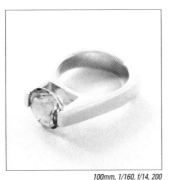
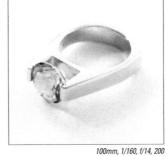

100mm, 1/160, f/14, 200 *100mm, 1/160, f/14, 200*

Figure 15-3: A black piece of foam core helps to add interest and separate the subject from its surroundings by creating lowlights.

Consider placing the black card so it's visible at your subject's edges to help create an outline of the subject's form or shape. The idea here is to produce crisp, sharp lines that emphasize the natural lines that exist in the subject already. To create the most contrast, position the black cards right next to the white cards you use to create your highlights.

If you want to add contrast but don't want the subject to appear too dramatic, then use a dark grey piece of foam core rather than a black one.

Creating a sparkle

A hard light source (such as an un-accessorized flash or strobe) doesn't do much for creating smooth highlights on a reflective subject, but it can be helpful in creating a sparkle.

If you position the light so that its reflection appears in the subject's surface, it will look like a small spot of light similar to a sparkle. The farther you place the light from the subject, the smaller its reflection appears.

Photographers often incorporate hard light sources into their lighting setups to add a shine to diamonds or to create a spot of interest. In Figure 15-4, I lit the subject in the first image with appropriate highlights and lowlights, but it lacks the shimmer that the second image has because I added a hard light source.

Casting a shadow

You can add a hard light source to your lighting setup in order to cast a shadow from your subject onto the background surface. Doing so can add drama or a sense of place to an image.

Because they provide soft lighting, the techniques that you use to create highlights in reflective subjects don't offer much in the way of shadows. You need a harder type of light to create a well-defined shadow.

By positioning your hard light source so it casts a shadow from the subject, you may be able to create the sparkle that I tell you about in the section "Creating a sparkle" and cast a shadow at the same time. Figure 15-5 shows an example of this technique.

Choosing a Shooting Surface

The surface material that you use when photographing jewelry or other reflective surfaces has a great impact on your final image and also affects which lighting styles work best. The characteristics of a subject and how you wish to portray it determine the proper lighting style for that subject. After you know how you'll light the subject, you must figure out which shooting surface will work best for your subject and message.

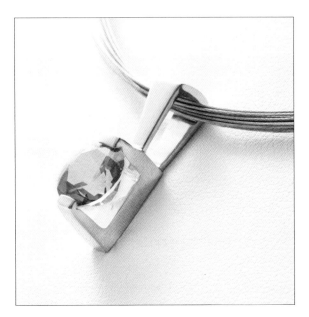

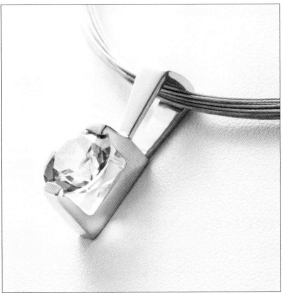

100mm, 1/160, f/22, 400

Figure 15-4: The reflection of a hard light source can add a sparkle to your images.

100mm, 1/160, f/22, 100 *100mm, 1/160, f/22, 100*

Figure 15-5: Use a hard light source to cast a well-defined shadow of the subject.

Plain background options

A plain background is ideal for creating clean compositions that minimize distraction and maximize the attention you draw to your subject. Plain backgrounds work great for revealing finer details in subjects like pieces of jewelry, which tend to be works of art themselves and don't require supporting elements to add interest in a photograph.

You have various options for surface materials, and each offers different qualities. Some of the things you need to consider when choosing a surface material include:

- ✔ **Shadow or no shadow:** You can cast your subject's shadow on a matte surface but not on a reflective surface.

- ✔ **Reflection or no reflection:** If you want to include a reflection of your subject, you need to make sure your shooting surface is reflective.

- ✔ **Tone and color:** Having a variety of surfaces for tone and color enables you to accommodate more subjects properly. A white shooting surface works well for many subjects, but sometimes a darker surface works better to reveal the detail you'd like to emphasize. Colored surfaces can create a mood or feeling (refer to Chapter 10 to find out about moods associated with colors) or add visual contrast.

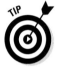

Colors that exist at opposite ends of the color spectrum create contrast when used in combination with one another. You can make a blue gemstone stand out vibrantly by photographing it against a yellow background. To create contrast for a green subject, choose a purple background. Choose color combinations that are closer to each other in the color spectrum to create a more subtle image with less color contrast.

Here is a list of different shooting surface options and the qualities they contain:

- **Paper:** An affordable matte surface material, paper enables you to cast your subject's shadow or not (depending on your lighting style). You can easily form it into a seamless background (as I describe in Chapter 9), and if a spot gets dirty, you can cut it off and roll out a clean section to work with. Paper doesn't produce a reflection of your subject.

- **Acrylic glass (commonly referred to by one of its trademark names, *Plexiglas*):** Acrylic glass is a reflective material and so eliminates the shadow of your subject, providing its reflection instead. Acrylic glass is more affordable than glass, and it's more flexible. Specialty dealers sell a variety of colors and tones and can form the material to the shape of your choice, making it easy to create seamless backgrounds.

- **Glass:** Quality glass is not as cheap, light, or flexible as acrylic, but it can provide much cleaner reflections. Glass is ideal if you're a serious photographer who is interested in optimizing the quality of your images as much as possible. You can either paint the bottom side of your glass to achieve a specific tone or color, or simply position the glass on a surface with the tone or color of your choice.

- **Cloth:** Cloth is similar to paper in that it can provide shadows (or not) and it doesn't provide a reflection of the subject. Cloth has to be cleaned if it gets dirty and must remain taut in order to avoid creases and wrinkles (which can create distractions or cause a photograph to appeared flawed).

- **Combining surface materials:** To create the most versatility in your studio, I recommend purchasing rolls of paper in multiple tones and colors. You can then purchase one clear piece of glass or acrylic. This is an affordable way to create a lot of options. If you first set up a seamless background (like the one I describe in Chapter 14) with the paper material, you can add the reflective material or take it away depending on whether you want to include your subject's reflection in your composition.

 Figure 15-6 shows a subject photographed without its reflection (by shooting it on the paper alone) and with its reflection (by adding glass to the set).

Creating a more natural look

In some instances, you may want to add to the story of a piece of jewelry by incorporating an environment around it. This style of shooting helps to give viewers an idea of who would be wearing a particular item, what time of year, holiday, or occasion it's intended for, or to give a sense of place to an image.

100mm, 1/10, f/16, 160

Figure 15-6: By placing a piece of glass on a tabletop studio setup, you can add the subject's reflection to your composition.

If a plain white background helps to say, "This is what our particular ring looks like," then a natural setting helps to say, "This is where our particular ring belongs."

When choosing a setting for your subject, try to consider the type of person you would like the image to appeal to. Then set your shot up based on the following elements:

> ✔ **Color** plays a major role in influencing how people feel about photographs (see Chapter 10), and it helps people make associations. For example:
>
> • A women's necklace might be best represented in an environment made up of feminine colors (such as pastels).
>
> • A young girls' necklace, which is meant to appear more hip than elegant, might be more appropriately photographed among bold colors.
>
> • A handmade piece of jewelry made from recycled silverware could be shot in the presence of natural, or earthy colors.

Each situation requires you as the photographer to determine what type of colors best suit your subject.

✔ **Props** provide supporting details in a photograph that tell viewers about the subject. These can consist of any element with literal or symbolic meaning, such as a person (or part of a person), flower petals, candy, a neck or ring mold, earring stand, or jewelry box. Positioning a diamond ring in a box of chocolates suggests that it's a good gift idea for Valentine's Day.

✔ **Textures** can give a sense of place to a piece of jewelry (or similar subject), while still providing a background simple enough that it won't distract from the details of the subject. For example, a sandy surface reminds viewers of the beach, wood grain provides a rustic setting, stone is harsh, and fabric can be comforting.

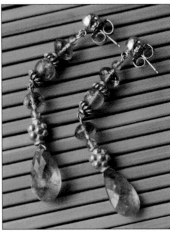

100mm, 1/60, f/4, 800

Figure 15-7: Texture and color add elements of design to the image without distracting from the subject.

In Figure 15-7, I considered color and texture when choosing the appropriate background. The muted orange color of the wood surface works well to bring out the color of the green stones without causing the image to be too loud (visually) for this particular subject. The texture of the surface works to give a sense of place to the earrings but isn't so distracting as to steal attention from them.

Working with Clear, Transparent Subjects

You light transparent subjects much like you light reflective subjects, but your background choices become a very important factor in how these types of subjects appear.

Because you can look right through a transparent subject, simply trying to light it won't do much good. The way you light your background is more important to an image containing a transparent subject than anything else, because what's behind the subject is what you actually see.

By aiming your key light behind the subject and at the background, you
cause the subject itself to appear illuminated. Figure 15-8 shows the differ-
ence between lighting the subject and lighting the background. In the first
image, I lit the subject, and it's hard to see. With lighting on the background
rather than on the subject, you can more easily make out the shape and form
of the clear glass subject.

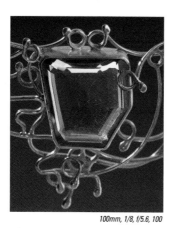 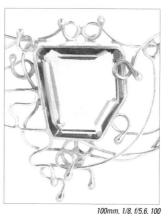

100mm, 1/8, f/5.6, 100 *100mm, 1/8, f/5.6, 100*

Figure 15-8: Lighting the background does more for a see-through
subject than lighting the subject itself.

Making the subject stand out from its background

Typically, the main goal when photographing transparent subjects is to make
them stand out from the background so that viewers can easily see them.
This section gives you a few ideas for techniques that separate transparent
subjects from their background.

A background's tonality determines how you go about making the subject
stand out. A light background and a dark one require opposite techniques.

Creating a high key look with a white background

A transparent object photographed on a white background is going to pro-
duce tones that are mostly *high key* (made of light grey to white tones). This
combination offers a clean, fresh, airy, and almost surreal look to most sub-
jects, but keep in mind how much detail appears in your subject.

The best way to cause your transparent subject to stand out from a white background is to include black cards in your lighting setup — a technique that I discuss in the section "Adding lowlights." Figure 15-9 shows you the result of using black cards to photograph a transparent subject. Because most transparent objects (like glass, plastic, crystal, and diamonds) also tend to have reflective qualities, you can use reflective lighting techniques to enhance their appearance in photographs.

The black cards cause dark streaks to appear in your transparent subject, making it stand out from the white background. In Figure 15-9, I placed the black cards on each side of the subject to give a symmetrical appearance to its shape, and to maximize its visibility in the image.

100mm, 1/160, f/16, 100

Figure 15-9: Black cards help a transparent subject stand out from a white background.

Revealing just the highlights with a dark background

When dealing with a dark background, use white cards to create a separation between the transparent subject and its background. You don't need to create lowlights in this scenario; they just blend in with the background. Instead, create bright highlights in your subject to contrast the dark background.

To photograph Figure 15-10, I positioned a white piece of foam core on each side of the subject to give it an even and symmetrical appearance.

100mm, 1/160, f/16, 100

Figure 15-10: Use white cards in your lighting setup to create contrast between a transparent subject and a black background.

Working with transparent subjects in a natural setting

Natural backgrounds (realistic environments with details, such as texture, shapes, lines, and literal elements) can be more difficult to work with than plain, studio backgrounds when you're photographing transparent subjects. You have to pay attention to the distracting elements in the background and compose your image accordingly.

To give your subject the cleanest representation possible, seek out the area in the background that has the fewest distracting details and compose your image so that area appears directly behind the subject. By doing so, you provide an environment for your subject without interfering with the true appearance of its shape, form, or texture.

16

Extreme Macro Photography: Working with Tiny Subjects

*T*he universe seems to provide layers of detail, from the galaxy, to the solar system, to the mountains, to the trees, to the animals, to the insects, and down to the bacteria and cells, to atoms and beyond.

Photography can capture the information provided at those various layers. How far down on the scale you wish to show in an image determines the type of equipment you'll need. Remember, a macro lens provides an image in which the subject is life-size (1:1) on the camera's digital sensor.

This chapter discusses ways to create images with ratios of 2:1 and greater, for those subjects that have very fine details and require more than a life-size representation to be seen clearly.

Why and How to Maximize Magnification

Your camera's digital sensor is quite small compared to a human subject, but it's rather large compared to most ants. This means an ant will appear small in a photograph, even when you use a 1:1 macro ratio to capture the image.

The smaller a subject is in relation to the size of your digital sensor, the more magnification you need to show its details.

An ordinary macro photograph of a tiny subject (like the image on the left in Figure 16-1) provides a clear representation of the subject's shape and gives viewers an idea what the subject looks like. But the detail provided in a macro photograph with twice the magnification reveals textures and features that were unclear before.

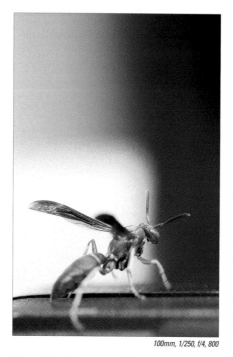 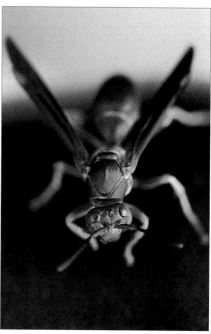

100mm, 1/250, f/4, 800 *100mm, 1/250, f/4, 800*

Figure 16-1: The greater the magnification ratio, the more fine detail is visible.

You might think that cropping into an image in postproduction is a suitable option for drawing a viewer's attention to specific details, but this isn't the case with tiny subjects.

Your images contain much more clear information about a subject when you photograph them with a greater magnification than when you crop into them. Notice the difference in Figure 16-2: I photographed the first image with a 1:1 ratio and cropped into it; I photographed the second image with a 2:1 ratio.

Cropping into a photograph diminishes its resolution and so makes the details less clear. Photograph the details you want at an appropriate level of magnification to ensure the image has high-quality resolution.

100mm, 1/60, f/16, 800 *100mm, 1/60, f/16, 800*

Figure 16-2: Cropping into an image to reveal detail is a poor substitute for creating it with more magnification.

Depending on your equipment, you have various options for achieving the levels of magnification that tiny subjects require. Part II of this book explains the lenses, magnification accessories, tools, and settings you need to create macro and close-up photography. This section explains specifically how to use those things to achieve the level of magnification needed for tiny subjects.

Lenses designed for "photomacrography"

Photomacrography refers to the art of photographing subjects larger than life-size on your digital sensor. (But for the most part, people still use the term macro photography.)

You can buy lenses that were designed specifically for creating extreme macro shots of tiny subjects. For example, the Canon MP-E 65mm 1-5x Macro Lens offers 1x up to 5x magnification (or 1:1 to 5:1). This lens begins where most macro specific lenses stop, and its unique design limits it to macro photography.

This type of lens is for photographers who are very serious about photo-macrography and who are willing to take the time to become familiar with their gear. The Canon MP-E 65mm 1-5x Macro Lens provides manual focus only. The working focal distance between the subject and the lens at 1x

magnification is about 100mm. At 5x magnification it's reduced to 41mm. These distances provide little room for additional lighting, and even less room for errors in positioning the point of focus and for minimizing camera shake and subject movement.

An alternative to this type of lens is to use *macro bellows*. This piece of equipment fastens between the camera and lens on your DSLR. It works in a similar way to an extension tube (which I describe in Chapter 4) but enables you to alter the distance between the camera and lens, depending on how much magnification you require. The farther you stretch the lens from the camera, the closer you can get to the subject while still achieving focus.

Getting more from your macro lens

If you're not super-serious about creating extreme macro photographs but you'd like to experiment with it, then increasing the abilities of your ordinary macro lens might be a good choice for you. In Chapter 4, I discuss extension tubes and tele-converters — tools that can help turn ordinary lenses into macro and close-up lenses. Using those same tools, you can turn an ordinary macro lens into an extreme macro lens.

A macro lens enables you to achieve focus close enough to a subject for a 1:1 magnification ratio. Adding an extension tube between your macro lens and your DSLR lets you get even closer. The larger the extension tube is (12mm, 25mm, 50mm, and so on) the closer you can get, and the more your subject is magnified.

The level of magnification you get from an extension tube varies depending on the size of the lens. For instance, a 25mm extension tube creates more magnification when paired with a 50mm macro lens than it does with a 100mm macro lens.

You can also use a tele-converter to increase the magnification of your macro lens. As I show you in Chapter 4, tele-converters are optical devices that you place between the lens and the camera. Tele-converters magnify the image created by the lens before it reaches the digital sensor.

Tele-converters come in various levels of magnification (1.4x, 1.7x, 2x, and 3x). Unlike extension tubes, they create a consistent impact no matter what lens you're using. A 2x tele-converter doubles the size of an image when paired with a 50mm macro lens or a 100mm macro lens (or any other lens). If you take advantage of a macro lens's ability to provide a 1:1 ratio (regardless of that lens's particular focal length) while using a 2x tele-converter, your photograph will have a 2:1 ratio.

Because the tele-converter acts as a middleman (rather than simply creating space between the lens and the camera, like the extension tube does) it doesn't cause you to move in closer to your subject. The magnification happens behind the lens rather than before it.

Tele-converters can lower the quality and sharpness of your images. Generally, the higher the level of magnification, the greater the loss in image quality.

Because they have optics of their own, be sure to seek a tele-converter that is high in quality and gets good reviews from other photographers online. Some forums and blogs post example images taken with various pieces of equipment. These provide a great resource for photographers who are shopping for new gear.

Working with Magnified Subjects: Tips to Keep in Mind

Creating a magnification ratio greater than 1:1 requires you to be extremely close to your subjects, and at such close range, even the slightest movement has a major effect on your point of focus and your exposure. If you handhold your camera at a 3:1 ratio, your subject becomes quite elusive, even when it's perfectly still. The movement that you cause is enough to make your point of focus bounce around, and this can become annoying or overwhelming.

The first step in eliminating movement is to put your camera on a tripod. This takes care of the shaking hand dilemma, but that's not the end of your issues when dealing with extreme magnification. You have to position your point of focus. You want to achieve as much magnification as possible, so your lens will be extended all the way out, and there's only one distance at which you can achieve focus. In this situation you have to move your camera rather than using the focusing ring.

If your camera's on a tripod, moving the camera around slightly to position the focal point is not easy. That's where the _focusing rail_ (see Chapter 6) comes in. This piece of equipment mounts on top of your tripod and enables you to make precise movements back and forth with the camera by twisting a dial. With a focusing rail you can pinpoint your point of focus without having to move the entire tripod.

If you're photographing a still subject, then you're in good shape at this point — your camera's secure, your focal point is precise, and you can use a long shutter speed without having to worry about anything moving. However, if you're dealing with wind or a moving subject, then you have more to consider.

A moving subject requires you to pinpoint your focus and then take the shot immediately before the subject moves away from the focal point. On top of that, you have to use a fast enough shutter speed to freeze the motion. This is an issue because increased magnification in photography means the lens is farther from the digital sensor and light is going to fall off before it reaches the sensor. In fact, the greater the magnification, the more fall-off occurs.

With light falling off, your exposure times become longer. Plus, depth of field becomes very shallow with increased magnification. You therefore need small aperture settings (like f/16) to depict more of the subject in focus. Small aperture settings require longer shutter speeds to compensate for the small amounts of light coming in the lens.

If you want to photograph moving subjects with extreme magnification, shoot in an area with a great deal of available light. Seek out bright, direct sun, and avoid cloudy days, open shade, and most indoor situations. If you do find a brightly illuminated subject to photograph, be sure not to block the light with your own shadow.

In situations that don't provide enough light to get the shot, you can use a flash to light your subject. Information on flash lighting appears in Chapters 6 and 9. The flash provides enough light to allow for faster exposure times and because it creates a burst of light for just an instant, the flash is ideal for freezing motion. The duration of the flash serves as a shutter speed within a shutter speed, so to speak.

Figure 16-3 shows the difference between a subject photographed with a 3:1 ratio using available light and flash lighting. Notice how the available light example (left) has issues with motion blur, while the flash lighting example (right) doesn't.

Keeping Composition in Mind

Sometimes photographers get so intrigued by or caught up in the technical aspect of extreme macro photography that they forget to create interesting compositions. Overlooking composition causes viewers to find interest in your subject (because they can see such fine detail in it), but it leaves something to be desired from an aesthetic viewpoint.

Say you're photographing a spider with extreme magnification. Being able to see how many eyes a spider has in an image is very cool, but it doesn't mean you can ignore the rest of your frame.

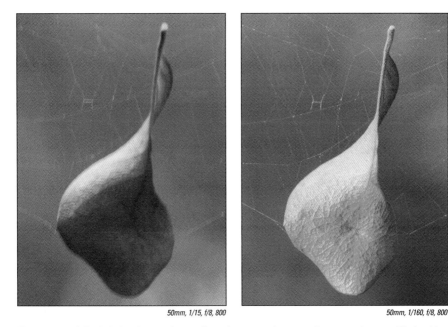

50mm, 1/15, f/8, 800 50mm, 1/160, f/8, 800

Figure 16-3: A flash helps freeze the motion when you photograph extremely magnified subjects.

The ideas behind photographic composition (see Chapter 10) apply to extreme macro photography just as they do to any genre. However, some limiting factors apply. This section helps you understand what those factors are and how to deal with them.

Your point of focus and depth of field

Positioning your point of focus exactly where you want it is very important in macro and close-up photography, and it's especially true in extreme macro situations. The slightest miscalculation has a great impact on your final image, causing viewers to question your choices — why you didn't put the eyes in focus, for example. Although it's easier said than done, you do need to achieve proper compositional results.

When you examine your subject through the viewfinder, you sometimes see details that aren't usually visible with the naked eye. Take the time to discover what's interesting about these details, and then position your point of focus exactly where you want viewers to look. This approach is the best way to highlight the details you would like to share through your photograph.

After you have the point of focus thing down, consider your depth of field. You can use a very shallow depth of field with high levels of magnification. (You might even get to the point where a spider's eyes are seen clearly, but its body is completely unidentifiable.)

A shallow depth of field can artistically draw viewers to your sharp point of focus and away from other blurry areas of the frame (as I explain in Chapter 10). This tends to be the opposite of an extreme macro photographer's goal, though. Usually you wish to show as much detail as possible, because the details are the interesting part of this style of photography. Figure 16-4 shows how a greater depth of field helps reveal your subject and a shallow depth of field creates an unclear image.

50mm, 1/10, f/2.8, 800

Select an aperture setting that lets you reveal important details to your viewers. Perhaps you require just enough depth of field to show the subject in focus, but you still want to blur out the background. This could mean the difference between f/11 and f/16, or f/16 and f/22, depending on your subject's size and distance to the background, and your level of magnification.

50mm, 13 seconds, f/32, 800

Figure 16-4: You can lose a lot of valuable detail by using a shallow depth of field in extreme macro situations.

Paying attention to your camera angle

A lot of photographers tend to overlook camera angle when they photograph tiny subjects. You may become so engrossed in getting close to a subject that you simply take the most direct approach, rather than thinking of a better one that's more suitable for your subject or your message.

The camera angle is a very important factor in the outcome of your image. As I discuss in Chapter 10, camera angle can affect your depth of field and how your subject and background appear. Remember to approach every subject from the angle that works best, regardless of how close your camera is to it.

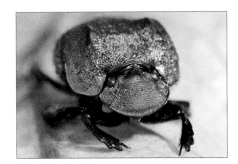

Figure 16-5 illustrates three separate camera angles used to photograph one tiny beetle:

- A low angle minimizes how much of the background is visible and provides a viewpoint similar to that of the subject.

- A higher angle provides a bird's eye view, which is how you would most naturally see this type of subject.

- An angle that was parallel to the subject's longest side got the most out of my depth of field, ensuring the sharpest focus throughout the subject.

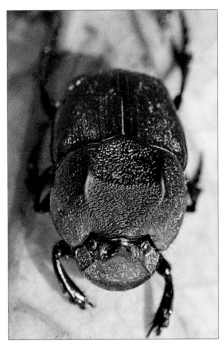

The lengths you'll go to get the best angle for a particular subject or message is what sets your images of tiny subjects apart from those of other photographers. Don't stop shooting an interesting tiny subject until you feel you have covered it in the best way possible (or until it runs, swims, hops, or flies away).

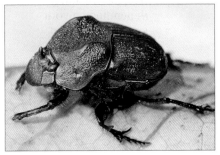

All images: 50mm, 1/160, f/11, 800

Figure 16-5: Choose a camera angle based on how you wish to show a subject and what you wish to say about it.

17

Improving Your Macro and Close-Up Images in Postproduction

A photographer's main goal usually is to capture images with the highest quality possible (based on your message). By following the techniques discussed in this book, you should have no problem creating macro and close-up photographs with correct exposures, sharp focal points, realistic color representations, and strong, effective compositions.

Even so, most images can be improved upon through postproduction via photo-editing software. And in some cases, you can use these programs to fix the occasional mess-up, like an image that's underexposed, has soft focus, was shot using the wrong white balance, or has compositional problems.

Adjusting Exposure After the Fact

Getting the correct exposure is one of the first steps to creating a beautiful photograph, as it ensures you have detail in your shadows and highlights. The next step is to enhance your exposures in postproduction, creating the perfect balance of contrast and tonal separation between those shadows and highlights.

The great photographers of the black-and-white film period knew the importance of manipulating their exposures after the image was captured on film. They would spend hours in the dark room, dodging and burning, and developing photos with various contrast filters to create the ideal look for a particular shot. Now you have the ability to make postproduction adjustments quickly and more efficiently. It's not cheating to use photo-editing software; it's just the newest way of doing things that have been done for ages.

Setting the contrast just the way you want it

Tonal contrast is the difference in appearance between shadows and highlights (or darks and lights) and is an important element of design. It determines the overall look and feel of an image.

Postproduction software offers various tools for altering contrast in photographs:

- **Exposure adjustment** enables you to apply more or less exposure to an image by moving a slider to the right (or up) for more brightness, or to the left (or down) for less brightness. The adjustments you make with this tool are general, meaning they affect the entire image consistently.

- The **Brightness/Contrast** tool provides two sliders to work with: one for brightness and one for contrast. The brightness slider affects the overall brightness of an image, making it darker or lighter. The contrast slider can increase or decrease the difference between highlight and shadow areas. By adding more contrast, the shadow areas become darker and the highlights become brighter. Decreasing contrast does the opposite.

- **Levels** puts you in control of your black point and your white point by providing a scale with sliders on each side. Slide the black point slider inward, and you make your shadows darker. Slide the white point slider inward, and you make your highlights lighter. A third slider in the center of the scale enables you to control the brightness of your mid-tones.

✔ **Curves** gives you maximum control and enables you to plot points in specific areas on a grid to control various tones in an image separately. By raising the curve in the highlight area and lowering it in the shadow area, you create more contrast in an image. By doing the opposite, you create less contrast. Raise the curve from the shadow side to create a high-key look. Lower it on the highlight side to get a low-key look.

✔ **Shadow/Highlight** provides two sliders — one affects the brightness of your shadow areas and the other affects the brightness of your highlight areas.

✔ **Photo-effect filters** enable you to apply specific looks to your photographs. These are sometimes included in package deals, or are available for purchase, and are great for the photographer who wishes to create certain looks — like enhancing fall foliage, increasing contrast, altering the colorization of an image, creating effects such as color halftone, solarization, brush strokes, or adding film grain — without spending much time at the computer. Most photo effect filters enable you to apply a filter and then alter certain aspects of it to achieve the look that works for you.

Creating a high-key image

A high-key image is one with mostly bright tones, which can give viewers a feeling that's surreal, light, dreamy, and clean. The frame contains an overwhelming amount of highlight areas, which can cause the few shadow areas to stand out and seem very important. Figure 17-1 shows an example of a high-key image.

To create a high-key photograph, choose a scene that contains mostly light tones (or light a scene to have very little separation between shadow and highlight areas) and expose it properly. Try using Curves to brighten your mid-tones and highlights without affecting your dark areas in the image. This creates a high-key image with a high level of contrast. Another option is to raise the tonal brightness of the entire image to create a high-key image with a low level of contrast. Each provides a different feeling and message.

The mysterious low-key look

The opposite of a high-key image is one that's low-key, or contains mostly dark tones. Low-key images usually offer muted, mysterious, or dismal themes to your message. They have subtle tones and are quieter than high-key images.

Figure 17-2 provides an example of a low-key image.

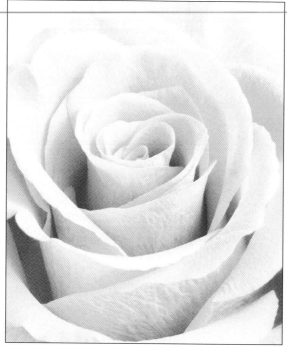

100mm, 1.3 sec, f/22, 320

Figure 17-1: A high-key image emphasizes bright tones.

Creating a low-key photograph in postproduction requires you to start with a proper exposure. This ensures you'll have details to work with in your shadows. (Even though your image is meant to be dark, you still want viewers to be capable of making out what's in the image.) Use a directional key light (side lighting works well to maximize separation between highlights and shadows) to create highlights in a scene and just enough fill light to reveal detail in the shadows. This set-up creates an image containing highlights and shadows with very few mid-tones.

With your properly exposed image, use a Curves layer (or the tool of your choice) to darken your highlights and mid-tones without affecting your shadow areas. Leaving the highlights brighter creates a more dramatic look, while darkening them more creates a subtler, softer look.

By keeping the darkest areas right where they are in regards to tonal value, and only darkening the highlights and mid-tones you can create a low-key image that still has visible detail in all areas. The idea behind this type of photograph is to provide viewers with an image that really forces them to look closely to see all of the details.

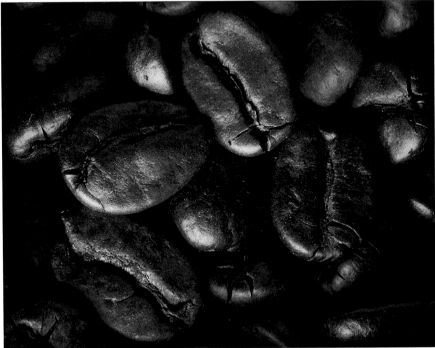

100mm, 1/125, f/22, 100

Figure 17-2: Images with mainly dark tones are considered low-key.

Striving for perfection with full-scale contrast

A full-scale image is one that contains a maximum range of tones, from black to white, and with everything in between. Unlike the high-key and low-key techniques, this type of image requires you to spread out the contrast evenly to provide a smooth gradation between your shadows and highlights.

The full-scale technique is generally what photographers go for, because it's more natural looking than high- or low-key images, and it helps photographs to really stand out visually. Figure 17-3 shows an example of a full-scale image.

In order to create a full-scale photograph, apply a Curves adjustment to your photograph. In Curves, you can darken the shadows and lighten the highlights so the image contains a high level of contrast. Just be sure not to get too extreme with your adjustments unless you wish to lose details in those areas. You can also choose to brighten or darken your mid-tones, depending on which you feel enhances the appearance of your image.

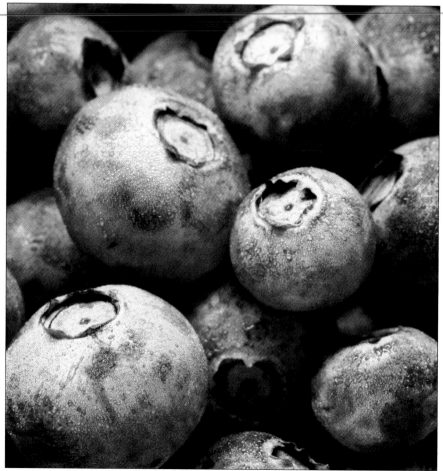

100mm, 4 sec, f/16, 400

Figure 17-3: A full-scale image provides a complete range of contrast.

Correcting an underexposed (or overexposed) image

Your exposure determines how bright your image looks. An underexposed photograph appears dark all around and typically contains little to no detail in the shadow areas. An overexposed image appears bright and can lose details in the highlight areas. The more under- or overexposed a photograph is, the more detail you lose and the harder it'll be to fix the file in postproduction.

If an image is slightly underexposed, you can fix it by using the exposure adjustment tool in your photo-editing software. Simply raise the brightness of the image until it looks the way you want it to, and that's that. For an image that's significantly underexposed, you may notice as you brighten in postproduction that you have little to no detail to work with in the shadow areas. If this is the case, you'll see a lot of digital noise in those areas as they become brighter and more visible. You may want to consider using the software's noise removal filter to reduce digital noise.

If you're working with an overexposed image, you want to lower its brightness with the exposure adjustment tool. If too much highlight detail was lost in the exposure (meaning there are areas in the frame that are pure white, with no information) then you won't be able to bring it back no matter how far you decrease the brightness of the image.

Most digital photographers tend to expose an image based on their highlights, ensuring they have information to work with in those areas. In postproduction they can bring up the shadow areas, if need be. If you notice that a scene has too much contrast to capture the shadows and highlights in one exposure, then apply one of the lighting techniques discussed in Part III of this book to balance the scene out some.

Shooting in the RAW format, rather than JPG enables you to have more postproduction control over your images. Your camera processes a JPG before it's saved to the memory card. This means the color balance, and shooting style is saved to that image. Your camera does not process RAW files, giving you control to change the color settings, exposure, contrast, saturation, and much more after the shot has already been taken. I recommend shooting in the RAW format any time you intend to perform postproduction enhancements to your images. For more on this topic refer to *Camera Raw with Photoshop For Dummies* by Kevin L. Moss (Wiley).

Enhancing Sharpness

Sharpness is very important, especially in macro and close-up photography. It's easy to spot focus-related errors in this genre because so much close detail is visible in the photographs.

Most photo-editing programs enable you to increase sharpness in an image, and when it's done correctly, this can add a crisp and realistic edge to your photographs. Knowing when to use sharpening tools, how they affect your photos, and what to avoid is important, so you can use them to enhance your images rather than to ruin them.

When to use postproduction sharpening tools

The best way to create sharp images is to start by getting your subject in focus and capturing the shot without any motion blur or camera shake. (Techniques for avoiding motion blur and camera shake are in Chapters 6 and 11.) Most digital photographers apply sharpening to all of their photos, even the ones that are already sharp. They do so because many cameras and lenses simply leave more to be desired (even when everything was executed perfectly).

By sharpening an already sharp image even further in postproduction, you can create a crisp, maximum level of sharpness that represents how you want the image to appear. Notice the difference in Figure 17-4 between a photograph that was captured in sharp focus and then enhanced with the sharpening filter in Photoshop. The enhanced image appears crisper and provides a more detailed image.

If you fail to capture your subject in sharp focus, then you can use sharpening filters in an attempt to make the image appear sharp. However, know that there's a limit. If an image is extremely blurry, there's no hope of bringing out the sharp detail. Photographs that are slightly blurred can often be salvaged, though.

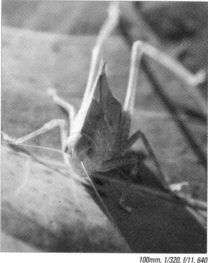
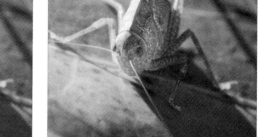

100mm, 1/320, f/11, 640 100mm, 1/320, f/11, 640

Figure 17-4: Even a photograph captured in sharp focus has room for improvement in postproduction.

How sharpening filters work

Sharpening filters work by emphasizing the edges (or adjacent areas with tonal contrast to one another) in an image. They create a fine highlight on the darker side of the edge, and a tiny lowlight on the lighter side of the edge.

This added contrast causes the edges to appear crisper from a distance, but when viewed up close, you can see a halo of sorts. Figure 17-5 provides a magnified example of what an image looks like after being sharpened in postproduction.

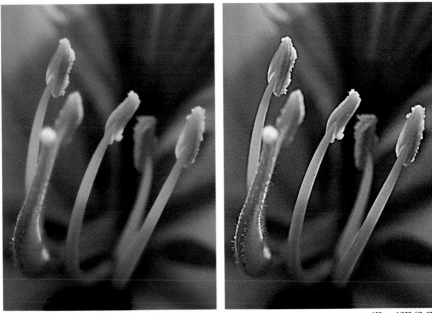

100mm, 1/160, f/8, 400

Figure 17-5: Contrast created by sharpening in postproduction.

A reliable sharpening tool (such as the UnSharp Mask Filter) provides three variable settings for you to adjust depending on the size of your image and how sharp you wish it to be. These three settings are:

✔ **Amount** controls the level of contrast created by the sharpening tool. A higher amount of contrast creates a greater difference between the highlight and lowlight edges.

✔ The **radius** determines the width of the highlights and lowlights created by the sharpening filter. You should choose the radius for a particular image based on what you see in the tool's preview window (by clicking

on the preview window, you can toggle the effect on and off to see just what it's doing to the image). An image with a higher resolution requires a greater radius than one with a lower resolution. Higher radius values can cause visible halos at the edges, so it's important not to get too carried away with this one, or it'll be obvious that you applied postproduction sharpening to your image.

✔ **Threshold** limits how much of the image is affected by the sharpening filter. It defines what is and isn't an edge by setting a standard of how far apart two adjacent areas must be in tonal value before they're affected by the radius and amount. In regards to threshold, high-contrast edges are more likely to be affected than smoother areas. A low value causes more of the image to be affected, and a high value causes less to be affected (protecting smoother surfaces in the image). One reason to choose a higher value would be to protect areas like a person's skin from being sharpened, which can cause the skin to look rough and overly textured.

The downsides to sharpening

The sharpening tool is one that can enhance or destroy the quality of an image, depending on how you use it. It works best when applied in moderation, with just enough of an effect to increase the appearance of sharp focus, without revealing itself too easily to viewers.

Some of the problems you face when using a sharpening filter can include:

✔ **Noise,** which, because it's made up of a bunch of small shapes, happens to be one of the easiest things to sharpen. That's bad luck because it also is probably the last thing you want to sharpen. When noise is sharpened it becomes more evident in an image, especially in the shadow areas. Try adjusting the threshold when applying a sharpening filter to minimize its effect on the noise in your image.

✔ A **halo** often becomes clear when you oversharpen an image or select too high a radius. This halo is a dead giveaway to viewers that an image was sharpened in postproduction. The trick to successful postproduction is to optimize an image without making the enhancements individually noticeable. Be sure to sharpen your images just enough so the halo isn't visible from a normal viewing distance.

✔ **Color artifacts** can sometimes appear after a sharpening mask has been applied. To correct this problem, you can select Edit➪Fade Unsharp Mask, and then set the effect to Luminosity mode (this technique must be done immediately after the filter is applied). Another option is to copy your image layer and apply the sharpening filter to the new layer.

Then set that layer to Luminosity mode. This ensures while you work with the color of an image, the contrast stays the same.

✔ The sharpening filter can sometimes **roughen smooth areas.** To keep this from happening you can set the threshold to keep those areas from being affected. Another option is to create a layer mask on the layer that you're sharpening, and block the effect from the smooth areas entirely.

Merging images to improve sharpness

Sometimes, a small aperture setting (such as f/22) is not sufficient to achieve the level of sharpness you want in an image. Macro and close-up situations naturally cause your depth of field to be shallower than usual, and you may wish to use a camera angle that makes it impossible to capture sharp focus throughout your subject without using postproduction.

Some photo-editing programs (like Photoshop version CS4 and later) enable you to capture multiple images of one subject, each with a separate point of focus, and merge the images to create one image with an expanded depth of field. You need to ensure that your subject can't move when you use this technique; photographing still subjects in the studio, where there's no wind, is ideal.

If you wish to maximize the sharpness in a macro or close-up subject, then follow these steps:

1. **Set your camera on a tripod and choose a camera angle and composition that suits your subject and message.**

2. **Lock the camera in place ensuring it won't move during or between shots.**

 If you have a focusing rail, then I recommend using it for accurate and easy focusing.

3. **Choose an aperture setting based on the sweet spot of your lens — neither wide open nor closed down, but somewhere in the middle of the lens's aperture range.**

 Most lenses produce their sharpest results when the aperture is not set to be extremely large or small. Because you'll be merging multiple images in this technique to produce one completely sharp image, there's no need to maximize depth of field.

4. **Position your focal point on the part of the subject that's nearest to your camera.**

 This is your starting point.

5. Take a photograph.

6. **Shift the focal point farther into your scene (achieving sharp focus on a part of the subject that's slightly farther from your camera).**

 I recommend that you use a focusing rail to shift your focus, but if you don't own one then simply rotate the focusing ring on your lens to shift the focal point.

7. **Take a photograph with your new focal point.**

8. **Repeat Steps 6 and 7 until you've taken enough images to cover the entire subject in sharp focus.**

 The size of your subject and your level of magnification determine how many photos you need to achieve focus throughout. Making smaller focusing shifts and taking more photographs ensures that you don't miss any areas, providing proper results when you process the images in the photo-merge.

9. **Open the images in Photoshop (or your preferred photo-editing software).**

10. **Select a base image, and drag the others into it.**

 Hold down the shift key to ensure the images are aligned when you drag them in. You end up with a single file containing each image on a separate layer.

11. **Select the bottom layer and then shift click on the top layer.**

 Doing so selects all of the layers.

12. **Go to Edit⇨Auto-Blend Layers, and choose the Stack Images method.**

13. **Click *OK* and wait for the software to do the rest.**

You end up with an image that's sharp and crisp from end to end. Figure 17-6 shows you an example of the process; note the varying focal points. Figure 17-7 shows the final image, with all focal points combined.

Sharpening an image with the High Pass filter in Photoshop

There are always multiple methods of achieving any task in Photoshop, and this is true for sharpening. One trick, which many photographers prefer, enables you to sharpen an image without using a sharpening filter. Instead, it requires you to apply the High Pass filter to an image and adjust its blending mode according to how sharp you wish the image to be.

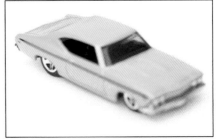

100mm, 1/160, f/11, 100

Figure 17-6: Shoot several different focal points to use Auto-Blend Layers.

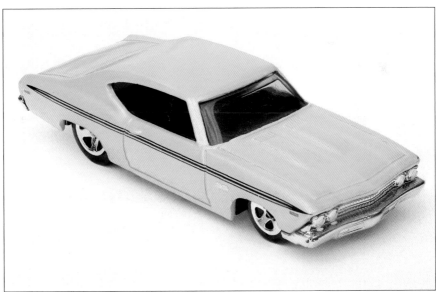

100mm, 1/160, f/11, 100

Figure 17-7: Use the Auto-Blend Layers tool to produce images with total sharpness.

Follow these steps to sharpen an image by using the High Pass filter:

1. **Pop open an image that you feel could use some postproduction sharpening.**

 If you're working on an image file with multiple layers, you need to either flatten the image or simultaneously press *Shift+Option+Command+N+E* to merge all layers to a new layer.

2. **Duplicate the flattened layer (or the new merged layer).**

3. **Apply a High Pass filter.**

 Select Filter⇨Other⇨High Pass, keeping the amount between 2 and 4 (depending on how much contrast you wish to create between edges, 2 being less and 4 being more.) Your image should look like the example in Figure 17-8.

100mm, 1/320, f/8, 800

Figure 17-8: Use the High Pass filter to sharpen an image.

4. **Now change the High Pass layer's blending mode to *hard light, overlay,* or *soft light*.**

 As Figure 17-9 shows, hard light maximizes the level of sharpening; overlay sharpens less than hard light; and soft light provides the least sharpening.

5. **Adjust the opacity of the High Pass layer or create a layer mask for even more control over how much or which areas of your image you sharpen.**

Idealizing Color in an Image

Color plays an important role in photography, whether it's to depict a subject for what it truly looks like (as in small product photography, which I discuss in Chapter 14) or to create a certain mood in an image (such as a blue cast, used to create a cool feeling).

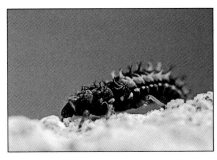

Postproduction processing puts you in total control of the colors in a photograph. No matter what type of light an image was photographed in and what color balance settings were used at the time of exposure, you can determine which works best when you're viewing the image on your computer's monitor. For instance, if you took a photograph in the shade but your camera was set for a daylight color balance, photo-editing software enables you to convert the color balance to open shade to give the image a natural look. You can even fine-tune the color balance settings to custom fit your specific image and the look you want it to have.

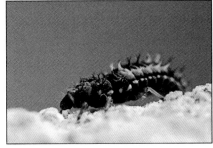

100mm, 1/320, f/8, 800

Figure 17-9: Hard light, overlay, and soft light offer different levels of sharpening.

By adding warm tones to an image, you can give it that sunset look. Cool tones can help to create a more frigid look. Plus, you can adjust saturation and vibrancy to make your images more or less colorful.

Some of the tools that enable you to manipulate color include the following:

- A **Curves** layer allows you to alter the amount of red/cyan, green/magenta, and yellow/blue in an image. This tool provides four curves: one for brightness, one each for the red channel, the green channel, and the blue channel.

 You add red by increasing the height of the red curve. To take out red (or add cyan) you lower the height of the red curve. Increase the height of the green curve to add green. Do the opposite for magenta; the same goes for blue and yellow.

- The **Hue/Saturation** tool enables you to increase or decrease saturation and brightness in an image. It also lets you change the hue of the entire image or specific color groups that you choose.

- **Selective Color** is a tool that uses (C)yan, (M)agenta, (Y)ellow, and Blac(k) to alter colors in an image. Choose a specific color and manage how much of the four determining colors are used to make up that color in your image. Say that you're working with red: Taking out cyan causes reds to become more pure and saturated; adding yellow causes the reds to appear more orange. Each selected color is affected differently as you alter the levels of CMYK.

- The **Vibrance** tool enables you to adjust the levels of vibrance and saturation in an image.

- The **Channel Mixer** filter lets you alter the colors in an image by controlling the output of each channel (red, green, and blue). It works great for changing a color image to black and white. Click the *monochromatic* box and then determine how each channel affects the tonalities of your image. The red channel produces dark skies and bright warm tones. The blue channel is ideal for maximizing texture in a person's skin.

- **Color Balance** is similar to a Curves layer, but it provides less precise control. This tool is ideal for creating general changes to the overall color of an image.

- **Photo Filter** offers many filters that were traditionally used by film photographers to warm, cool, change the color, or increase contrast in an image. These filters are designed to mimic the effects of the original filters they're named after.

- **Black and White:** Arguably the best way to change an image to black and white is with this filter. It provides control over each color in your image and how bright those colors appear when converted to grayscale. If you want to brighten the reds, simply slide the red slider up. Slide the blue slider down to darken the blues. By using these sliders, you can control the contrast in your black and white conversions with precise detail.

Compositional Improvements to Strengthen Your Message

You always need to consider good composition when setting up and taking a photograph. I tell you more about composition in Chapter 10, and for a complete guide, check out my book *Digital Photography Composition For Dummies* (Wiley).

Even after you compose your image and capture the shot successfully, you can apply postproduction techniques to further improve the aesthetics of your composition and strengthen your message.

Enhancing aesthetics and leading viewers to your subject

In macro and close-up photography, your subject is often very obvious, since the camera is so close to it and it's often represented largely in your frame. Even so, you can improve its presence and lead viewers to the specific details you find interesting or relevant to your message by performing some basic photo-editing techniques.

As I show you in the section "Setting the contrast just the way you want it," the Curves tool can be used to manipulate contrast in a scene. By creating the Curve on its own layer and applying a layer mask to it, you can specify which areas of the image are affected by the curve and which are not. White areas on a layer mask tell the Curve tool where to affect the image, and black areas tell it where not to affect the image. You can create the white and black areas by painting on the layer mask with the brush tool or by filling in areas of the mask with the gradient tool or paint bucket.

By creating more contrast in the subject's surrounding area, you can draw viewers into that space in your frame. This helps to reinforce what your subject is and guide them to it.

In Figure 17-10, an original image appears next to one that has been altered to draw more attention to the subject.

This technique also enables you to remove contrast from areas that you feel are distracting or unpleasing.

100mm, 1/250, f/8, 400

Figure 17-10: Increasing contrast in certain areas of the frame draws attention to those areas.

Getting rid of flaws, dust, and distractions

Many factors can cause visual distractions in a photograph. These tend to detract from the subject and can cause images to appear messy or unclear.

From a technical standpoint, you might have dust on your digital sensor that's making its way into your photos. This causes spots to appear in the areas where the dust is.

Another problematic issue can be that the subject (or another element in the scene) has flaws on its surface, such as dust, scratches, pimples, litter, or smudges. And in some cases, your scene might include an element that you wish wasn't there, like an awkward, half-eaten leaf on a flower's stem, or an unwanted label or logo on your subject.

Make these types of distractions disappear by using the clone stamp or the healing brush in postproduction. Each of these tools enables you to sample an area from the image that's similar in texture to the area you wish to clone out. With the sample, you can brush over the unwanted area until it's blended with its surroundings. If you use the tool properly, viewers never know the difference. Figure 17-11 shows an example of an image in which distracting elements were cloned out.

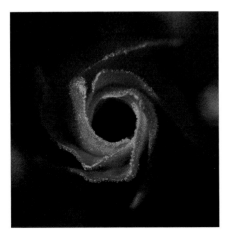 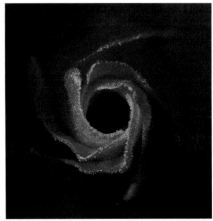

100mm, 1/250, f/8, 200

Figure 17-11: Use the clone stamp, or healing brush, to remove distractions from a photograph.

You can easily remove dust from an image with this technique, because it's small, and the changes required are so minor. A simple click of the mouse can remove a dust spot. Larger areas of distraction, however, require more strategic methods for cloning them out. You don't want to make it obvious that you replaced one area with information from another, as this creates a pattern that people can easily pick up on.

When cloning large areas, constantly select new sample points to ensure that your cloned area contains details from various areas and doesn't appear to be a direct replica of the area you sampled from. Choosing only one sample point results in repeating elements (or plainly visible patterns.) Check out Figure 17-12 for an example of what not to do.

Fixing your perspective

Sometimes to get the proper angle on a subject, you end up with the wrong perspective, resulting in distortion. This can mean lines that are supposed to be straight appear bent. Or elements that should be even in size are disproportioned.

100mm, 1/160, f/11, 400

Figure 17-12: Choose a new sample point often while cloning, or you'll end up with a pattern.

For situations like these, postproduction programs provide perspective filters that enable you to have your cake and eat it, too (or get the angle you prefer and the perspective, too).

In Figure 17-13, I chose a high angle to show the three dimensions of the subject. This in turn caused the sides of the subject to be distorted. To correct the issue, I used a lens correction filter in Photoshop. This filter enables you to increase the size of the frame's bottom end without affecting the top half. In turn, the distortion is corrected and the subject appears to be standing straight up. Using this technique enabled me to show the subject's dimension without compromising its shape.

Excessive distortion correction can compromise the sharpness or overall quality of an image. When possible, choose a camera angle that works for your message without relying on too much of a lens correction in postproduction.

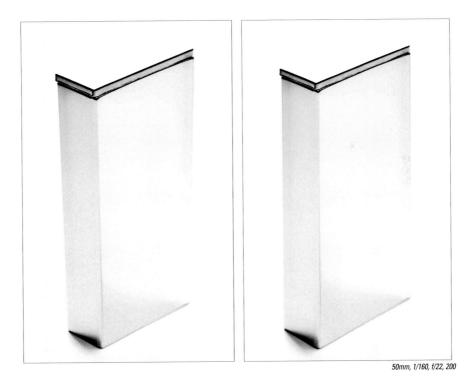

50mm, 1/160, f/22, 200

Figure 17-13: A lens correction filter can correct distortion in an image.

Part V
The Part of Tens

The 5th Wave By Rich Tennant

"I read that you should always divide your pictures into thirds, but I can't for the life of me see how that improves them."

In this part . . .

*E*very *For Dummies* book contains a Part of
Tens, which offers quick bits of information.
In this one, I give you ten tips for getting the most
out of your digital point and shoot camera, and I
run through ten subjects that are worth exploring
with your macro and close-up photography.

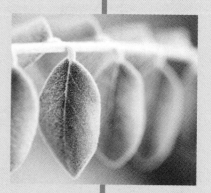

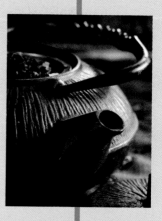

Ten Tips for Close-Up Photography with Your Digital Point and Shoot

*W*hen it comes to macro and close-up photography, a lot of information is available to photographers with DSLR equipment, while photographers who primarily use point and shoot or compact digital cameras are left fending for themselves. Most serious photographers in this genre are expected to acquire the gear necessary to produce the highest-quality results (which means going with the DSLR line of equipment).

But your digital point and shoot camera has much to offer and can be a very useful tool, providing quality images of all sorts. This chapter provides useful information for maximizing the quality of your macro and close-up shots when using your digital point and shoot camera in its macro or close-up shooting mode. For information on how to set the camera to this mode refer to your owner's manual or Chapter 7 of this book.

Shooting with a Wide Angle of View

By choosing the camera's widest angle of view (zoomed all the way out), when in the macro shooting mode, you can take advantage of its closest possible focusing distance. Some digital point and shoot cameras let you get within a centimeter of your subject.

Zooming all the way out maximizes magnification and provides a wide angle of view. This combination enables you to photograph your subject with great detail and show its surrounding environment at the same time.

Having your camera so close to the subject may block the natural light (casting a shadow on the subject), and your on-camera flash will be rendered useless by the extremely close proximity. In order to light your subjects you can either position yourself so that you don't block the natural light, bounce light in from the side with a reflector, or use a flash from off-camera or a ring light. For more information about lighting your subject in this situation, refer to Chapter 7.

Using the Camera's Zoom Function

If you want to cut out some of the surrounding environment from your composition, create a more shallow depth of field or create some distance between your camera and your subject. Then you can zoom in with the camera's optical zoom function. By doing so you produce a narrower angle of view, but you also lose some size and detail in your subject.

The more you zoom in, the greater your minimal focusing distance becomes and the smaller your subject becomes in the frame. Therefore, this technique works best for subjects that are larger in size or for subjects that you'd prefer to keep your distance from. This could include living creatures that could scare (or scare you) easily, or any scenario in which having your camera too close blocks the light and makes capturing a good exposure of the subject difficult.

Many photographers automatically assume that zooming in will create a larger representation of a subject, but when using your digital point and shoot's macro mode, the opposite is true. Become familiar with the results you get at different zoom levels when shooting in this mode so you can know what works best in various situations.

Focusing the Camera

Some digital point and shoot cameras offer manual and auto focus controls. Find out whether yours does by reading the owner's manual. If so, then you're in luck.

Focus is very important in macro and close-up photography. Because the subject is so close to the camera and includes such great detail, a misplaced point of focus is very obvious. For instance, if you take a macro shot of a butterfly on a flower and the flower is in focus rather than the butterfly, the photograph might look awkward. Had the butterfly not been there you'd want the flower to be your point of focus, but if the butterfly is in the scene, it should be in focus.

Here are some things to keep in mind when attempting to position your point of focus with a digital point and shoot camera:

✔ In auto-focus mode you can position your point of focus by centering your subject in your frame, pressing and holding the shutter release button halfway, and then composing your image after your focus has been set on your subject. Be sure not to let go of the shutter release button after you set your focus, or you will have to do the whole process over again.

✔ If your digital point and shoot allows you to use manual focus controls, you can position your point of focus without readjusting your composition. Each camera is different, so refer to your owner's manual to see whether yours offers manual focus and to find out how to use it. In manual focus mode, you can shift your focal point through the scene while viewing the results on the camera's LCD screen until you have it right where you want it.

Steadying the Camera on a Tripod

Most photographers don't think to position their point and shoot digital camera on a tripod, but in macro and close-up situations doing so is a good idea. A tripod can help to maximize quality in a few different ways.

Use a tripod with your digital point and shoot to:

- ✔ **Avoid camera shake:** Any movement in the camera during your exposure will cause blurring in the photograph.

- ✔ **Get a more precise point of focus:** Having the camera perfectly still is the best way to ensure your point of focus doesn't move between the time you set it and the time you take the shot.

- ✔ **Free up your hands:** Having your hands free enables you to hold lighting accessories in place, and to hold distracting elements, like an unwanted plant limb, out of the way of your shot.

Paying Attention to Composition

Just because you're using a point and shoot camera doesn't mean you have to literally point and shoot at your subjects. You need to compose each image you create in a way that depicts the scene in its best way and gets your intended message (or your reason for taking the photograph) across.

Consider your distance from the subject and how much of its surroundings appear in your frame. Do you want to isolate the subject with a narrow angle of view or show its environment with a wide angle of view? Think also about your camera angle. Does a high or low angle work better to reveal the shapes and relationships of the elements in your scene? Are you going to shoot your subject straight on, or from the left or right?

Your depth of field has a big impact on how an image appears. Consider which works better for your message:

- ✔ A shallow depth of field (caused by a large aperture setting) isolates the subject by blurring the background.

- ✔ A great depth of field (caused by a small aperture setting) includes sharp detail throughout more of the scene.

The placement of your subject and other elements in your frame can determine how viewers see them. The rule of thirds states that your subject, horizon lines, and other visual points of interest in a scene are best represented when placed on the thirds of a frame rather than in the center or at the far edges.

For a complete guide to photographic composition, read *Digital Photography Composition For Dummies* (Wiley), by yours truly.

Controlling Your Shutter Speed

Your shutter speed is an exposure setting that determines how quickly a photograph is taken. A faster shutter speed (such as 1/250 of a second) can freeze motion in a scene, while a slower shutter speed (such as 1 second) can reveal motion in a scene.

Use a faster shutter speed when

- ✔ You wish to photograph a moving subject and capture a sharp image of it.
- ✔ You're handholding the camera.

Use a slower shutter speed when

- ✔ You're photographing a moving subject and wish to capture motion blur.
- ✔ Your camera's on a tripod and you're working in a low-light situation.

Each camera has a specific maximum sync speed in which it'll work with a flash. If you're shooting with a flash, be sure to choose a shutter speed that captures the flash's light. Refer to your owner's manual to discover the max sync speed of your camera.

Setting the Aperture

Your aperture value controls the depth of field in a photograph. A small aperture setting (determined by a higher number such as f/16) gives your image a greater depth of field and brings more of the scene into sharp focus. A larger aperture setting (determined by a lower number such as f/2.8) gives your image a shallower depth of field and allows less of the scene to appear in sharp focus.

Use a great depth of field in situations in which you want background details to be clearly visible. This means the background adds to your message and doesn't come across as distracting. However, if you determine that the background is distracting and you feel that eliminating background detail would better depict the subject, then choose an aperture value that provides a shallow depth of field.

Finding Subjects That Work Well with Your Camera

By using your digital point and shoot in macro and close-up situations, you'll get a feeling of how much detail can be depicted in subjects of various sizes. Your camera may enable you to take beautiful photographs of butterflies, but may not be so great for capturing intimate detail in smaller ants.

If you know the limits of your camera, then concentrate on photographing subjects big enough to provide detail you can capture. It makes no sense to continuously photograph subjects you know to be too small for your camera, hoping for results you know you won't get.

There are plenty of beautiful subjects out there that are the right size for photographing close-up shots of with your digital point and shoot. For subjects that you find are too small for your camera to capture detail, check out the section "Using Macro and Close-Up Attachments."

Using Macro and Close-Up Attachments

Accessories designed to increase macro and close-up abilities are available according to camera. These are generally known as tele-converters, close-up filters, or close-up lenses.

You place one of these accessories in front of your camera's lens. They have optics that enhance the magnification of what your camera sees. They come in various levels of magnification, but with a common sacrifice: the more a close-up lens magnifies your image, the lower your image quality becomes. Determining the balance between magnification and quality that works best for your photographic style is important.

One close-up lens that stands out from the others is the Zoerk Macroscope. This is an aspherical, coated lens that screws on to the front of your ordinary lens. It provides high-quality optics and can produce 1:1 ratios when combined with an 80mm lens.

Lighting Your Subject

Depending on the model, your digital point and shoot camera can enable you to get within a centimeter of your subject while still achieving sharp focus on it. This can tend to be problematic when it comes to lighting, as your camera can cast its shadow on the subject.

A few different approaches can help you avoid this problem and produce beautiful lighting for your subject. Below is a list of options:

- **Use a ring flash (also known as a ring light).** The ring flash is designed to produce an even lighting on your subject, even when the camera is very close to it. Because the ring flash surrounds the lens, its light enters your scene in equal amounts from all angles. You won't get dramatic sidelit style shadows when using this type of light, but you will be able to get as close to your subject as possible without having to worry about lighting.

- **Use an ordinary flash from the side.** With your camera in close, you can sidelight a subject without casting your camera's shadow upon it. Also, try lighting the subject from above. Just ensure that your flash never gets too far behind the camera, as this will cause a shadow. You may need a sync cord or remote firing device to time the flash with your shutter. If your camera can't sync with an off-camera flash, then try using a very slow shutter speed and firing the flash manually while the shutter is open.

- **Use a reflector to bounce in light.** Bounce light from the side or from above. The closer your camera is to the subject, the less room you have to work with in positioning your reflector.

- **Select a camera angle based on the available light.** If you're using natural, or available, light for your subject, then you have to choose a camera angle or camera-to-subject distance that doesn't cause your camera's shadow to become visible in the scene.

19

Ten Subjects to Explore with Macro and Close-Up Photography

*A*fter you discover your own ability to capture photographic detail in life's smaller scenes, you may want to explore the possibilities of macro and close-up photography, creating beautiful images with intricate messages.

This chapter suggests ten subjects that offer limitless possibilities and range, from things you find in your backyard or around the house, to items you may wish to sell online, to your friends and family.

Capturing the Beauty of Flowers

It's no secret that flowers make great photographic subjects. The elements of design they contain are a gift to photographers, offering unique opportunities within each individual subject. No two flowers are exactly alike; therefore, no two flower images are the same.

Flowers tend to have beautiful colors, shapes, forms, lines, and textures. This variety of interesting elements provides you with choices in how you'll compose your image in a particular situation. When photographing a flower, ask yourself what it is that drew you to this one. Was it larger than the others around it, more colorful, was its form more attractive, or did it look kind of sad for some reason?

After asking yourself why you chose a subject, then ask yourself whether the image in your frame represents what you see in the subject. The slightest movement in camera angle can change the way viewers see an image of a flower. Pay attention to how each petal appears in your frame. Ask yourself whether you should crop into the subject or show it in its entirety.

Another very important aspect of flower photography is light. Photographers often avoid photographing flowers in direct sunlight, because diffused light is softer and tends to produce a more beautiful look for flowers. You can find softer light in open shade areas, on cloudy days, or by blocking the direct sunlight with a scrim or a piece of cardboard. For more information on shooting flowers, refer to Chapter 12.

Small Creatures and Insects

By photographing small living creatures you can create images that reveal fine details, which are generally overlooked or not visible with the naked eye. This kind of detail helps to provide insight to viewers and to draw their interest, as they notice things they haven't noticed before.

Small creatures and insects are also great subjects to work with because they provide a challenge. Depending on the individual subject, you may have to work quickly, use specific techniques, or come up with a strategy to get the shot. These practices tend to build your skills as a macro and close-up photographer. Some things to consider are:

- **The speed at which your subject moves.** A still or slower-moving subject lends itself more easily to being a photographic subject. Subjects that move more quickly require more skill and technique to get the shot. You face challenges in positioning your point of focus exactly where you want it, capturing the image without motion blur, and composing the image how you want it.

 - Placing your point of focus and getting the shot becomes difficult because a moving subject may move away from your focal point between the time you position it and take the shot. Therefore, you should work quickly, wasting no time between focusing and releasing the shutter.

 - Freezing motion is important for producing sharp images that can be seen clearly. A moving subject can become blurry if your exposure time is too lengthy. Use a fast shutter speed (such as 1/250 of a second or faster) when working with moving subjects.

- Composing the shot can also be a challenge when you're close-up to a subject and it continuously moves. The closer you are to the subject, the greater the effect of its movements on your composition. Find your camera angle, compose the shot, and capture the image quickly before the subject moves and changes everything.

✔ **How close the subject will allow you to get to it.** If your subject has the ability to move, then it has the ability to be scared off. Some creatures are more comfortable with having a camera shoved in their face than others. If you come across a subject that's uneasy with your close presence, try using a macro or close-up lens with a longer focal length. Doing so enables you to keep a greater distance while achieving the same level of magnification.

For more on photographing small living creatures, refer to Chapter 12.

Tiny Things That Fly

An even greater challenge than small creatures and insects that move on the ground is working with those that fly. This type of macro and close-up photography requires the most patience, and can also be the most rewarding when your desired results are achieved.

Capturing a sharp image of a tiny flying insect can be difficult, whether you capture the shot while the insect is in flight or in a moment of rest. The more quickly and spontaneously the creature moves, the harder it is to position your focal point before taking the shot.

When photographing butterflies, bees, dragonflies, or other things of the sort, try to position yourself in an area where they'll come to you rather than you having to chase them around. Pay attention to the types of flowers they're flocking to and make yourself comfortable in a spot that's surrounded by those flowers. This way, you seem like a natural part of that area when the flying bugs arrive on the scene.

Try first to get shots of the subjects as they land on a flower taking a moment to inspect it. That moment may be the only chance you have to catch them while they're still. After your shot is composed and your subject's in focus, take the shot before your subject takes off in flight again.

There are basically two approaches to capturing an image of the creature in flight. Doing so provides rewarding results, but you need even more patience than usual.

One option is to set up a focal point that's near a flower. Set your camera on a tripod and select a very fast shutter speed. Then wait for the subject to fly into your range en route to the flower, and snap your shot right as it passes through the area where your point of focus is positioned. This requires practice, luck, and timing. You might spend a whole day attempting this technique without any perfectly sharp images to show for it. Remember that using a small aperture setting gives you a greater depth of field to work with, increasing the range of what appears in focus.

The other option is to handhold the camera (using a fast shutter speed and your lenses' image stabilization mode, if available) and to track the flying creatures. Use the continuous auto-focus mode (which should help reduce the time it takes to lock focus on your subject) and take the shots very quickly. If your camera and lens are fast enough to catch the moving subjects, then you'll be able to get some sharp images. Just remember that this method doesn't provide much (if any) time to consider your composition.

More information on photographing things that fly appears in Chapter 12.

The Intricacies of Water

Water makes for a very interesting subject, as it can be transparent, reflective, or both simultaneously. Water can reveal movement, or it can be motionless and frozen in time.

A dewdrop on the side of a plant can tell the viewer that the photograph was taken in the early morning. On the outside edge of a glass it tells the viewer that the drink inside the glass is cold. A reflection in a drop of water dripping from a faucet can reveal details in the room that can't otherwise be seen by the viewer.

When photographing water, remember that you're photographing what the water sees more than the water itself. Choose an angle that doesn't reveal your own reflection in the water's surface. And apart from that, experiment with your camera angle until the water's reflection reveals exactly what you want it to.

A flowing, or moving water source provides an opportunity to either show the movement or to freeze it. By shooting with a slow shutter speed (with your camera on a tripod), the image on your digital sensor becomes blurred due to the motion. This causes water to seem misty, or smooth. Experiment with varying speeds to find the one that works best for your specific situation. The slower you set the shutter speed, the foggier the water appears.

A faster shutter speed captures a still representation of the water, giving it a more crisp and clear look.

Whatever's at Your Fingertips

The things around you probably provide a pretty good portrayal of who you are. You may not have thought about this, but you're surrounded by things that say something about you.

A seamstress's room most likely has threads, needles, and pincushions lying around. A crafty person might be surrounded by glue, scissors, tape, and yarn. A cook has flour, knives, measuring spoons, and so on.

The point is that you don't have to go far to create images that provide intimate information and strong messages. The simple detail of thread looped though the eye of a needle shows a relationship that the seamstress is quite familiar with. A metal needle has such a different texture from that of the thread, which creates a contrast that provides visual interest. Macro photography is the perfect tool for portraying that odd relationship.

Small details are everywhere, and many of them get overlooked. Find the ones that exist in your surroundings and experiment with revealing them through macro and close-up photography.

Interesting Textures

Texture can add a lot to your message. It can inform viewers of the subject's condition, provide a sense of touch to an image, and show similarities between different things.

A rusty chain provides a much different feeling than that of a brand new shiny chain. The rusty texture reveals the subject's age and how well it was taken care of (or not taken care of). The rusty chain has been forgotten, or ignored and has suffered the natural elements on its own. This story is told through texture alone.

Another thing that texture does for a photograph is to provide a sense that viewers can almost touch the subject. A sidelit scenario helps to emphasize texture by creating highlights on one side of the elevated areas and casting shadows on the other. This creates visual contrast and helps to show the surface's three-dimensional qualities.

Another way you can use texture creatively is to relate qualities of two different scenes. For instance, the textural details in a close-up shot of a leaf can look very similar to the textural details in an aerial shot of the countryside.

The Many Phases of Leaves

Leaves can make for an excellent macro and close-up subject, because they tend to go through many phases, each with its own interesting qualities.

When a leaf is alive and well, it's usually colorful, firm yet supple, and healthy-looking. As soon as the leaf falls to the ground, it begins to change. Although it remains colorful for a while (providing varying colors to choose from) it becomes less supple, and more rigid-looking. After the leaf has spent a good amount of time on the ground, it becomes more neutral in color and begins to decay. It is then more fragile than anything, and appears completely lifeless. Through time, some leaves tend to shed, leaving behind what appears to be a skeleton of a leaf.

The leaf is one subject that's readily available and provides a variety of tones, moods, and messages for the macro and close-up photographer.

Small Products

It's common these days for people to sell small products online, whether as a business, a hobby, or a quick way to get rid of unnecessary stuff; the best way to sell a product is to provide a clear and attractive image for potential buyers to see. People want to know what it is they're about to buy, and the more descriptive the photo is, the more likely they'll feel comfortable enough to buy what's in it.

Macro and close-up photography enables you to create detail-oriented images of even the smallest products. If you're trying to sell some of that old camera equipment that you have lying around, or you're looking to sell your old phone in order to upgrade to a new one, then create some interesting photos of the products that'll grab people's attention on eBay and Craigslist.

When photographing a small product, pay attention to its selling points, and then emphasize them in the images. If it's a name brand product, then be sure to highlight the name or logo so viewers can see it clearly. Choose a camera angle that reveals the subject's shape in an ideal manner, and choose a setting with little to no distractions.

For a detailed guide to photographing small products refer to Chapter 14.

Jewelry

One of the more difficult subjects to photograph is jewelry. This also makes it one of the most fun to explore.

Macro and close-up techniques enable you to capture detailed shots of even the smallest pieces of jewelry; but lighting the pieces is the challenging part. Many pieces of jewelry tend to have reflective or transparent surfaces. This means that to control the appearance of your subject, you have to pay attention to what surrounds the subject both within and out of your frame.

Anything that appears in the reflection of your subject will show up in your image. The goal is to create clean highlights and shadows by using your light sources and reflective (and subtractive) cards. For information on lighting jewelry read Chapter 15.

When creating images of jewelry, attempt to reveal the true shapes and forms of the individual pieces by strategically placing shadows and highlights in areas that require contrast.

Close-Ups of People

Although it may make some people uncomfortable, macro and close-up photography of human subjects can produce very beautiful and interesting results. If you have a friend who's not camera shy, try experimenting with macro and close-up techniques to see what you can come up with.

The eye is a typical close-up subject as it naturally has intricate details that are beautiful and unique. When photographing someone's eye up close, remember that the surface of the eye is a reflective surface. In order to see the color and details beneath the surface, choose a camera angle that doesn't reveal your light source in the surface's reflection.

In general, try using a longer focal length lens to keep some distance between you and your subject. Doing so creates a more comfortable shooting situation and cuts down on the chance that you see your own reflection in their eyes.

For more on shooting close-ups of people read Chapter 13.

Index

Notes

Notes

Apple & Macs

iPad For Dummies
978-0-470-58027-1

iPhone For Dummies,
4th Edition
978-0-470-87870-5

MacBook For Dummies, 3rd
Edition
978-0-470-76918-8

Mac OS X Snow Leopard For
Dummies
978-0-470-43543-4

Business

Bookkeeping For Dummies
978-0-7645-9848-7

Job Interviews
For Dummies,
3rd Edition
978-0-470-17748-8

Resumes For Dummies,
5th Edition
978-0-470-08037-5

Starting an
Online Business
For Dummies,
6th Edition
978-0-470-60210-2

Stock Investing
For Dummies,
3rd Edition
978-0-470-40114-9

Successful
Time Management
For Dummies
978-0-470-29034-7

Computer Hardware

BlackBerry
For Dummies,
4th Edition
978-0-470-60700-8

Computers For Seniors
For Dummies,
2nd Edition
978-0-470-53483-0

PCs For Dummies, Windows
7 Edition
978-0-470-46542-4

Laptops For Dummies,
4th Edition
978-0-470-57829-2

Cooking & Entertaining

Cooking Basics
For Dummies,
3rd Edition
978-0-7645-7206-7

Wine For Dummies,
4th Edition
978-0-470-04579-4

Diet & Nutrition

Dieting For Dummies,
2nd Edition
978-0-7645-4149-0

Nutrition For Dummies,
4th Edition
978-0-471-79868-2

Weight Training
For Dummies,
3rd Edition
978-0-471-76845-6

Digital Photography

Digital SLR Cameras &
Photography For Dummies,
3rd Edition
978-0-470-46606-3

Photoshop Elements 8
For Dummies
978-0-470-52967-6

Gardening

Gardening Basics
For Dummies
978-0-470-03749-2

Organic Gardening
For Dummies,
2nd Edition
978-0-470-43067-5

Green/Sustainable

Raising Chickens
For Dummies
978-0-470-46544-8

Green Cleaning
For Dummies
978-0-470-39106-8

Health

Diabetes For Dummies,
3rd Edition
978-0-470-27086-8

Food Allergies
For Dummies
978-0-470-09584-3

Living Gluten-Free
For Dummies,
2nd Edition
978-0-470-58589-4

Hobbies/General

Chess For Dummies,
2nd Edition
978-0-7645-8404-6

Drawing
Cartoons & Comics
For Dummies
978-0-470-42683-8

Knitting For Dummies,
2nd Edition
978-0-470-28747-7

Organizing
For Dummies
978-0-7645-5300-4

Su Doku For Dummies
978-0-470-01892-7

Home Improvement

Home Maintenance
For Dummies,
2nd Edition
978-0-470-43063-7

Home Theater
For Dummies,
3rd Edition
978-0-470-41189-6

Living the
Country Lifestyle
All-in-One
For Dummies
978-0-470-43061-3

Solar Power Your Home
For Dummies,
2nd Edition
978-0-470-59678-4

Available wherever books are sold. For more information or to order direct: U.S. customers visit www.dummies.com or call 1-877-762-2974.
U.K. customers visit www.wileyeurope.com or call (0) 1243 843291. Canadian customers visit www.wiley.ca or call 1-800-567-4797.

Internet

Blogging For Dummies,
3rd Edition
978-0-470-61996-4

eBay For Dummies,
6th Edition
978-0-470-49741-8

Facebook For Dummies, 3rd
Edition
978-0-470-87804-0

Web Marketing
For Dummies,
2nd Edition
978-0-470-37181-7

WordPress
For Dummies,
3rd Edition
978-0-470-59274-8

Language & Foreign Language

French For Dummies
978-0-7645-5193-2

Italian Phrases
For Dummies
978-0-7645-7203-6

Spanish For Dummies,
2nd Edition
978-0-470-87855-2

Spanish For Dummies,
Audio Set
978-0-470-09585-0

Math & Science

Algebra I For Dummies,
2nd Edition
978-0-470-55964-2

Biology For Dummies,
2nd Edition
978-0-470-59875-7

Calculus For Dummies
978-0-7645-2498-1

Chemistry For Dummies
978-0-7645-5430-8

Microsoft Office

Excel 2010 For Dummies
978-0-470-48953-6

Office 2010 All-in-One
For Dummies
978-0-470-49748-7

Office 2010 For Dummies,
Book + DVD Bundle
978-0-470-62698-6

Word 2010 For Dummies
978-0-470-48772-3

Music

Guitar For Dummies,
2nd Edition
978-0-7645-9904-0

iPod & iTunes
For Dummies,
8th Edition
978-0-470-87871-2

Piano Exercises
For Dummies
978-0-470-38765-8

Parenting & Education

Parenting For Dummies,
2nd Edition
978-0-7645-5418-6

Type 1 Diabetes
For Dummies
978-0-470-17811-9

Pets

Cats For Dummies,
2nd Edition
978-0-7645-5275-5

Dog Training For Dummies,
3rd Edition
978-0-470-60029-0

Puppies For Dummies,
2nd Edition
978-0-470-03717-1

Religion & Inspiration

The Bible For Dummies
978-0-7645-5296-0

Catholicism For Dummies
978-0-7645-5391-2

Women in the Bible
For Dummies
978-0-7645-8475-6

Self-Help & Relationship

Anger Management
For Dummies
978-0-470-03715-7

Overcoming Anxiety
For Dummies,
2nd Edition
978-0-470-57441-6

Sports

Baseball
For Dummies,
3rd Edition
978-0-7645-7537-2

Basketball
For Dummies,
2nd Edition
978-0-7645-5248-9

Golf For Dummies,
3rd Edition
978-0-471-76871-5

Web Development

Web Design
All-in-One
For Dummies
978-0-470-41796-6

Web Sites
Do-It-Yourself
For Dummies,
2nd Edition
978-0-470-56520-9

Windows 7

Windows 7
For Dummies
978-0-470-49743-2

Windows 7
For Dummies,
Book + DVD Bundle
978-0-470-52398-8

Windows 7 All-in-One
For Dummies
978-0-470-48763-1

Wherever you are in life, Dummies makes it easier.

From fashion to Facebook®,
wine to Windows®, and everything in between,
Dummies makes it easier.

Visit us at Dummies.com